BAROQUE
AND ROCOCO ART

ERICH HUBALA

UNIVERSE BOOKS
NEW YORK

Published in the United States of America in 1976
by Universe Books, 381 Park Avenue South, New York, N.Y. 10016
© Chr. Belser Verlag, Stuttgart
English translation © 1976 by George Weidenfeld & Nicolson, Ltd., London
Library of Congress Catalog Number: 73-88459
ISBN 0-87663-195-2
Printed in Germany

CONTENTS

PHOTO CREDITS Alinari, Florence 10, 14, 16, 18, 20–21, 29, 32, 83, 85, 110–11, 118 – Anderson, Rome 13, 82, 87–88, 91, 113, 117, 119 – Archives Photographiques, Paris 59 – Baerend, Munich 9 – Bayerisches Nationalmuseum, Munich 178 – Bayerische Staatsgemäldesammlungen, Munich 125, 128, 179 – Bayerische Verwaltung der staatlichen Schlösser, Munich 101 – Bildarchiv Foto, Marburg 17, 102 – J. Blauel, Munich 137, 140, 148, 149 – Brenci-Angeletti, Rome 89–90 – British Museum, London 168 – F. Bruckmann Verlag, Munich 181 – Bulloz, Paris 184 – H. Busch, Frankfurt/M. 42, 172 – J. Cailleux, Paris 187 – Cas Oorthuys, Amsterdam 78 – Chomon-Perino, Turin 28 – Columbia University, New York (back of dust jacket) – Combier-Viollet, Paris 66 – Deutscher Kunstverlag, Munich 51–52 – Devonshire Collection, Chatsworth 154, 164 – Fine Arts Gallery, San Diego 126 – Frans Hals Museum, Haarlem 136, 138 – E. Frodl-Kraft, Vienna 31, 35, 40, 43, 45 – Germanisches Nationalmuseum, Nuremberg 47 – Giraudon, Paris 56, 106, 124, 156, 159–61, 163, 169–70 – Herzog-Anton-Ulrich-Museum, Braunschweig 129 – H. Hinz, Basel (front of dust jacket) – Institut für Film und Bild, Munich 104 – A. F. Kersting, London 76–77 – Kgl. Schloss, Stockholm 95 – Kunsthistorisches Institut der Universität, Kiel 22, 55, 57–58, 60–63, 65, 71–73 – Kunsthistorisches Museum, Vienna, Foto Meyer 143, 150, 151 – Landesbildstelle, Berlin 97 – A. Laprade, François D'Orbay, Paris 67 – P. Ledermann, Vienna 38–39 – Lennart af Petersens, Stockholm 80 – G. Mangin, Nancy 158 – MAS, Barcelona 94 – Mauritshaus, The Hague 141 – E. Müller, Kassel 68 – Musées de la Ville, Strasbourg, Foto Franz 127 – Musées Nationaux, Paris 114, 174–77, 183 – National Gallery, London 135, 142 – Nationalmuseum, Stockholm 157, 185–86 – Photo Meyer, Vienna 96 – Th. Poensgen, Berlin 120 – J. Remmer, Munich 121, 123, 133 – Retzlaff-Bavaria, Gauting 173 – G. Reinhold, Leipzig 167 – Rijksmuseum, Amsterdam 79, 86, 130, 132, 134, 144–45 – Roger-Viollet, Paris 70 – J. Roubier, Paris 69 – Scala, Antella-Florence 108–9, 115, 122, 152, 155 – T. Scott, Edinburgh 166 – H. Schmidt-Glassner, Stuttgart 98, 103 – T. Schneiders, Lindau 41, 44, 54, 81 – E. Smith, London 74, 75 – Staatliche Graphische Sammlung, Munich 11 – Staatliche Museen, Berlin, Foto Steinkopf 84, 105, 116, 139, 146, 147, 153 – Staatliche Museen, Berlin, Kunstbibliothek 33 – Staatliche Schlösser und Gärten, Potsdam-Sanssouci 171 – Staatsbibliothek, Berlin 34 – J. Steiner, Munich 46, 48–50 – F. Stoedtner, Düsseldorf 131 – Strähle, Schorndorf 53 – Tecniphoto-Napoli, Naples 162 – Telarci-Giraudon, Paris 165 – Ullstein, Berlin 30 – Universitätsbibliothek, Zagreb 37 – Verwaltung der Staatlichen Schlösser und Gärten, Berlin 182 – Vienna Press, Vienna 107 – E. Zwicker, Würzburg 180.

INTRODUCTION

It is only in the last hundred years that the Baroque has come to be considered as an independent style in vogue between the Renaissance and the age of Neoclassicism. The term Baroque did not even exist for the artist of the period. Not until halfway through the 18th century, when Baroque art had already begun to wane—or rather when rationalist art criticism deemed that it should—was it so named, and then with the attribute "baroque" used in the sense of bad, bizarre taste that did not conform to the rules, and implying primitive formal characteristics as well (*baroquer* was the French cabinetmakers' term for turning and curving). The volley of abuse hurled at the Baroque during the Enlightenment (the German *Sturm und Drang* period) was, however, mingled with other attitudes, such as those of the novelist Wilhelm Heinse, for example (*Letters from the Düsseldorf Picture Gallery,* 1777), of Goethe (notes for the *Essay on Architecture,* 1795: "Sense of splendor and monumentality—containing immense diversity"), and of Christoph Martin Wieland, who made nondoctrinaire use of the word "baroque" in 1808, calling Part I of Goethe's *Faust* "a tragedy of baroque genius." But these indications of a growing understanding of Baroque art disappeared after 1830 in the wave of enthusiasm for the Italian Renaissance, which reached its culmination with Jacob Burckhardt's *The Cicerone* (1855) and *The Civilization of the Renaissance in Italy* (1860). Baroque was now regarded as the late phase of the Italian Renaissance, its decline, its debasement. This view at least prepared the way for the emergence of the art historical concept of the Baroque, even if it was not yet recognized as an independent style and was criticized in a negative spirit. After 1860, more and more artists and architects looked sympathetically at this allegedly decadent art, and under the influence of Impressionism Velázquez, Frans Hals, and finally Rembrandt were rediscovered (Eugène Fromentin, *Old Masters of Belgium and Holland,* 1876; Carl Justi, Velázquez studies, 1867 ff.), with Burckhardt referring to the "growing respect for the Barocco." Art history was now competing with the natural sciences in its attempt to become methodologically autonomous, and to emancipate itself from aesthetics. The fundamental concept of the Baroque as a historical style emerged (Heinrich Wölfflin, *Renaissance and Baroque,* 1888; Alois Riegl, *Die Entstehung der Barockkunst in Rom,* published posthumously in 1908), as a result of which the Baroque style was shown to have evolved from 1520 onward in Rome out of the Renaissance and as a reaction to it, and to have remained dominant in European art for about two hundred years until 1720–30.

The second intensive phase of international research into the Baroque (1918/20–40) resulted in an important adjustment to this theory; the concept of Mannerism arose and was proclaimed (perhaps prematurely) as an independent stylistic period. Thereafter, much that Wölfflin had in 1888 assessed as "already Baroque"—for example, the first Roman Jesuit church, Il Gesù—was judged to be Mannerist. The Baroque style was seen as an anti-Mannerist movement, with its origins in the period 1590–1610 (Walter Friedländer, *Mannerism and Anti-Mannerism in Italian Painting,* 1927). Further-

more, as a result of research, the view of the so-called Late Baroque had altered completely. The evolution of a "second" Baroque style about 1690 was recognized in Austria, Bohemia, Franconia, and Bavaria, and in the Alemannic regions of the Lower Alps (W. Pinder, 1912; H. Sedlmayr, 1925, 1930; K. Lohmeyer, 1928/29; Baroque exhibition, Prague, 1938). The flowering of the Baroque in these regions, as well as in Berlin and Saxony, lasted until 1740–60. This discovery laid to rest the misguided notion that simultaneity was the most important factor in the history of style, and raised anew the question of the Late Baroque (H. Rose, 1922). It is a question that remains unresolved to this day, but that can best be described as concerning the distinction between two substantially different versions of the Baroque, both of which occurred after about 1660. One version appears in regional developments of the Italian Baroque—in Naples, Florence, Genoa, and Venice—or as a national-political product (and consequently in a more limited form) in France, Holland, England, and Scandinavia. The other form of Late Baroque, though likewise distinctly recognizable from 1650–60 onward, cannot be defined simply in chronological terms, but must be assessed in terms of its content and origin. The home of this "Ornamental Baroque"—whose roots reach back to the Late Gothic period—was the East Alps, the Flemish and German Netherlands, Westphalia, and the Weser region. In these regions from the 15th century onward there was an unbroken tradition of woodcarving which continued with only minor modifications throughout the 16th and 17th centuries. Another material that appeared in the Alpine regions after 1560 was stucco, which was used for figural, ornamental, and geometric decoration; concurrently, guilds guaranteed the preservation of ancient crafts (for instance, the Wessobrunn stucco-workers, the Vorarlberg guild of masons). The Ornamental Baroque of the Alpine lands was inspired by Italian models, while North German Baroque was influenced by the Netherlands, and from 1680–90 both streams also made use of the French ornamental engravings of such artists as Jean Bérain. Among the masterpieces of this Late Baroque are altarpieces and church furniture, such as the choir stalls in Leubus, Lower Silesia (from 1678), by Matthäus Steinl or the double altar in St. Wolfgang on the Abersee, near Salzburg (1675–76), by Thomas Schwanthaler, and in the North, epitaphs such as H. Gudewerdt's in Eckernförde, near Kiel (about 1653). This kind of ornamentation, which hardly figured at all in Rome (although a certain parallel to it can be found in the Brustolon workshop in Venice), was without doubt a favorable influence in the transformation of the Baroque style north of the Alps and helped to determine the special forms of the Rococo. The Spanish Baroque of the 18th century belongs largely to this Ornamental Baroque, and in fact developed from an indigenous tradition.

The Baroque follows the Renaissance not only chronologically but also iconographically. The Baroque artist likewise uses the language of the antique order of columns. For him too, art consists of arrangement and of the relationships resulting from the interacting of shapes according to height, width, and depth. The themes and types of Baroque painting are the same as those of the Renaissance—including that

of ceiling decoration as a form of figural painting designed to be intelligible to the observer. So-called illusionism—that is to say, the illusion of spaciousness by a deceptive extension of the place in which the beholder finds himself—was not a Baroque innovation but was realized in extreme forms by artists as early as 1500 (Donato Bramante's illusionistic choir in S. Maria presso S. Satiro in Milan). Admittedly, these are mere exercises, conventional pretexts, as it were, for artistic creation, but they are nevertheless genuine elements of art, revealing a greater historical and cultural continuity. They belong to both the Baroque and the Renaissance, and may loosely be defined by the concept of European humanism. Moreover, the significance of illusionism for artistic concerns, in the narrower sense, becomes evident when one remembers that the age of humanism and of the architectural orders was also the time of the development of chiaroscuro in painting (Ernst Strauss), and that the elementary color contrast of blue and red, which is indisputably fundamental to Baroque painting, had already been used by Titian to its full potential.

The principal distinction between the Baroque and the Renaissance, however, lies in the ability of the former to encompass totality—not merely giving it a coordinated or subordinated unity, but "equivalents." Jacob Burckhardt coined this apposite term to capture the totality of Rubens's pictorial form, which outweighed even the sharpest contrasts. With these Baroque "equivalents" we are no longer concerned with the comparison of similar figures, but with an intellectual symmetry that is presented in pictorial form and is capable of reconciling physical and moral inequalities into a visually harmonious whole. Such equivalents cannot be measured by Renaissance standards; they cannot be assessed quantitatively, as is implied by the frequent use of the term "unity," which is a scholastic hangover from rationalist aesthetics. Baroque art contains qualities which are visually effective, and consequently comprehensible; however, they are no longer the product of "metrical" but of "physiognomical" considerations. Baroque has nothing to say to those who suffer from blindness of the soul: it must be seen with internal as well as external eyes if it is to be comprehended in its full sense, embracing the totality of man. All this is reminiscent of the principle of "overlapping" and "overlapped" forms (H. Sedlmayr) of Gothic art of the High Middle Ages. Baroque art, seeking to create a whole out of equivalents, might therefore seem to some to be a return to "overlapping" form on a higher plane and under organic conditions. This very quality may, however, make the Baroque suspect to others, who refuse to concede a metaphysical principle in art.

Baroque art is imaginative art. This is the key to the mystery of equivalents. For it is the activity of the imagination alone that produces the analogy in art between seeming and being, between form and strength, which is an axiom of Baroque art. To this extent the Baroque artist works like the poet, whose verbal material is available to all persons sharing the same language, but which he alone uses to fashion something that, though we may understand it, we are unable to produce ourselves. This type of the *artifex poeta* or poetic creation (K. Badt) is the Baroque ideal and the guarantee of its continuing impact in post-Baroque times, even up to the present day.

Bernini, whom Poussin called *un gran favolatore* ("a great fabulist"), and Rubens, whom Burckhardt considered the "greatest narrator" after Homer in the history of art—a comparison already made by Winckelmann—are the most perfect representatives of the Baroque along with Rembrandt, whom Fromentin called an "ideologist." And what better term could there be for the masterpieces of Baroque architecture—the Piazza of St. Peter's in Rome, the Karlskirche in Vienna, or the pilgrimage church of Vierzehnheiligen—than Wilhelm Dilthey's notion of an "art of imagination"? It applies equally to Dutch landscape painting, which only a hundred years ago was still regarded as no more than a copy of "reality," and to Claude Lorrain. Certainly there is verisimilitude in Baroque paintings, that is to say, a continuous and immediately recognizable link with our common experience of the natural; but even in the wake of the so-called realists, truth is colored by imagination. There is an ideal quality in Baroque art which is often only barely distinguishable from everyday reality, and which should not be overlooked even in a picture whose subject is ostensibly quite trivial, as in Caravaggio or Georges de la Tour. This power of transformation, inconceivable at that stage in the development of art without the participation of the imagination, produced a revival of ancient mythologies, the construction of allegories, and the belief in miracles embracing both heaven and earth.

The artistic concept of imagination also explains how the Baroque stands in relation to antiquity and to nature. The rationalist—who regards himself as a classicist—views Baroque illustrations of antique themes with derision. He regards antiquity as a storehouse of material that should be faithfully reproduced. For the Baroque artist, however, antique statues, buildings, and pictorial documents were evidence of a magnificent past, which was also recorded in ancient literature. Even if he could not read this in the original, but had it retold to him or accepted the stories in the form of myths, his aim was to recapture them by the power of his own imagination and to bring them to life in his work. Much the same is true of the Baroque artist's attitude to nature. Nature studies—and the Baroque examples are without exception drawings or sketches, not finished paintings—are often enchanting on account of their power of observation, their sure vision, and their not infrequent humor. There are those who regret that Annibale Carracci, Rubens, Poussin, and Guercino never painted what they sketched. Yet a closer examination of the Baroque shows that even when "copying," the Baroque artist is altering, selecting, rearranging, in short, transforming. Then, when he makes use of this wealth of material from classical antiquity and nature to create his paintings, he changes not just one motif or another, but the entire character of his studies. This is not to say that antique "quotations" or studies from nature are excluded from Baroque painting, for both are prerequisites of this mode. Even in the pictures of Caravaggio, who has been accused of portraying too realistically the sometimes sordid details of life, there is an idealization of the human figure, albeit only in the arresting beauty of the color; and indeed it can be shown that he too used antique prototypes for his figures. Both elements, then—antiquity and nature—contribute to the character and beauty of Baroque art.

Both in range and in quality, the supremacy of the visual arts over literature and philosophy in the Baroque age is quite striking. In the one area uniting all the arts, where man himself appears as a representative artist, namely in the theater, the 17th century produced some outstanding literary masterpieces, particularly in England, France, and Spain. In the 17th century too, opera gained European recognition: dramatic spectacle, in the broadest sense of the word, became the favorite entertainment in an era which delighted in fancy dress and disguises even in pictures and statues. The *festa teatrale* or masque became an established ingredient of aristocratic entertainments. All the arts were employed in the staging of these masques, and the architectural framework was retained until well into the 18th century. But this basic love of spectacle was also bound up with equivocal, fashionable Baroque weaknesses, such as a delight in *trompe-l'œil* and all sorts of prosaic and trivial accessories—the high ostentation of the costumes, and the wealth of the decorative productions.

Today the Baroque tends to be seen more as a reaction against international Mannerism than as an independent movement itself reacting against the Renaissance, the view current around 1900. Mannerism, with its predilection for intellectual speculation and formal experiment, for small sculptures and cabinet pictures and social refinements, was the analytical art *par excellence,* and was countered by the synthesizing style of the Baroque with its claim to comprehensiveness and its monumental tendency. This new style had clearly emerged in Rome by 1600. The anti-Mannerist aspect of the Baroque has a strong affinity with the High Renaissance: indeed, apologists of the new movement claimed it to be a "renaissance" of the Renaissance, an indication that the new style was not a sudden, arbitrary manifestation of empiricist virtuosity. Raphael's fame never wavered throughout the 17th century; the high esteem in which Correggio was held is widely recorded; and even Dürer was appreciated by such great Baroque painters as Rubens and Poussin, while Titian was revered, studied, and eagerly collected. Leonardo da Vinci's treatise on painting was not published until the Baroque period—with drawings by Poussin, incidentally. Baroque architects studied antiquity; and the church of St. Peter's in Rome, begun in 1506, served as their university. Carlo Maderno, Francesco Borromini, and Pietro da Cortona took Michelangelo as their authority, and in 1665 Bernini stated in Paris that as an architect Michelangelo was unsurpassable. Baroque architecture could be criticized for having produced no manuals or treatises of its own, but they were hardly needed: Italian art literature, from Alberti to Palladio and Scamozzi, provided excellent textual material for the 17th and 18th centuries. It is this very absence of any "independent" architectural theory that is proof of the ideological connection between the Baroque and the Renaissance.

That the Baroque style began in Rome has become a fundamental assumption. It is certainly true of architecture and sculpture, a fact impressively demonstrated by the new work done at St. Peter's. For Baroque painting, however, the story is more complicated. Baroque art has been equated, incorrectly, with "painterly" qualities: contrary to what this would imply, the Baroque style of painting did not arise in Venice, with its tradition of the free handling of paint, but in Rome. Its thesis

evolved in the work of the Bolognese painter Annibale Carracci, whose frescoes in the gallery of the Palazzo Farnese in Rome were plainly inspired by Raphael. Michelangelo Merisi da Caravaggio represents its antithesis, although on the whole his pictorial ideas are related not to Rome but to North Italian models of the High Renaissance. The synthesis of these apparently irreconcilable beginnings was produced neither by a Roman nor in Rome, but by the Fleming Peter Paul Rubens. The masterpieces that he painted in Antwerp from 1609 onward, after his return from Italy, are without doubt perfect examples of the Baroque style. These facts need more consideration than they have hitherto received, for they show that as far as Baroque painting is concerned, the development of the style has a twofold origin—both Italian and Northern. How else are we to account for the contribution to the evolution of Baroque landscape painting in Rome made by Adam Elsheimer, Paul Bril, Claude Lorrain, and Nicolas Poussin? How do we explain the attraction Caravaggio had for Dutch painters, including Frans Hals and Rembrandt, the echo of Rubens and Van Dyck in Genoese painting, the effortless absorption of Johann Liss into Venetian painting, and the reflections of Rembrandt's etchings that appear in Italy during the latter half of the 17th century? The brisk interchange between artists from the North and South during the Baroque period is no adequate explanation, for it had already existed in the 16th century and had intensified during the international Mannerist period. Paradoxically, the Baroque is not an "international" art: on the contrary, it was only in the 17th century that the various nations of Europe emerged each with their own distinct, individual artistic contributions. In the 17th and 18th centuries, it was not simply a matter of subjects or of motifs being taken over, but of a far more profound understanding between North and South, which can only be understood as a living alliance within the style itself.

Despite the twofold origin of the style, there is no doubt whatsoever as to the leading role played by Rome in the Baroque. There are two aspects to this phenomenon. One concerns the physical reality of Rome—the city of ancient monuments, of High Renaissance masterpieces, headquarters of the Roman Catholic Church, which Goethe (in typically German manner) apostrophized as "Baroque paganism"—the sole place in Europe at that time where intellectual freedom, nondoctrinaire patronage of the arts, and uninhibited life existed. Elsewhere, conditions such as these could only be yearned for from afar, and they bound men like Bernini, Elsheimer, Poussin, and Claude to the Eternal City until their deaths. The other aspect of Rome is more difficult for us to appreciate today, but must not be overlooked if we are to arrive at an understanding of the art of the 17th and 18th centuries. It concerns Rome as an idea, as a vision, a magnet for the mind, able to excite the powers of imagination and will in artists far removed from Italy, to give them direction, to lead them to a self-realization that they would not otherwise have attained. As early as the 16th century the ideal of Rome inspired French literature and politics; by the 17th century it dominated all areas of French life, under the influence of the visual and representational arts. By 1660–65 Paris had become the new Rome. This often-cited

"change of leadership" from Rome to Paris was, seen as a whole, a continuous process and the outcome of just this mysterious attraction to Rome as an idea. It would be absurd to attempt to explain this phenomenon of world history, the aftermath of which can be felt to this day, by some pedestrian theory of direct influence, for France was never more French than in that century of the Baroque.

The Counter-Reformation preceded the Baroque, but it was by no means essential to it, and was certainly not its cause. The great reforming popes—Pius V, Gregory III, and Sixtus V—showed none of the proverbial Baroque vitality, nor did the saintly founders of new religious orders, such as Cajetan of Thiene (Theatines), Ignatius of Loyola (Jesuits), Filippo Neri (Oratonians), and Carlo Borromeo (Oblates of St. Ambrose). The works of art that they sponsored and encouraged have nothing Baroque about them. With the exception of Michelangelo's work, Roman painting between 1530 and 1590 was Mannerist in style (H. Voss, N. Pevsner, W. Friedländer), even when it adhered strictly to the ideas and demands of the reformers and followed the recommendations of the Council of Trent (1545–63) with regard to subject matter and vestments.

The new "congregational" form of church building established in Rome by the reformers after 1530 consisted of a hall, often with a flat roof, while the functional layout of the chancel, the approaches to it, the main altar, vestibule, and side chapels were all designed to meet specific requirements (M. Lewine). Such a building was an impressive expression of the unity of the congregation and served as a constant public confession of faith, but it was sober, bare of any decoration, and uninspiring. The Baroque impression conveyed today by a number of Roman churches built in the 16th century is due largely to their 17th-century decoration. This applies to Il Gesù, the first Jesuit church in Rome (1568–84), and to St. Peter's itself. The architectural feature that gives the Gesù its monumental quality, and that was regarded as a model for the Baroque outside Italy, is its combination of a broad, spacious barrel-vaulted nave with a dome of high profile over the crossing; and this cannot be explained with reference to the "congregational" church of the reformers, or to their intentions.

How Baroque urban architecture of the 17th century differs from the pioneering achievements of the great reforming popes! Compare, for instance, the obelisks of Sixtus V with the smaller ones that Bernini placed on the Fountain of the Four Rivers in Piazza Navona or on the back of an elephant in front of S. Maria sopra Minerva. Consider also how Sixtus V's pilgrimage roads hurried along across hill and valley, and compare them with the frequently small Baroque squares that open up unexpectedly in front of S. Andrea al Quirinale, S. Maria della Pace, and S. Ignazio. The differences that emerge are stylistic contrasts—the concept of place, the scope, movement, and ease of the one being unmistakably Baroque, the other embodying and recording the strict, nonartistic, but politically acute spirit of Catholic reform. In Prague too, where a radical reinforcement of Catholicism took place from 1620 onward, architecture retained a stern character, grand but lifeless, until about 1690.

Only then did everything come alive to be filled with festive, joyful movement, at a time when there was no longer any challenge to the supremacy of the Church in Bohemia and Moravia. In this respect, we are bound to agree with Peter Meyer's view of the Baroque style as the "expression of a firmly anchored authority, no longer fighting for recognition, but expanding in all directions."

The relation of Baroque art to absolutism is a different matter. French art from 1661 onward, especially at Versailles, is an often-quoted instance of the Baroque style put to the service of the monarch, for his glorification and self-aggrandisement. Throughout Europe Baroque buildings were being erected for spiritual and secular princes. Their expenditures on festivities, temporary decorations, and large-scale buildings were astoundingly high. Castles and palaces of unmistakably Baroque character were built in Europe at a rate and on a scale that had never been seen before. By strokes of bold transplantation, ecclesiastical motifs such as the dome appeared on palaces, and the 16th-century *casa di villa* developed into the *château de plaisance*. Halls and stairways assumed the forms and pretensions of sumptuous ecclesiastical constructions, while extensive parklands, costly fountains, and artificial canals and waterfalls all contributed to the expansion of the aristocratic palace. What all this proves is that those in power during the 17th and 18th centuries felt compelled to cut an official figure, and that in so doing they fulfilled a social need.

The court and state art of Louis XIV drew heavily on the vocabulary of Roman Baroque art; nevertheless, these newly acquired elements were used to lend authority to a French ideal. Neither the concept of an absolute monarch nor the idea of an absolute state, which was steadily gaining ground in France, had any part in the creation of the Baroque style as it had evolved in Rome around 1600. Precursors of the absolutist art of Louis XIV might perhaps be found in the art produced in Rome about 1500 under Pope Julius II (an art which, as we have seen, had no influence on the emergence of the Baroque) and in Philip II's Spain, where the union of Church and State is embodied in an exemplary way in the monastery-palace of the Escorial, never regarded as a Baroque design. The use of a "sacred" dome on a secular building, mentioned above, first occurred in Venetian villa architecture (Palladio's Villa Rotonda) and in the markedly non-Baroque architecture of 16th-century French palaces (the Tuileries in Paris), without causing any great historical stir. The Baroque cannot therefore be explained simply as the product of absolutism. However, unlike the cliché that it was the product of the Counter-Reformation, this popular idea of an association between the Baroque and absolutism is essentially correct. During the Baroque age, art could serve to glorify princes and states without having to surrender its own individual style. This would suggest that from 1600 onward a certain solidarity had developed among those in power and their subjects, a hypothesis strengthened by the way in which the Baroque style spread across denominational boundaries into Berlin, Saxony, Holland (*Ill. 79*), England (*75, 76*), and Scandinavia (*80, 81*). By about 1700 the Baroque style had largely lost its specifically Catholic connotations, even for Protestants, and had become the artistic language common throughout Europe.

ARCHITECTURE

The Baroque styles of Rome, Paris, and Central Europe are the three pillars upon which the history of European architecture from 1600 to 1760 rests. All other specifically national forms—even those in Spain—are of only limited historical importance, or are offshoots of the three parent art centers, such as the architecture of Turin, Amsterdam, London, Stockholm, Leningrad, and Warsaw. Each of the three centers is in itself distinctly individual and marks the close of a long, indigenous process of formation and development. Rome and Paris, representing Italy and France respectively, displaying close genetic ties with the architecture of the 16th century, evolved particular architectural systems. Yet all three are interrelated; in the order in which they are listed here, which is irreversible in the context of art history, they form a significant historical picture, which must be seen as a whole in order to justify the concept of a European Baroque architecture. The Baroque in Rome constitutes the foundation: from about 1630–35, Roman Baroque gave rise to and served as a touchstone both for the *style classique* in France and for the French form of Baroque architecture. This was quite distinct from Roman Baroque architecture, and managed for a century to overcome (or at least repress) the two "original sins" of the Renaissance—slavish imitation of antiquity and Mannerism. Baroque architecture reached its peak considerably later, from 1690 to 1760, in the Central European lands of the former Holy Roman Empire. This third artistic region derived its inspiration from Paris as well as from Rome.

As far as the Baroque in its ideal form is concerned and in terms of stylistic history, the three related artistic centers can be considered within the framework of a dialectical process of development, with Rome postulating the thesis, Paris the antithesis, and Central Europe the synthesis. The internal consistency of this sequence can be deduced from the fact that the third, synthesizing phase—which unlike both the others was not the product of an urban culture and consequently did not possess an artistic center such as Rome or Paris—did, however, put into practice all that had gone before in the two main endeavors of its time: the building of churches and palaces. Thus, one is stylistically justified in calling all three phases of architecture between 1600 and 1760 "Baroque," even though the third phase—Central European Baroque—partly coincides with the Rococo, and even though much of the building that went on during those one hundred and sixty years obviously cannot be described as in any way Baroque.

Baroque architecture may be said to have been born in Rome on November 18, 1593, when Pope Clement VIII consecrated the gilded cross on top of the lantern of St. Peter's dome, marking the completion of the building (9). From that moment the city acquired its focal point, in a building that surpasses everything the Renaissance could produce and that is free of all that the Mannerist painter-architects felt unable to omit from their designs. The supreme feature of St. Peter's is the double-shelled dome with an internal diameter as large as the Pantheon and with its indescribably

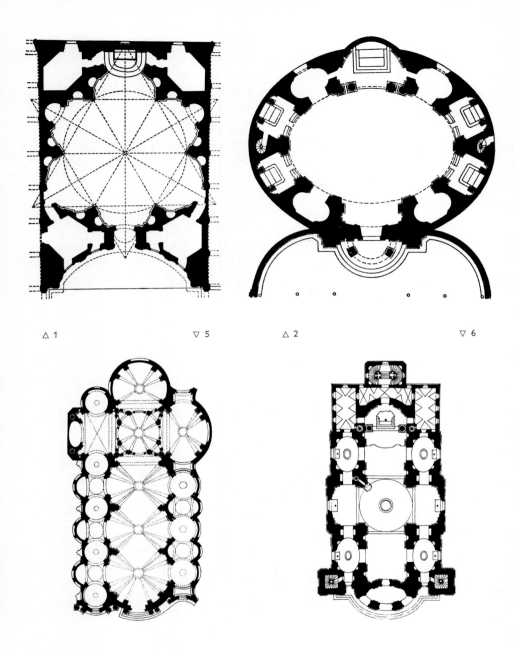

△ 1 ▽ 5 △ 2 ▽ 6

1-8 BAROQUE INNOVATIONS IN CHURCH PLAN-
NING: an alternating pattern of recesses (*1*),
counterpoint between the main space and
subsidiary spaces (*2, 3*), the combination of
round and oval main spaces with elliptical
apses (*4*), and the extension of spaces into
groups, rows, and interlocking chains of units
(*5, 7, 8*) in which the complete interpenetra-
tion of the domed basilican form and the
domed cross-shaped form should be noticed
(*6*). Balthasar Neumann's pilgrimage church
of Vierzehnheiligen (*47*) is the foremost prod-
uct of these efforts in German 18th-century
church architecture. (*1*) S. IVO DELLA SAPIENZA,

14

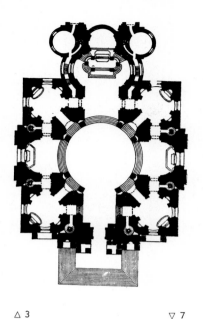

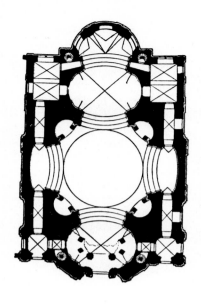

△ 3 ▽ 7 △ 4 ▽ 8

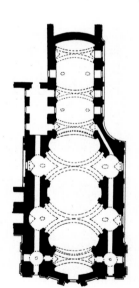

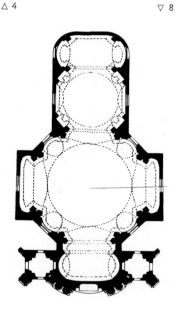

ROME. Francesco Borromini. 1642–50. (*2*) S. ANDREA AL QUIRINALE, ROME. Gianlorenzo Bernini. 1658–70. (*3*) ST-LOUIS DES INVALIDES, PARIS. Jules Hardouin-Mansart. 1677–1706. (*4*) CHURCH AT DEUTSCH-GABEL (Německé Jablonné). Johann Lukas von Hildebrandt. 1699–1711. (*5*) DESIGN FOR A CHURCH. Guarino Guarini. Before 1683. (*6*) KOLLEGIENKIRCHE, SALZBURG. Johann Bernhard Fischer von Erlach. 1696–1709. (*7*) ABBEY CHURCH AT BANZ (West Germany). Johann Dientzenhofer. 1710–13. (*8*) CHURCH AT BERG-AM-LAIM, MUNICH. Johann Michael Fischer. 1738–42.

15

9–12 ST. PETER'S, ROME. The great dome (9), begun by Michelangelo in 1552 and completed by Giacomo della Porta in 1588–93, crowns the central space above the tomb of St. Peter. (The small dome on the right, over the Cappella Clementina, is by Della Porta.) Its silhouette forms one of the chief landmarks of the city of Rome. During the Baroque period this towering structure was extended toward the city and opened up to the world by Carlo Maderno's nave and façade, of 1608–12, and Gianlorenzo Bernini's Piazza, of 1657–70 (10, 11). The two-storied façade, with its giant order of columns and with the Benediction Loggia in the center of the upper story (there were to have been two towers as well, but they were never completed and their remains were later demolished), forms the backdrop for Bernini's Piazza. This consists of two colonnades, each with three aisles divided by rows of unfluted Doric columns, crowned with statues of saints and martyrs which encircle an oval space some 190 meters wide, and thus form an architectural and spiritual link between church and city.

Bernini placed the Scala Regia, of 1663–66, to the right, forming a monumental entrance to the papal palace from the colonnade. The stairway's Ionic columns carry on the theme of the Piazza, transplanting it to the interior, and achieve a festive emphasis because of the dominance of the central aisle and the ascending columns (12). Bernini's equestrian monument to the Emperor Constantine (12, right) was placed in such a way as to be visible from the narthex of the church, a position that underscores the historical link between antiquity and Christianity, between Rome and the Church, in a Baroque form.

13 S. ANDREA DELLA VALLE, ROME. Mother church of the Theatine Order. Begun 1594. Façade designed by Carlo Maderno and built in 1608–23. It is based on Giacomo Vignola's Il Gesù: tunnel-vaulted nave with chapels, clerestory in the nave, plus transept and choir, and a high dome above the crossing. New are the external form and the interplay between dome and façade, with the rigid alignment of forms of the 16th century giving way to a more dynamic interrelationship.

14–21 ROMAN BAROQUE CHURCH FAÇADES. These illustrate both the underlying principles and the variety of the new architectural style. (14) S. SUSANNA. Carlo Maderno. Completed in 1603. (15) S. ANDREA AL QUIRINALE. Gianlorenzo Bernini. 1658–70. (16) SS. VINCENZO ED ANASTASIO. Martino Longhi the Younger. Completed in 1650. (17) S. MARIA IN CAMPITELLI. Carlo Rainaldi. 1663–67. (18) S. CARLO ALLE QUATTRO FONTANE (S. Carlino). Borromini. 1665–67. (19) S. AGNESE IN AGONE IN PIAZZA NAVONA. Begun by Girolamo and Carlo Rainaldi in 1633, major features by Borromini. 1653–57. (20) S. MARIA DELLA PACE. Pietro da Cortona. 1656/57. Baroque façade on an early Renaissance church. (21) SS. MARTINA E LUCA. Pietro da Cortona. 1635.

Four of these designs (14, 16, 17, 21) have features typical of Roman church façades after 1540: they are divided into two stories and display strong central emphasis. Particularly notable is that all have columns and pilasters grouped in bays. Three of the façades (15, 19, 20) are formed of a tripartite group of motifs. They make use of the interplay between cylinders and prisms, and between flat, concave, and convex surfaces. Here the balancing of relative sizes and the variation of predominant motifs is critical. S. Andrea al Quirinale (15) makes use of the greatest contrasts in size, and the entrance is treated as a sacred portal, beautifully adapted to its position in a piazza. S. Maria della Pace (20) has the greatest ornamental and pictorial richness, the most complex articulation, and the sharpest contrast between a frontalized, flat structure and a three-dimensional tempietto structure (the curved colonnade). Even this slight suggestion of movement is highly effective in the restricted space of the small piazza where the church stands. At S. Agnese (19) the separation of the towers was necessitated by the location—a long, narrow site: a brilliant solution was found in the use of an attic story which links all the elements with its elegant proportions, and in the development of the chief motifs of the dome and the portal in the towers. S. Carlino (18) is proof of the fact—frequently unrecognized—that

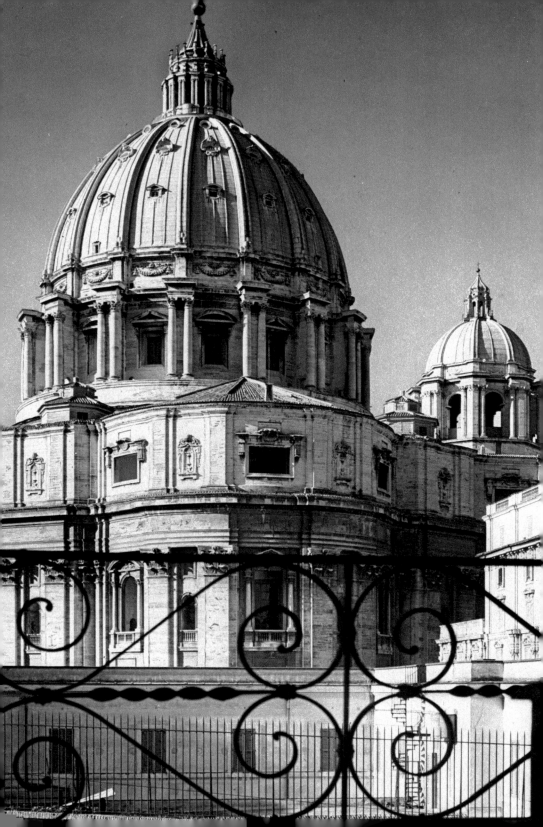

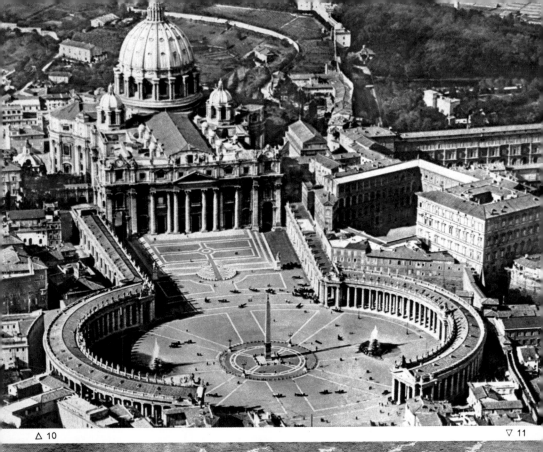

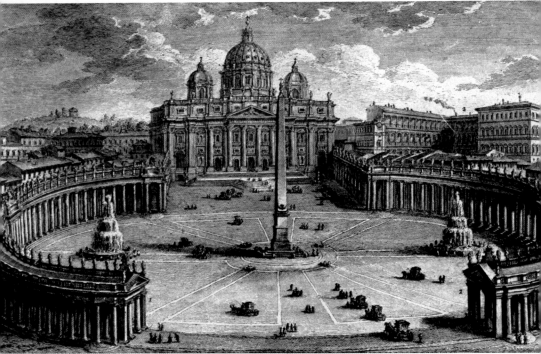

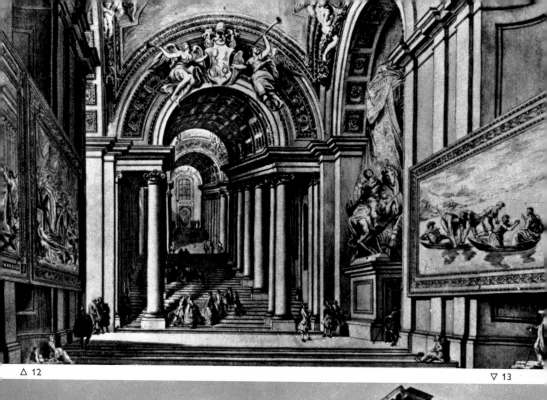

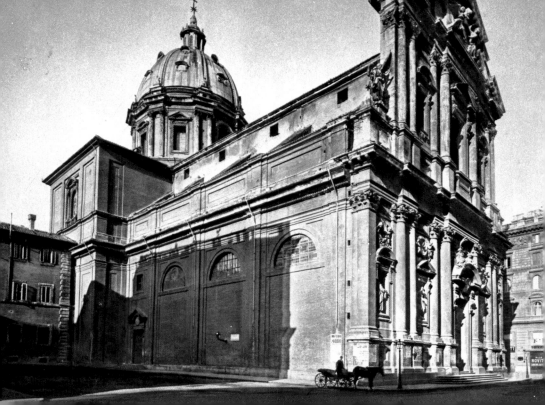

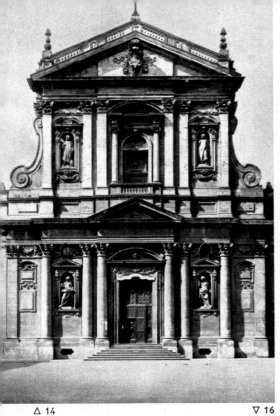

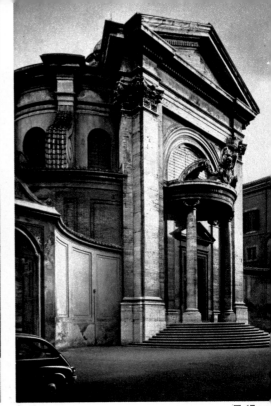

△ 14 ▽ 16

△ 15 ▽ 17

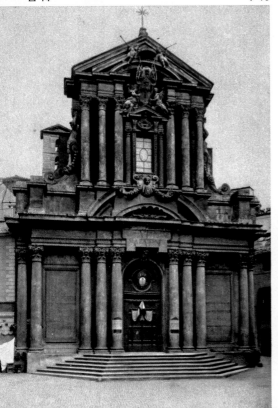

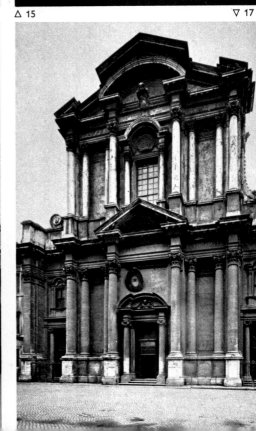

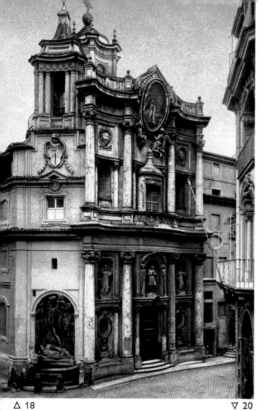

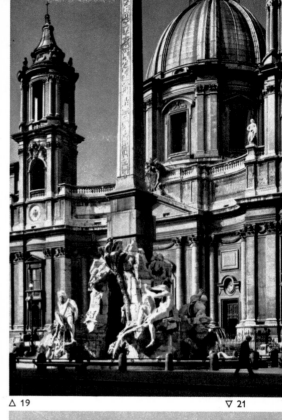

△ 18

▽ 20

△ 19

▽ 21

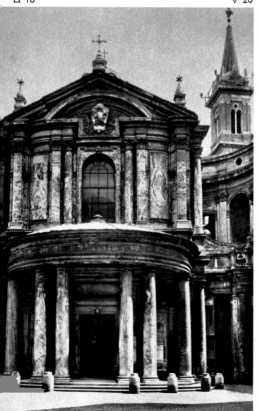

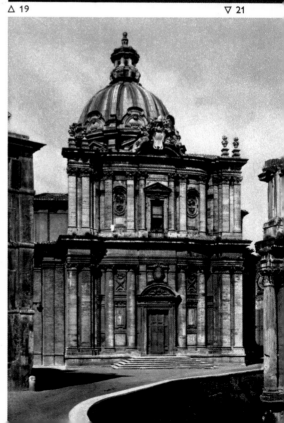

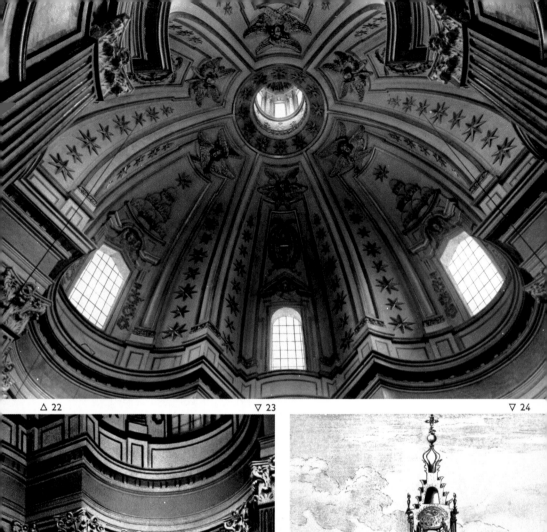

△ 22

▽ 23

▽ 24

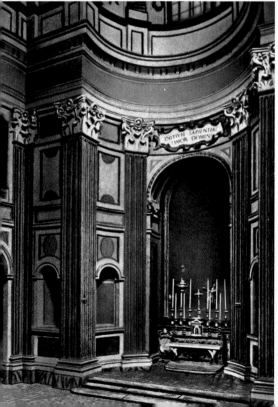

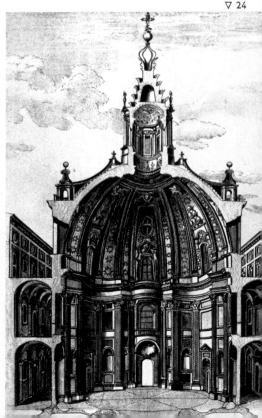

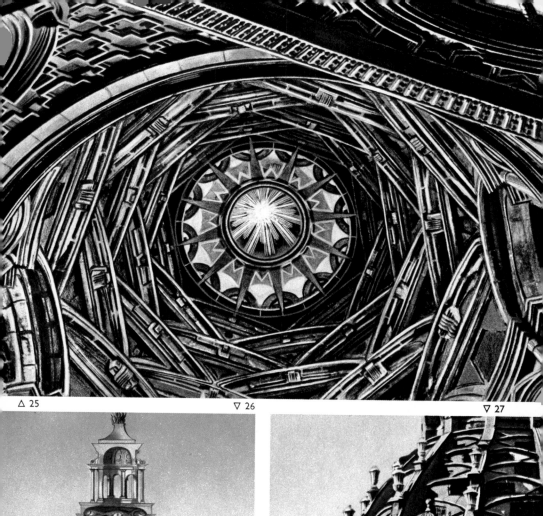

△ 25 ▽ 26 ▽ 27

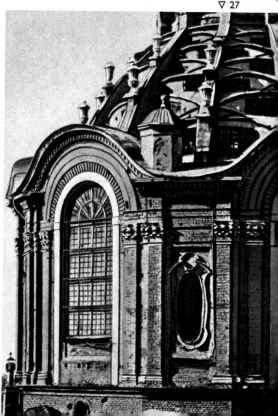

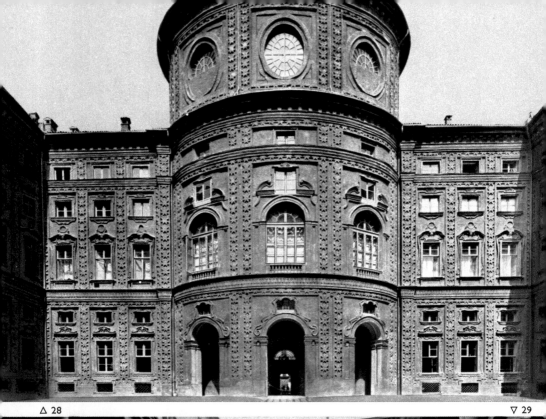

△ 28

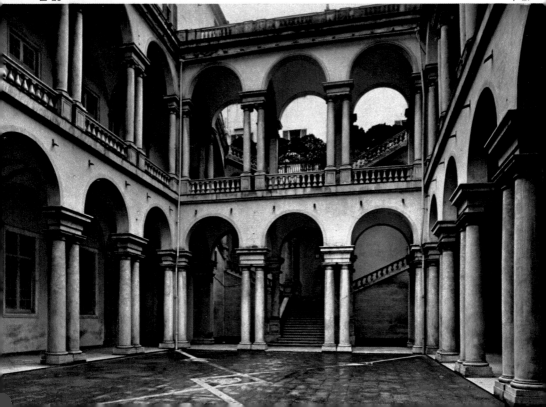

▽ 29

Borromini, who was a fervent admirer of Michelangelo, in no way infringed the rules of the classical orders; his mastery lay, rather, in adhering to them meticulously and yet producing altogether new effects. The concave-convex-concave curve that makes the massive entablature so striking is not achieved so much by making the wall itself curve, as by the arrangement and presentation of the large and small columns and their gradation in size.

22–24 S. IVO DELLA SAPIENZA, ROME. The church of the Pontifical University, built by Borromini in 1642–50. Vault (22), view of the altar (23), and section (looking toward the entrance) from Borromini's *Opus Architectonicum* (24). For the plan, see *1*.

25–27 CAPPELLA DELLA SS. SINDONE, TURIN. Domed reliquary chapel (for the Holy Shroud) attached to Turin Cathedral, by Guarino Guarini, begun in 1657 on a circular plan and built to Guarini's design in 1667–94. Vault (25), section from Guarini's *Architettura Civile* of 1737 (26), and exterior view of drum and dome (27).

S. Ivo (22–24) and the chapel of the Holy Shroud in Turin (25–27) are outstanding examples of the Roman High Baroque and North Italian Late Baroque treatments of a centralized structure. Borromini used the rotunda form of Roman antiquity (Pantheon, Temple of Minerva Medica). The walls of S. Ivo are carried up to the vault but distinguished from it, and they are articulated by pilasters. The ground plan of S. Ivo (*1*), however, is not circular but consists of a six-

pointed star with niches instead of points, niches that are alternately curved and straight-sided and which produce in the interior an impressive effect of clarity and calm. This effect is achieved by purely architectural rather than theatrical means.

Guarini, on the other hand, divides his church into three arched zones, the uppermost crowned by an openwork vault consisting of short segmental arches resting on each other. This "Islamic" vaulting produces an immense ornamental richness, making the interior somewhat cavelike, an effect increased by the theatrical lighting and the strong chiaroscuro effects. Here the impression is one of enmeshing, intertwining, and interlocking; with Borromini it is one of order, articulation, and clarity.

28 PALAZZO CARIGNANO, TURIN. Guarino Guarini. 1679–85. View of the projecting staircase, seen from the courtyard. The design was inspired by Gianlorenzo Bernini's first Louvre design (1664), but the total effect is thoroughly non-Roman: the patterned brickwork distracts from any sculptural feeling of movement, offering instead an effect of massive wall and chiaroscuro relief.

29 COURTYARD OF THE UNIVERSITY, GENOA. Bartolomeo Bianco (before 1590–1657). 1634–36. View toward the rear staircase. The courtyard, with its arcades supported on twin columns, a motif already popular in the Early Baroque period, is raised above the level of the vestibule that precedes it, and is over-looked by the higher terrace beyond. Staircases link these three levels in a transparent sequence.

beautiful line above the mighty drum, which seems virtually transparent from a distance. The dome was not completed until after the death of Michelangelo, but Giacomo della Porta (1537–1602) and Domenico Fontana (1543–1607) followed his designs with only minor modifications. Thus it was Michelangelo, with his dome that terminates St. Peter's on a vertical note, who showed a way out of the Renaissance impasse and laid down principles for the evolution of Baroque architecture.

The fascination that the dome of St. Peter's held for Baroque architects lay in the impression of movement that this colossal design managed to convey—an impression produced by only two elements, whose form, character, and direction are in permanent contrast. Both these elements appear in the drum, begun by Michelangelo himself:

they consist of the pairs of columns masking the radial buttresses, and the rectangular, pedimented window recesses that are distributed over the intervening spaces. In the upper story of the dome the two appear closer together, with the first element standing out sharply in the form of ribs on the exterior curve, and reappearing as pairs of columns on the lantern, now so closely set that the intervening spaces look like no more than dark slits beneath the conical roof, whose convex and concave modeling completes the structure. Such contrasts, which had become a fashionable feature in Mannerist composition, mean very little in themselves. They convey this impression of movement in St. Peter's only because they have been arranged as part of a magnificently simple and visually restful overall picture, which gives them prominence. It was this that appeared new and unique to the Baroque architects, and they took it as their model. Whether seen close up or from a distance, the dome always appears as a unified whole, and despite its enormous size it produces an illusion of towering, even soaring animation. It was in this feature that the new style must have discovered the principle it was unconsciously seeking.

Baroque architecture employs individual elements, grouping and emphasizing their differences of form, character, and direction, while nevertheless subordinating them to the overriding theme that it wishes to stress. Such a theme can only be comprehended by the onlooker—and the dome of St. Peter's is a prime example of this—if the illusion of animation is conveyed and the monument is constructed not merely as a compositional unity, which can be analyzed intellectually, but as a pictorial whole that can be immediately grasped. The animation, which in the Baroque is always a vigorous, dynamic expression, is achieved by the contrasting of elements outlined above. These contrasts merge into a greater unity, however: they are not an end in themselves, nor do they produce the restless effect found in Mannerist designs of the 16th century. This is because the elements are not simply mechanically repeated, composed, or put together, but are modified to meet the demands implicit in the representation of each particular theme. This is what makes Baroque architecture appear at once restful and yet at the same time potentially mobile, and it is this that is the outward characteristic of the style: the "theme" of the building, the *concetto* (to use the term Bernini borrowed from Mannerist poetry to apply to a totally non-Mannerist idea), governs the differences of form, character, and direction, in which the interaction of large and small motifs and their gradation play a significant role, especially in the sense of a relative rather than an absolute proportioning ("optical scale"). The outcome is a vital rebirth of developing, distinctive features in an architecture which now combines the monumental and the pictorial, and which naturally utilizes all earlier antique and modern alternatives to attain its new goal.

To call Michelangelo the "father of the Baroque" is both understandable and correct in historical terms. Admittedly, however, to pursue the metaphor, the father should not be confused with the children; for Baroque architects were no mere imitators of Michelangelo in the way that many Mannerists were. Baroque architecture is not a prolongation of the axis that connects it with the Michelangelo of the dome of

St. Peter's: it revolves on that axis, using it as the pole for the development of its own world. This is the light in which one must see the Baroque contribution to St. Peter's itself and to its extension in Bernini's Piazza of 1657–70 (10, 11). In the latter, breadth is allied with roundness: the freestanding column, that utterly independent element of classical architecture, which had already been detached from the solid mass of wall on Carlo Maderno's façade (1608–12), here appears in the austere form of Bernini's colonnade. The four concentric rows of columns form a continuous yet transparent "wall," which is crowned with a host of statues and articulated by distinctive piers joining the ends and centers of each side. The curved colonnades enclose an oval space which is separated from the church by a trapezoidal forecourt over three hundred feet deep, and takes on an effortlessly "thematic" appearance of outstretched, enfolding arms.

This colossal architectural composition is harmonious from all viewpoints, because its proportions were carefully calculated to be seen from close up and from a distance. The church is not merely displayed and framed as a majestic prospect: the effect is of a larger whole, incorporating the Piazza, with the colonnades forming a prelude to the interior of the church, which is dominated by Michelangelo's dome, itself barely visible from the Piazza. A hundred years after Michelangelo's death St. Peter's had changed from what it was originally intended to be when construction began in 1506 into something quite new—not by any fundamental alteration to the basic structure, but by its transformation into an ecumenical and civic monument. In place of the absolute, self-sufficient colossus aspiring to heaven which Michelangelo created in the dome of St. Peter's, the feeling emanating from Bernini's architecture—for all its impressively vigorous power and size—is festive, buoyant, liberated; in Wölfflin's words, "The heavy solemnity appears to lift, the forms breathe more joyfully."

There now followed a corresponding change in the relationship of buildings to their surroundings, to the street, piazza, valley, or hillside in which they were placed. Even in the arch-conservative area of Roman palace architecture, the unfriendly, unadorned isolation that characterizes the Palazzo Farnese gave way after 1600 to buildings that open outward and are adapted to their individual sites (Palazzo Borghese, by Martino Longhi the Elder, begun 1605), visibly delighting in varying views, with three-sided stagelike settings consisting of a courtyard and galleries (Palazzo Barberini by Carlo Maderno, Bernini, and Borromini, begun 1625), frequently combined with a church façade and fountains with figures (Palazzo Pamphili in Piazza Navona by Girolamo and Carlo Rainaldi and Borromini, begun 1646; the Trevi Fountain by Nicola Salvi, begun 1732). Villa motifs appear increasingly in city architecture (Belvedere of the Palazzo Falconieri by Borromini, c. 1640), and, conversely, small country residences expand into building complexes of palacelike proportions (Palazzo del Quirinale, begun by Flaminio Ponzio in 1574, completed in the 17th century by Bernini). A feature now appearing in Rome is the arrangement of pilasters to divide up the façades of palaces, one that, with a few early exceptions, had been absent from Rome in the 16th century, though it had been in common use throughout North Italy (Palazzo

Chigi-Odescalchi by Bernini, begun 1664; Collegio di Propaganda Fide by Borromini, begun 1662; Palazzo della Consulta by Ferdinando Fuga, 1732–37). In terms of the Roman tradition, all this represented an influx of heterogeneous elements from the outside, a mingling of types (villa, "suburban" villa, town house, feudal castle), and an erosion of the barriers between secular and religious architecture. The treatment of the palace as a feature in the townscape is a visible demonstration of this trend.

The change occurred even more suddenly and noticeably in church architecture.

30 LA SUPERGA, OUTSIDE TURIN. Commissioned by Duke Vittorio Amadeo in 1707 as a thanks offering for victory, the basilica was built in 1717–31 by Filippo Juvarra, who exploited to the full the hilltop site.

31 KARLSKIRCHE, VIENNA. Founded by the Emperor Charles VI after an outbreak of plague, built in 1716–25 to the design of Johann Bernhard Fischer von Erlach, consecrated in 1737 as a monument to the Empire. The façade combines elements from antiquity (temple front, Trajan's column in Rome) and the Renaissance (dome of St. Peter's in Rome) to represent imperial dignity as an all-embracing concept.

32–34 BAROQUE ARCHITECTURE OF FANTASY. 16th-century Italy presented new requirements for "country architecture." During the Late Baroque period, the villa and palace were combined in grandiose imaginative projects, which restructured the landscape architecturally—often, admittedly, only on paper. (32) STUPINIGI, NEAR TURIN. The cross-shaped central block of this hunting lodge was begun in 1729; the four wings were extended outward about 1750. (33) DESIGN FOR A "CHATEAU TRIANGULAIRE." Filippo Juvarra. 1705. (34) KARLSBERG GARDENS, KASSEL-WILHELMSHÖHE. Design by G. F. Guerniero, of 1701–17; engraving by A. Specchi, 1706. Based on an octagon pattern, the elaborate plan features a "Hercules pyramid" and cascade. "Baroque does not adapt itself to the terrain, but yields to it" (Wölfflin).

35–37 JOHANN BERNHARD FISCHER VON ERLACH. (35) PALAIS TRAUTSON, VIENNA. 1709–11. Street façade. (36) BELVEDERE IN THE LIECHTENSTEIN PALACE GARDENS, VIENNA-ROSSAU. Designed in 1689, demolished in the 19th century. Engraving. (37) GARDEN ARCHITEC-

TURE. Design for a pleasure pavilion with tripartite façade. Drawing c. 1690. University Library, Zagreb.

38–41 JOHANN LUKAS VON HILDEBRANDT. (38, 39) UPPER BELVEDERE, BELVEDERE PALACE, VIENNA. 1721–23. View from the garden, showing the first cascade and the sunken parterre; entrance façade, with central porte cochère and the great pool in front. (40) DAUN-KINSKY PALACE, VIENNA. 1713–16. (41) WEISSENSTEIN SCHLOSS, POMMERSFELDEN, FRANCONIA. Staircase. The palace itself was built by Johann Dientzenhofer in 1711–16. Hildebrandt's staircase hall is planned as a covered, arcaded courtyard on three levels, the stairs forming both a bridge over the passage to the garden loggia and a balcony in front of the entrance to the banqueting hall on the main floor. Here a small, hypaethral dome was incorporated, possibly at the suggestion of the patron, Prince-Bishop Lothar Franz von Schönborn.

42 ZWINGER, DRESDEN. Built in 1709–22 as part of a new plan for palace and town by Elector Augustus the Strong of Saxony (who had become king of Poland in 1697), the Zwinger encloses a ceremonial open space with a central area of 106 × 107 m. flanked by two semicircles. It served as a setting for festivals in some measure resembling the circuses of antiquity. The architecture consists of single-storied galleries linking two-storied pavilions. The Wall Pavilion illustrated here was built in 1716–18 by Matthäus Daniel Pöppelmann and decorated with sculptures by Balthasar Permoser (reconstructed after World War II). It is a perfect illustration of the union of sculpture and architecture in the German Baroque style and of the importance of sculpture to architecture of this kind.

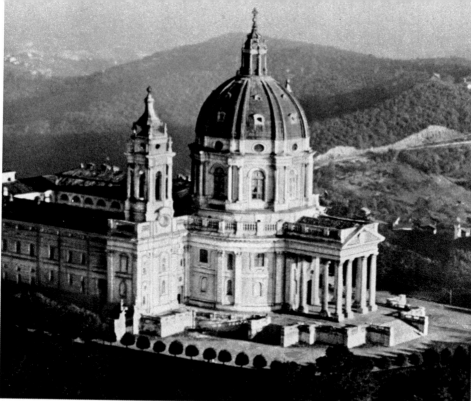

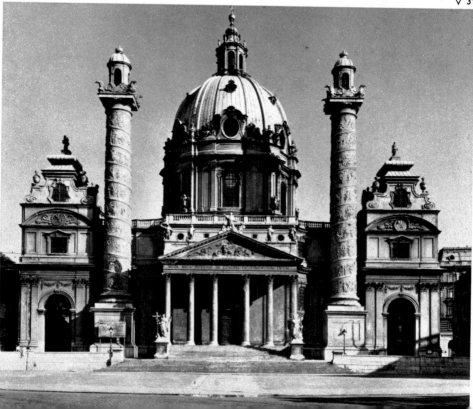

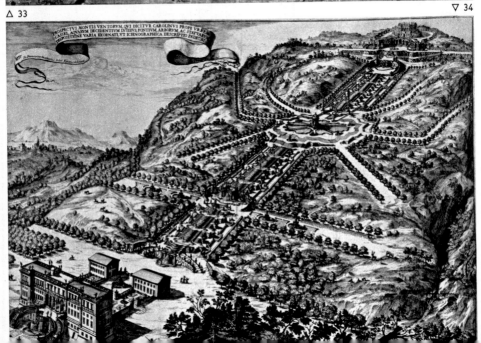

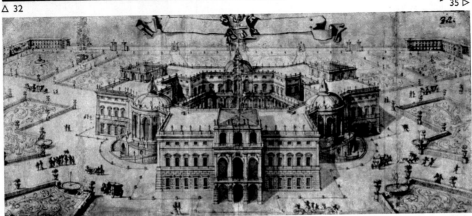

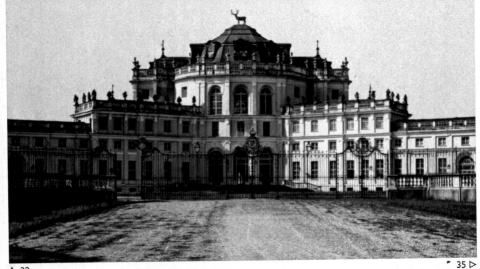

△ 32

△ 33

▽ 34

35 ▷

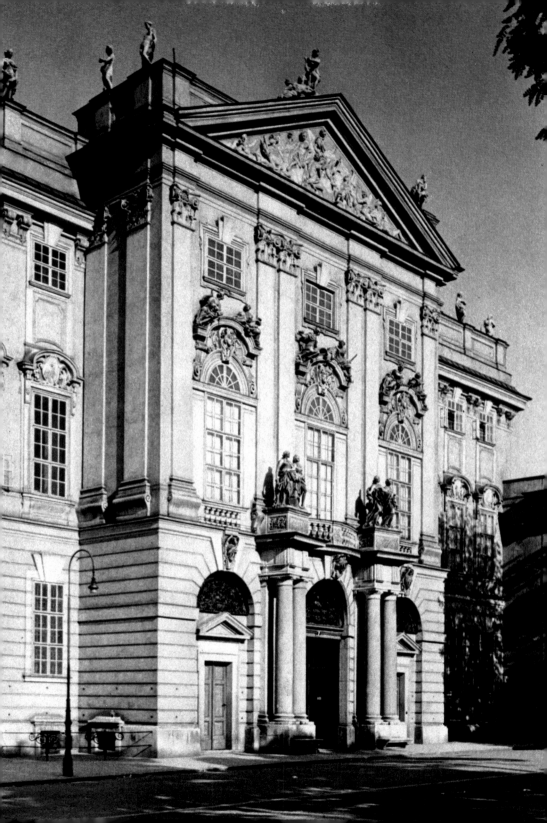

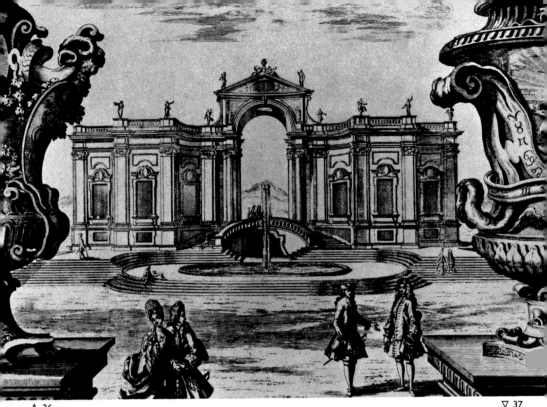

△ 36

△ 37

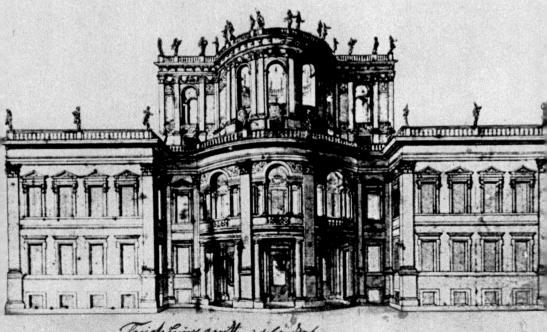

Fassade seines garttens gebäudes b.

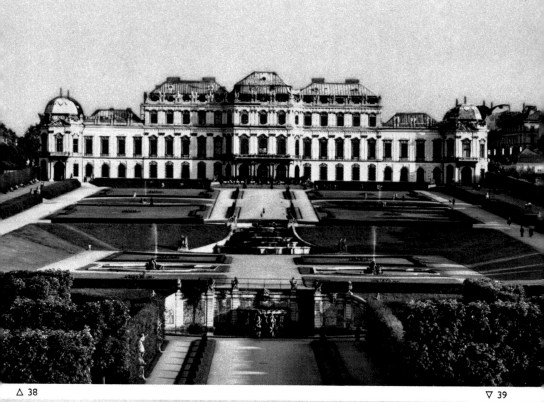

△ 38 ▽ 39

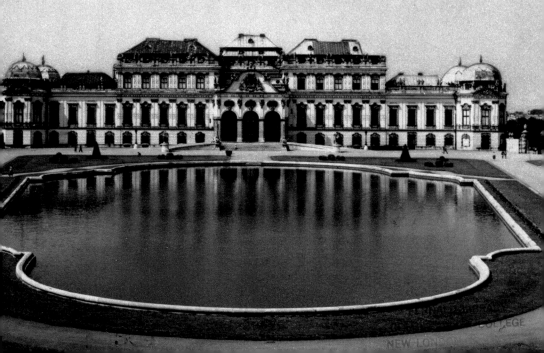

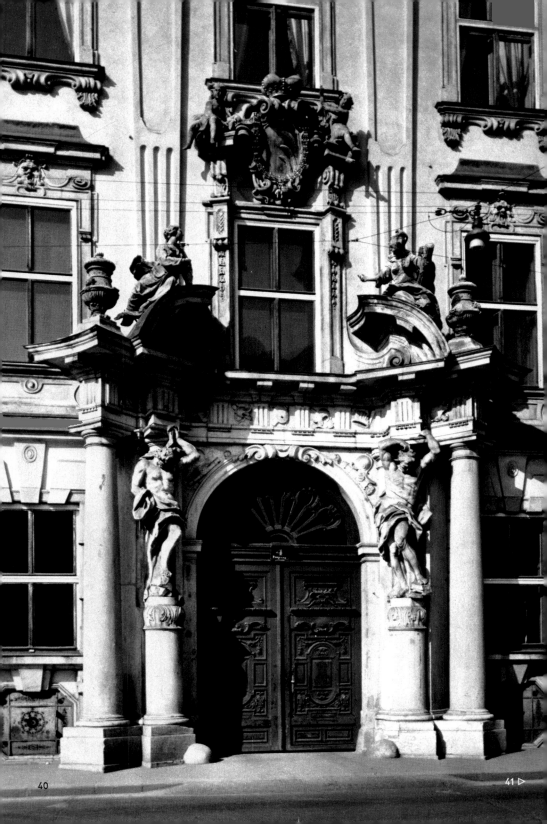

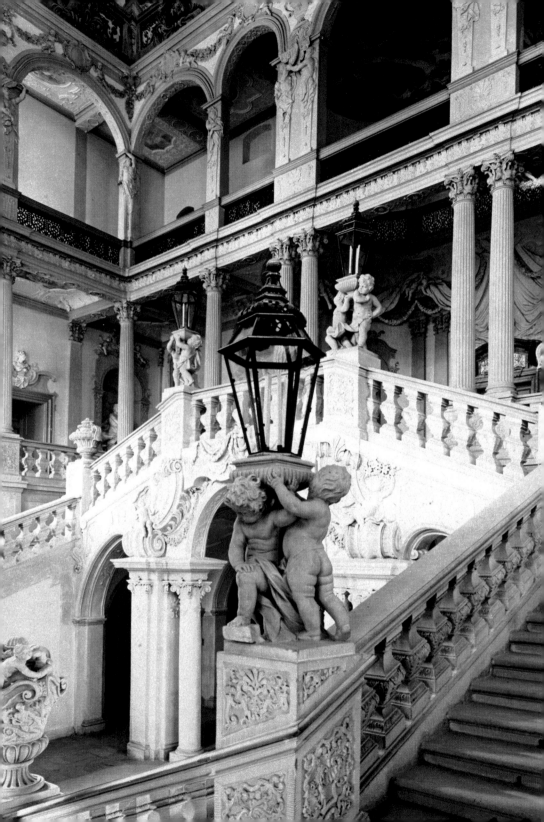

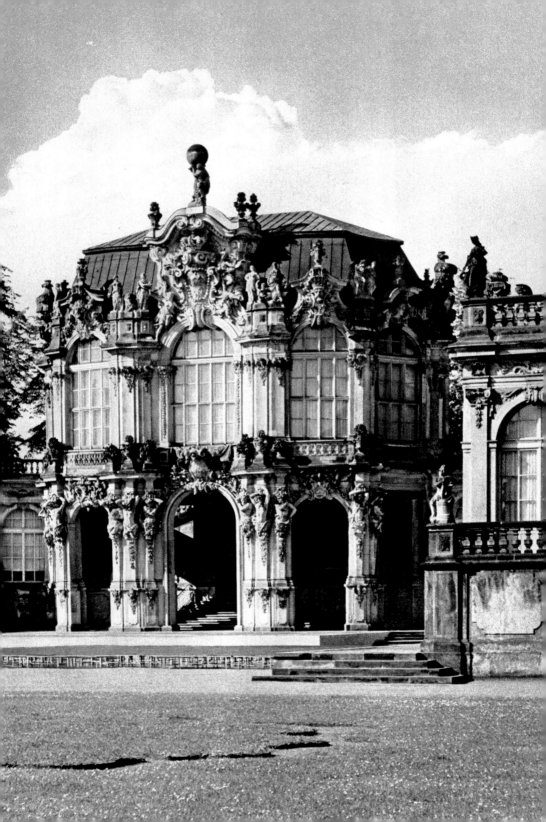

The development in Rome of the dome above the crossing, the church façade, and the piazza in front of the church shows the influence of the Baroque transformation of St. Peter's dome. Until the Baroque age, Roman crossing domes were insignificant, either concealed below a tent-shaped roof or resting on a low, undecorated drum (Il Gesù, S. Maria dei Monti by Giacomo della Porta). It was not until the 17th and 18th centuries that domes began to appear as central structures, towering above the roofs of a city, with the drum pierced by windows and divided up like a façade (S. Carlo ai Catinari by Rosato Rosati, after 1612). The first important example of this form is the dome of S. Andrea della Valle (*13*), with an interior span of 53 feet. It was completed by Maderno in 1622, and shows his awareness of the dome of St. Peter's not only in its arrangement, but also in the emphasis placed on the drum. Henceforth drums were used in all the Baroque domes built in Rome (for example, Borromini's S. Agnese in Agone in Piazza Navona [*19*], where a dome is combined with twin towers, an unusual Northern feature), and soon they were used all over Europe to ease the tension arising out of the juxtaposition of dome and façade. The interplay between these two elements had already affected the problems of the design of the church piazza—a spatial composition pioneered in Rome and made world-famous in the example of the Piazza of St. Peter's. No one formula was followed; rather, a variety of individual solutions was put forward. It was not the ground plan that mattered, but the elevation and the composition. Sites that were in fact irregular were made to look symmetrical (Carlo Rainaldi's twin churches in the Piazza del Popolo, 1662–79). The appearance of a Baroque building often brought a small Roman corner into prominence, as for example the rotunda of S. Ivo near S. Eustacchio or Borromini's tower for S. Andrea delle Fratte, which even today by its position on the very edge of the street commands the eye to travel upward. This trend toward a one-sided emphasis and a free equilibrium achieved by the grouping of different elements (S. Susanna [*14*]; S. Maria della Vittoria; and the Acqua Felice by Fontana, 1585–87) was extremely popular. It was not the massiveness of proportions that counted: there are many entrancing small, even diminutive church piazzas whose architecture is such as to make one forget their actual dimensions. The Baroque architect is master of the art of arranging and dividing up even the smallest space in such a way as to conjure up an impression of large and small, proximity and distance (S. Maria della Pace [*20*]; S. Andrea al Quirinale [*15*]; Piazza S. Ignazio by Filippo Raguzzini, 1727–29).

Church façades had the greatest effect in terms of civic architecture, raising problems of style in general and producing individual solutions in a number of masterpieces (*10, 11, 13–21*). The 16th century, or Cinquecento, was the first period in the history of modern European architecture to produce a distinctive and artistically significant solution to this particular problem. The development of the two-tiered façade built of smooth travertine blocks (S. Spirito in Sassia by Antonio da Sangallo the Younger, 1538–44) up to the time of Giacomo della Porta (Il Gesù, completed in 1584; Madonna dei Monti, 1580–81) was described and critically assessed by Wölfflin in 1888. Out of the simple rows and layers of stone a compositional unity evolved in the form

of a clear, horizontally organized, many-layered pattern of relief, with the sides distinctly subordinated to the center and a massive, broad outline full of dramatic tension. Pilasters, composite or double pilasters (Il Gesù) divide the design into bays; columns are reserved for the portal or the upper central window. The center is emphasized as a projection, without actually being detached from the compact whole. The side bays are linked, overlap, or are incomplete; but even on the façade of the Gesù the central bay is complete, framed on either side by double pilasters.

In the Early Baroque period (1590–1625) this façade pattern was fundamentally transformed, though at first the two-storied arrangement of the 16th century was retained. The decisive step was taken by Carlo Maderno (1556–1629), the outstanding architect of the time. After the death of Giacomo della Porta in 1603, Maderno succeeded him as architect at St. Peter's. Maderno was a careful and experienced architect, with a sound knowledge of both his native North Italian and Roman traditions. The Mattei Palace, 1598–1618, the Barberini Palace, designed by Maderno just before his death in 1628, and above all the church of S. Andrea della Valle (*13*) are impressive examples of his work. His achievements as a stylistic innovator are probably largely the outcome of his experience with building the nave, narthex, and —under exceptionally difficult circumstances—the façade of St. Peter's.

Maderno must have made a lengthy study of Michelangelo's architecture and assessed the possibility of using columns in conjunction with such a massive structure before he produced his own solution to the problem. His design of 1607 (*10, 11*) has been much criticized, but it embodies those principles which determined the stylistic transition into the Baroque and which emerge most clearly in his façade of S. Susanna (*14*). The wall surfaces of the bays project progressively more toward the center, with the central bay on the upper tier further emphasized by pilasters (compare Michelangelo's Vestibule in the Laurentian Library in Florence). Because the bays are no longer interlocked, and the columns stand free of the wall surface, the effect of this projection produces a totally convincing statement, one which shows an understanding of architecture in general and which is related to the illusion of movement. The effect of the façade, which extends between two low, simple adjoining structures (not visible in [*14*]), is vertical: athletic in appearance, loosely articulated with decoration in the bays between the orders, clearly organized even by the standards of the strictest followers of Vitruvius. In short, everything is well ordered and clear.

Compared with the façade of Della Porta's Il Gesù, S. Susanna (like all subsequent Baroque façades) is softer and more mobile; its general impression is simpler, more readily comprehensible, and yet its composition is far more complex and full of contrasts. Maderno destroyed the Cinquecento's indissoluble unity of composition, and out of the pieces he reconstructed independent elements, which he employed to serve the themes of projection and verticality. "March separately, strike together" was his motto, whereas that of Della Porta might well have been "All or nothing." Della Porta's relief façade, with its strictly frontal orientation and forcibly constrained opposing elements, is totally unified and static. Maderno, however, grouped his elements

to convey the idea of a movement that has only just ceased. He thus achieved that impression of splendor, force, and moderation which Wölfflin praised and which, in art historical terms, succeeded in reconciling the massive forms and use of columns in the architecture of Michelangelo and Palladio, and enabled architecture to produce more dramatic effects.

All this must be taken into consideration in order to arrive at a true assessment of the wealth and abundance of imaginative forms in Roman church façades of the High Baroque period (1625–80), and to do justice to the personal style of the important architects involved (*15–21*). Martino Longhi the Younger (1602–57), for example, selected a simple idea for the façade of SS. Vincenzo ed Anastasio (*16*), commissioned by Cardinal Mazarin and built after 1646. All the energy is concentrated on the center, where three complete bays are stepped in a concentric arrangement, the dense triplets of columns contrasting with the plain side bays. The columns are detached from the wall, which provides a background for them, that has its source in the *scaenae frons* of Hellenistic theaters, with its elaborate columnar composition. Carlo Rainaldi (1611–91) also used this device for the far more important façade of S. Maria in Campitelli (*17*). He grouped small, large, and intermediate bays, making some project, and placing them side by side and within each other to produce what is called an aedicular façade. The architecture has a rich and harmonious splendor; though harder and less flexible than Maderno's, Rainaldi's design allows for more perspective effects and remains more closely allied to the Bolognese type of columnar architecture.

Rainaldi began by working with his father Girolamo (1570–1655) on the Palazzo Pamphili and S. Agnese in Agone in Piazza Navona. He never took part in the work on St. Peter's, which served as a kind of architect's university, and in effect he always remained something of a "theater" architect. This emerges quite clearly in his chief works—the twin churches in the Piazza del Popolo, the choir façade of S. Maria

43–45 PIER AND SHELL CONSTRUCTION IN THE 18TH CENTURY. The exterior of the Benedictine church of ST. MARGARET in PRAGUE-BREUNAU (Praha-Břevnov) (*43*), built by Christoph Dientzenhofer in 1708–15, is a fine example of the combination of the two building techniques in a way peculiar to Bohemian Baroque, with its fondness for loading architecture with heavy curving pediments and for effects produced by contracting and expanding the elements used. The fundamental difference between the architecture of the pier and that of the shell is well illustrated by the interior of the Benedictine abbey church of WEINGARTEN, NEAR LAKE CONSTANCE (*44*), 1715–24, a late masterpiece of the Vorarlberg School, and by the Jesuit church of ST. NICHOLAS IN PRAGUE-KLEINSEITE (Praha Malá Strana) (*45*), 1704–11, a major work of Bohemian Baroque, though its interior decoration is later. At Weingarten there is an alternation all down the nave between the bright well-lit apses and the massive piers, which are in reality the projecting faces of internal buttresses, or *Wandpfeiler*. The transverse vaults of the chapels open into the longitudinal vault of the nave. The vaulting of the church of St. Nicholas dominates not merely the ceiling, but also the walls, which project in pilaster-laden extrusions and recede into the apses. The light seems to force its way, by contrast with Weingarten, where it billows in.

46–50 VIERZEHNHEILIGEN, NEAR BAMBERG. 1743 to 1772. Begun by Balthasar Neumann and completed by Jakob Michael Küchel, who also designed the altar (*50*), this pilgrimage church represents the climax of the integration of the church interior. The cruciform exterior, with its vertical lines, many windows and two-towered façade (*46*) houses a lofty, broad interior space (64 m. long and 23 m. high), made up of five oval main elements, with the central oval containing an altar that soars upward (*50*). By contrast with the exterior, inside there are no dead angles, no frontal orientation: all is curves and vaulting. Yet despite the curving lines and the flood of light, the effect of the architecture is one of quiet, sober stillness. Shell and pier construction and the themes of domed rotunda, two-storied gallery church, and cruciform basilica are blended together. The spatial elements are complementary, the articulation is clear: there is nothing confusing in this "total interior." Central and cruciform spaces are here combined in a building that is both a church for a congregation and a image of the Cross. The frescoes by Giuseppe Appiani and the stucco by Joseph Anton Feuchtmayer were executed after the death of Neumann, who had intended to emphasize the flowing structure of the vaulting by even more pronounced curves in the decoration.

51, 52 MONUMENTAL DECORATION IN GERMAN PALACES. In the Baroque period the staircase and hall were often brought together in the center of the main building and given the maximum ceremonial and ritualistic significance. (*51*) SCHLOSS AUGUSTUSBURG, BRÜHL. Staircase. Balthasar Neumann, 1741–48. The staircase was inserted within the existing walls of a structure built by J. C. Schlaun. The frescoes, by Carlo Antonio Carlone, date from 1750; on the landing is a memorial to Elector Clement Augustus, of 1775. (*52*) RESIDENZ, WÜRZBURG: Kaisersaal, or Imperial Hall. Balthasar Neumann. Completed in 1741. The room is a vaulted octagon in the central pavilion of the garden side of the palace. The decoration, in which white stucco and yellow, green, and agate-colored artificial marble are combined with the bronze bases

and gold capitals of the columns, is crowned by three frescoes by Giovanni Battista Tiepolo in the vault. That visible in the illustration shows Frederick Barbarossa conferring the title of Duke of the Franks on the Bishop of Würzburg in 1168.

53 RESIDENZ, WÜRZBURG. Begun in 1720 by Prince-Bishop Johann Philipp Franz von Schönborn, and continued by his nephew, Prince-Bishop Friedrich Carl von Schönborn; completed in 1745. Although the plan and basic architectural form were laid down by Balthasar Neumann, he was obliged to incorporate suggestions from Vienna and Mainz, and, in 1723, from the Parisian architects Robert de Cotte (1656–1735) and Germain Boffrand (1667–1754). Facing the main courtyard, between the two lateral blocks (the palace chapel is on the right), is the *corps de logis* with vestibule, a hall opening on to the garden, the great staircase, and, on the upper floor, the Kaisersaal (*52*). The lateral blocks, emphasized by oval pavilions, each have an interior courtyard. They are quite distinct from the French tradition (compare Versailles, *66*), though their general layout would never have evolved without the example of France. The elegance and clarity of their articulation is unsurpassed in Late Baroque palace architecture. The vast palace covers an area of 170×90 m.

54 BENEDICTINE ABBEY OF MELK (Austria). Building of the twin-towered and domed monastic church began in 1702 under Abbot Dietmayr and completed in 1714 (the spires were built after 1738 by Josef Munggenast). The distinctive feature of the abbey is the arcaded gallery between the Marble Hall and the Library (which was built after the death in 1726 of Jakob Prandtauer, the first master-mason). Melk is the undisputed masterpiece of 18th-century monastic architecture. The long wings with their simple articulation thrust forward to form a terminating feature—a brilliant extension of the old medieval abbey's site and situation. From near and far the quality of the architecture is evident: the complex of buildings dominates the countryside through being integrated into it.

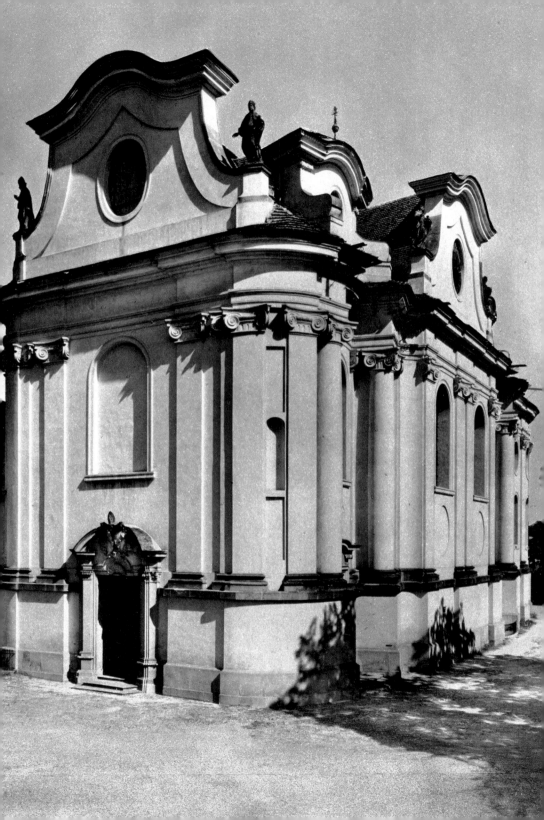

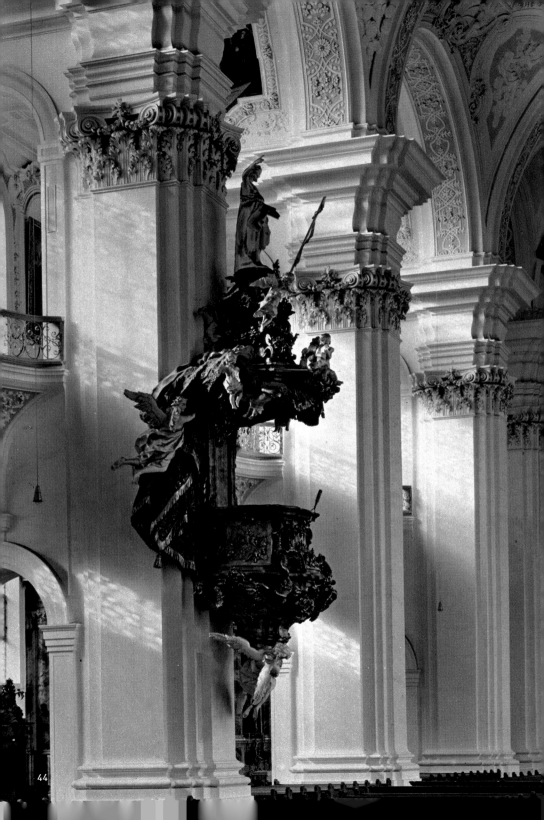

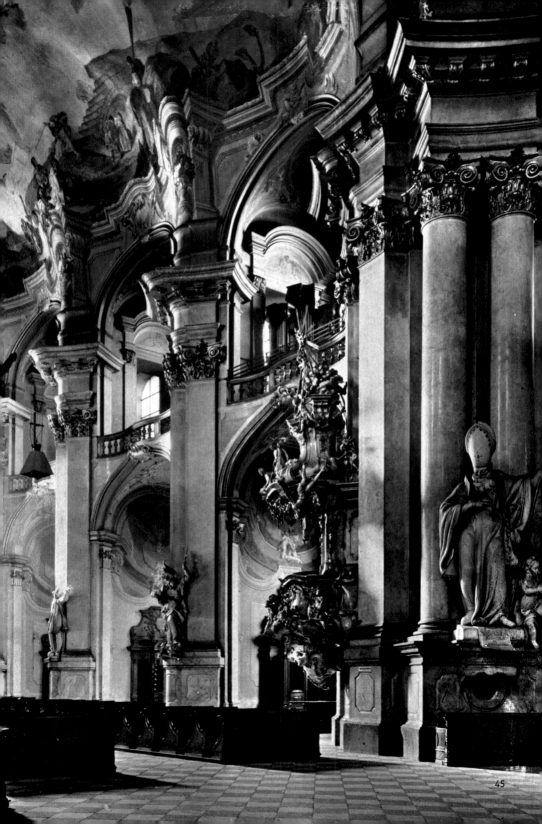

45

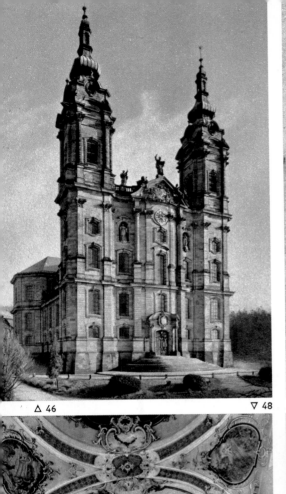

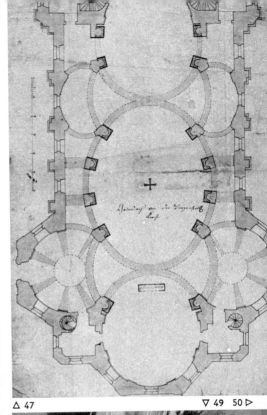

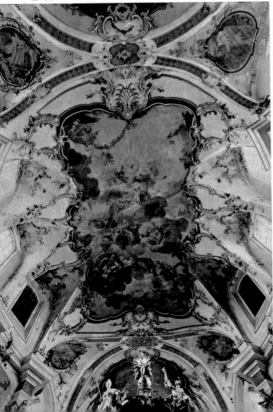

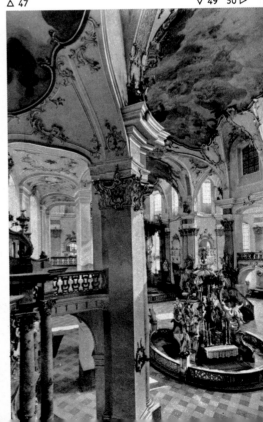

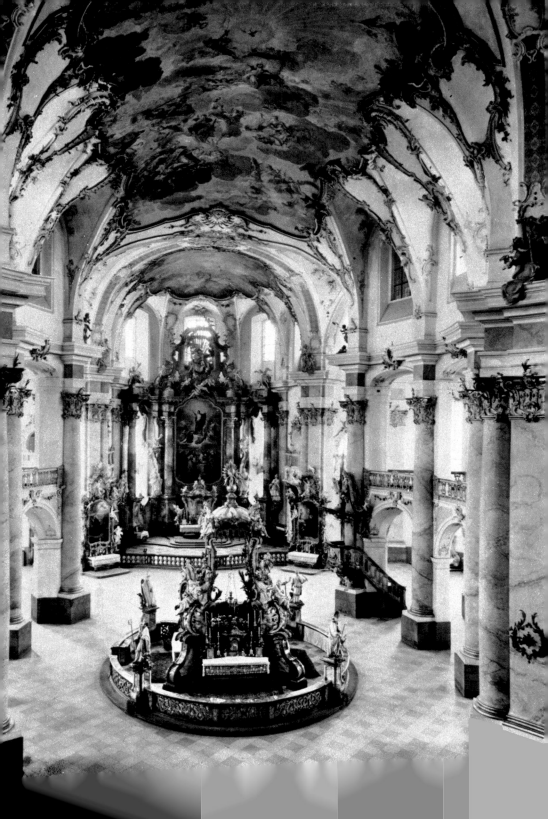

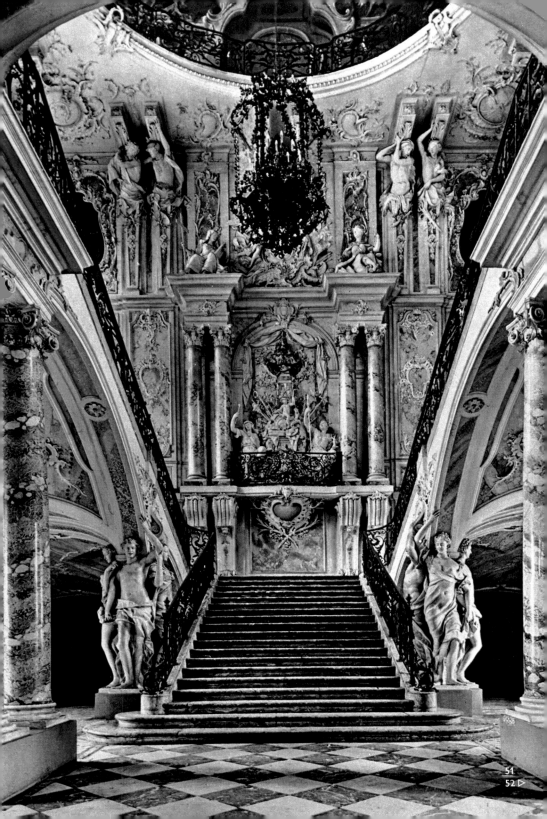

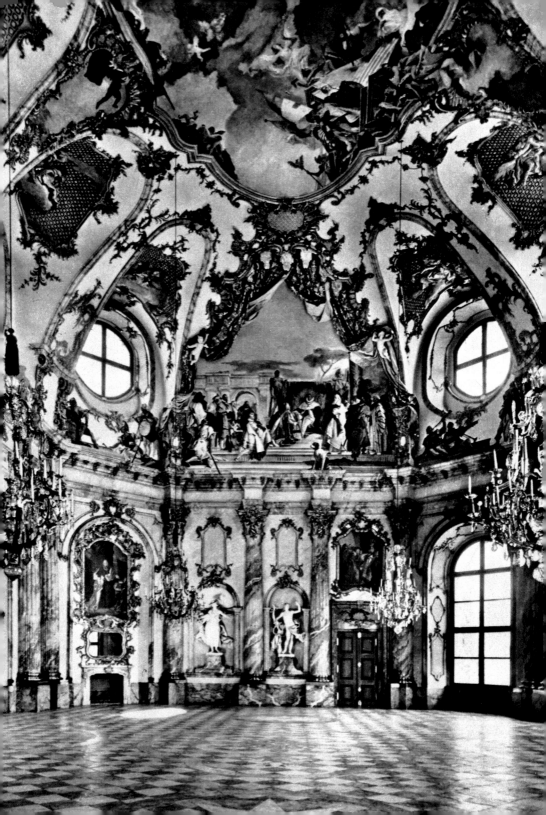

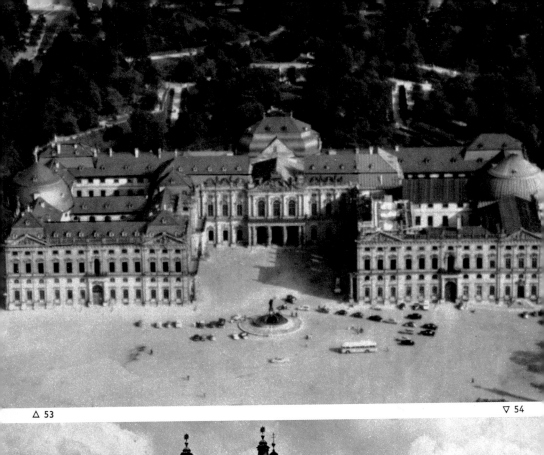

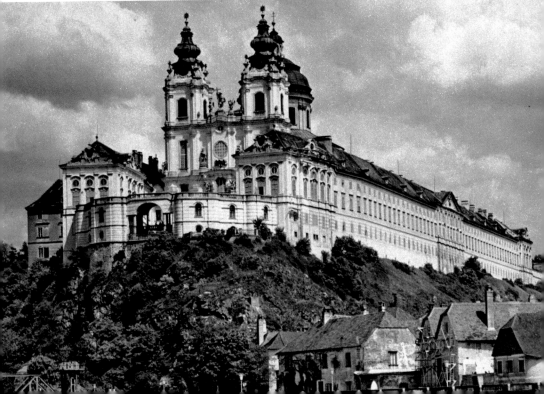

Maggiore (a late work, dating from 1673), remarkable festival decorations, and designs for the Piazza of St. Peter's and for the Louvre (1664), neither of which was executed.

Rainaldi's counterpart, in a sense, was Pietro da Cortona (1596–1669), the artist who established High Baroque ceiling painting in Rome and Tuscany. His precocious and considerable ambitions were revealed before 1630 in the Villa del Pigneto, built for the Sacchetti family (though no longer in existence, it is fortunately well documented), and from 1634 onward in the church of SS. Martina e Luca (*21*), near the Arch of Septimius Severus. His masterpiece is the façade of S. Maria della Pace (*20*). Its main characteristic is the rich, dense concentration of the relief, which emphasizes the contrast between curves and pierlike elements and boasts a number of motifs taken from Michelangelo. Yet for all its many contrasts, its general appearance is tranquil. A simple, classicizing basic scheme can usually be discerned behind the great display of diversity in Pietro's works—a fact which could explain the influence of this type of architecture north of the Alps, in France.

The career of Gianlorenzo Bernini (1598–1680) as an architect began in 1624, under the pontificate of the Barberini pope, Urban VIII. Already a successful painter and sculptor, the young artist was entrusted with the task of producing a grand scheme for the area beneath the dome at St. Peter's. In the same year Bernini designed the portico of S. Bibiana, which, though modest, was remarkable in terms of his stylistic development. His task at St. Peter's was so vast that he did not return to architecture until the pontificate of Alexander VII (1665–67). Bernini's major works—all late—date from this time: they are the Piazza of St. Peter's (*10*); the churches of Castelgandolfo (consecrated 1661) and Arricia (1664); and S. Andrea al Quirinale in Rome (*2, 15*), a simple oval building set behind the familiar grouping of portal, flanking structures, and gabled façade. At S. Andrea al Quirinale, by comparison with Maderno's work (*13, 14*), the interplay of individual elements and their relationship to the whole has become effortless. Bernini's architectural language is extremely evocative, without any hint of theatricality. The spiritual link with Michelangelo is much greater than before, though there is no specific reference to his work, and the scale is not overwhelming. Compared with Pietro da Cortona's façades (*20, 21*), the effect of the miniature temple forming the portico, for example, is sculptural, convincing, and intimate. The simplicity toward which Bernini is striving here has a natural quality (not to be confused with naturalistic quality) that is reminiscent of his colonnades at St. Peter's.

It is against such artistic heights that the most important manifestation of Baroque architecture must be measured. The work of Francesco Castelli, known as Borromini (1599–1667), has perhaps more than any other been greatly misunderstood—ideologically, aesthetically, and art historically. Borromini received his training in the company of the master masons working on St. Peter's under Maderno's guidance; the latter soon promoted his highly gifted young countryman, who had an outstanding talent for drawing, to more demanding work. Maderno initiated Borromini into the secrets of the building of St. Peter's, instilling in him not only a respect for antiquity, but also a love of Michelangelo, which remained with him for the rest of his life. Borromini's

collaboration with Bernini on the baldacchino of St. Peter's and on the Palazzo Barberini had led inevitably to a rift between them, and shortly afterward Borromini left St. Peter's. In 1634 he began work on the monastery and church of S. Carlo alle Quattro Fontane, usually known, because of its small size, as S. Carlino (*18*) and from 1637 he worked on the Oratory for the Congregation of S. Filippo Neri and on the church of S. Ivo della Sapienza (*22–24*). During the pontificate of Innocent X, when Bernini encountered the single crisis of his glorious career, his great, antisocial rival was shown considerable favor: the pope commissioned Borromini in 1652–53 to complete S. Agnese in Agone (*19*), entrusted him with the remodeling of the Lateran basilica for the Holy Year in 1650, appointed him architect to the Collegio di Propaganda Fide, and also commissioned him to do the exterior of S. Andrea delle Fratte. These works occupied Borromini until his death.

Borromini's artistic personality can hardly even be hinted at here. Through his work the Baroque method of synthesizing opposing elements attained a new, entirely personal, and—in terms of the overall history of the Baroque—an altogether revolutionary form. He was not merely concerned with exteriors, and so it will be necessary to consider his designs for church interiors, which naturally posed far greater problems. The church plan which is stylistically important for the Roman Baroque is not one with traditional nave and aisles, but with a central space. Such centralized churches predominate among the new buildings of the 17th century, and almost without exception their dimensions are moderate, so that they can be taken in at a glance; they are always vaulted and always have a clerestory, which is significant for their lighting effects.

There were two traditional types of construction for domed churches with a centralized plan: the rotunda, and the cross-shaped church with a dome erected over the crossing by means of arches and pendentives (that is, a dome with a zone of transition). The latter type was sanctioned by St. Peter's, the former during antiquity by the Pantheon, and both were used by the 17th-century architects we have just discussed. The rotunda no longer appears simply as a circular building, but sometimes as an oval, with side chapels leading off from the central chamber. Bernini's S. Andrea al Quirinale (*15*) is an example of this plan. In it an additional small domed oval (with its own lantern) is integrated into the eastern wall to serve as a chancel. A striking feature here is that the oval nave is placed transversely in relation to the entrance. Bernini's aim was twofold: to make a domed rotunda—which in itself is essentially static—into a dynamic form, and to eliminate the "dead corners" that occur in a church built on a rectangular plan with a crossing.

Borromini's approach to the problem of vaulting a centralized church was unusual and decisive for subsequent developments. He gave other architects an impetus to utilize both types of crossings and also to form a centralized single space which includes elements from both types and thereby acquires efficiency and qualities which neither type alone possesses. The small, superbly executed interior of S. Carlino (1638–40) has transepts and even pendentives, but the space that is spanned by the oval dome displays a maximum of curves: corners and sharp edges are virtually eliminated, an

impression that is reinforced on the façade by the placing of the columns in an extraordinarily flexible arrangement (*18*).

S. Ivo della Sapienza (*1, 22–24*) also belongs basically to the type of the domed rotunda. Here the dome is divided into six segments, which grow out of the entablature of a giant order of fluted pilasters and carry the curved rhythm of the walls in an ascending motion—alternately concave and straight, convex and straight—until they meet around the oculus of the lantern. The clearly organized design, which develops continuously from the ground level up toward the top of the dome, includes angular as well as curved elements and other highly important features that arise out of the complex hexagonal plan (*1*). Altogether, they impart to S. Ivo a richness and breadth that was never equaled in any subsequent centralized church.

The way was thus paved for a development which maintained a highly individual direction and which had decisive implications for the future. This development took place in northern Italy, still during the 17th century, through the mathematician,

55–56 LUXEMBOURG PALACE, PARIS. Begun by Salomon de Brosse in 1615 for Marie de' Medici, widow of Henry IV. The motif of the domed gatehouse had already appeared in French palace building in the 16th century, as had the motif of coupled columns. The rustication echoes that of the Palazzo Pitti in Florence, home of Marie de' Medici. The layout of the palace as a whole (seen in an engraving by Michel-Etienne Turgot, *56*), however, includes significant innovations. Instead of a symmetrical four-sided chateau around a central courtyard, there is a main building in front (*corps de logis*) given palace-like emphasis. From its two corner pavilions lower flanking wings project at right angles, each with a gallery (the one on the left housed the series of paintings by Rubens known as the Medici cycle: see *149*). Closing the fourth side of the court is a narrow, single-storied screen, from which the domed gate pavilion rises prominently. Unquestionably this initiated the classic form of French palaces built in the Baroque period.

57 HÔTEL DE SULLY, PARIS. Built by Jean I Ducerceau (c. 1585–1659) from 1624 onward. Detail of the façade. A typical example of Mannerist decorative art, built in a combination of brick and ashlar, a construction method current about 1600, through which a polychrome effect is obtained. The materials link the design with Netherlandish architecture.

58 FONTAINEBLEAU: Salon of Louis XIII. c. 1630. The chief motif of this interior is rows of panels of varying sizes, similar to those commonly used in France for external articulation.

59–63 DEVELOPMENT OF THE FRENCH CHATEAU IN THE 17TH CENTURY. (*59*) BALLEROY (Calvados). Built by François Mansart in 1626–32 for Jean de Choisy. Still definitely Early Baroque in spirit and choice of materials, but unusual in that the architectural elements are grouped in a pyramidal form. (*60, 62*) MAISONS, MAISONS LAFFITTE, NEAR PARIS. Built by François Mansart in 1642–50 for René de Longueil. The arrangement of the garden front (*60*), with a central pavilion linked by short wings to two corner pavilions, is traditional; however, the grouping and stepping of the pilasters on the façade is imaginative and the proportioning of all the elements consistent. This is a very elegant example of the period (1630–60) in which the standards of French Baroque architecture were laid down. (*61, 63*) VAUX-LE-VICOMTE, NEAR MELUN. Built by Louis Le Vau in 1657–61 for the finance minister, Nicolas Fouquet. Splendidly decorated, and remarkable for the new, High Baroque motif of the central oval salon on the garden site.

Compared with Mansart's architecture, Le Vau's is brighter, softer and, even on the exterior, more "Baroque." The contrast between the rustication of the walls and the smooth surfaces of the great pilasters plays a more important role at Vaux. But the two-storied pedimented projection set in front of the round salon is not Italian, and it reduces the plastic effect of the salon's novel shape. The palace garden was laid out by André Le Nôtre. At Vaux, Louis XIV discovered some of the immense possibilities of princely display that he was later to develop on a regal scale at Versailles. Mansart's and Le Vau's quite different ideas of the treatment of the wall—which emerge quite clearly when one compares the illustrations of Maisons (62) and Vaux (63)—were both fundamental to French architecture after 1650.

64, 66–68 VERSAILLES. Palace, park, and city are brought together in an ideological and artistic combination invested by the guiding principle of absolute monarchy—which Louis XIV here conceived in very personal terms—expressed through the allegory of the Sun King (66, 67). Buried in the center of the present-day complex is the small hunting lodge of Louis XIII, enlarged and decorated in 1631. From 1661 onward the young Louis XIV had this structure and the existing park converted into a setting for the staging of festivities and entertainments. It was not until 1668, after the Treaty of Aix-la-Chapelle, that the first structural extension began. It was entrusted to Louis Le Vau. After the Peace of Nijmegen in 1678 Louis XIV extended the palace on a gigantic scale. The architect in charge was Jules Hardouin-Mansart, and he gave Versailles the form it has today, adding the long recessed north and south wings, and encasing the central structure on the garden side, facing west (64). Each of the three freestanding sides of the central block thus has a range of rooms looking out over the garden: the Grande Galerie in the center of the west side, the Salon de la Paix on the south (with the queen's apartments), and the Salon de la Guerre on the north (at the beginning of the Grands Appartements). As a result, the king's bedchamber no longer lay at the center of the complex. On the town side, the forecourt widens like a stage, with three avenues fanning out from it, between which the stables were built as independent "chateaux" in 1679–82. To the right, beyond the north wing (given a new façade in 1771), is the Royal Chapel, whose foundations were not laid until 1689, and which was built in 1699–1710 by Robert de Cotte to the design of Hardouin-Mansart. Its elegant interior has an elevation in two stories with a gallery behind a majestic fluted colonnade (68). It is one of the most beautiful, and, in terms of "color" and disposition of light, one of the most remarkable creations of Late Baroque architecture in France.

Engravings of 1725 by J. M. Chevot and C. Sionneau show another superb example of the interiors at Versailles: the Grand Escalier des Ambassadeurs, so called because of its ceremonial function. It was in the north wing, and was removed in 1752 (67). The staircase was lit, entirely from above, by a rectangular opening in the vaulted ceiling (seen in the top half of the engraving). Charles Le Brun's ceiling frescoes were allegorical and mythological in subject (the four continents, virtues of the monarch), indicating the claims and spirit of absolute monarchy. The almost total absence of sculptural decoration is remarkable.

65 EAST FRONT OF THE LOUVRE, PARIS. After Bernini's plans for a Baroque building had been rejected in 1664/65, work began, to a classical design by Claude Perrault incorporating ideas from Charles Le Brun and Louis Le Vau, and continued until 1678. The motif of the giant colonnade of fluted columns arranged in pairs echoes Roman antiquity, an interest also reflected in contemporary sources; but it would be inconceivable without the immense influence of Bernini, perceptible even in this classically remote creation, in the motifs of the balustrade with statues, the absence of a high pitched roof, the all-embracing rhythm of the articulation in the basement story and colonnade, and the pedimented windows. This is the façade of a palace, not a chateau, and it glorifies not merely the king but the kingdom.

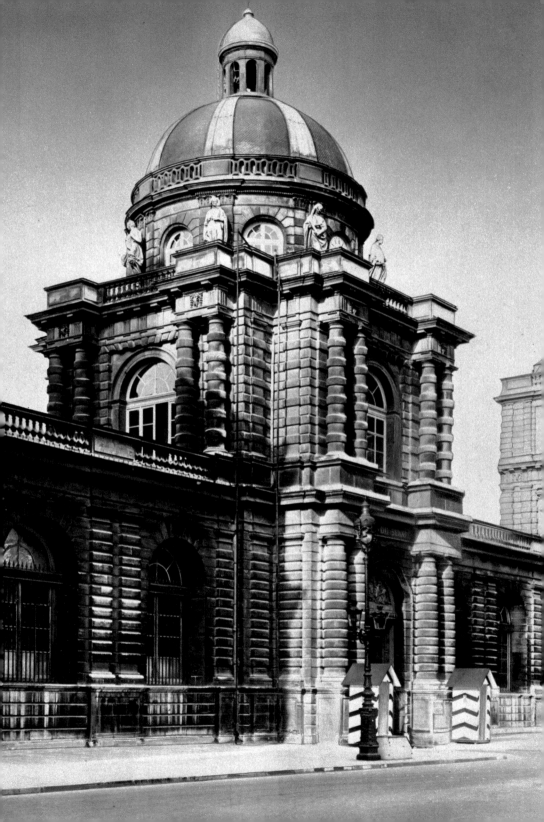

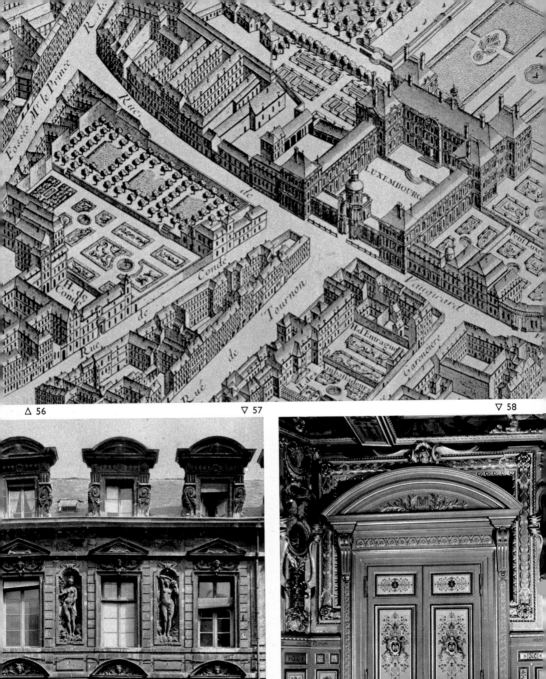

△ 56

▽ 57

▽ 58

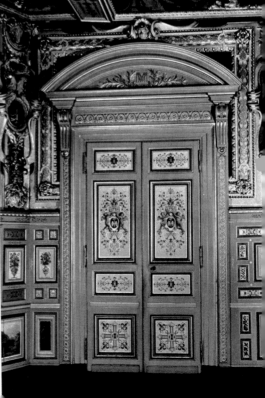

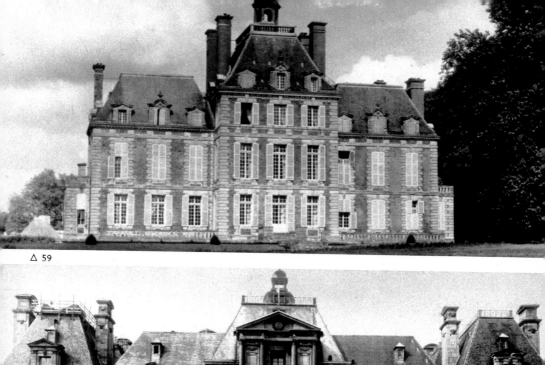

△ 59

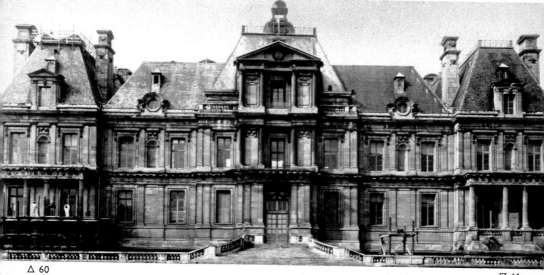

△ 60

▽ 61

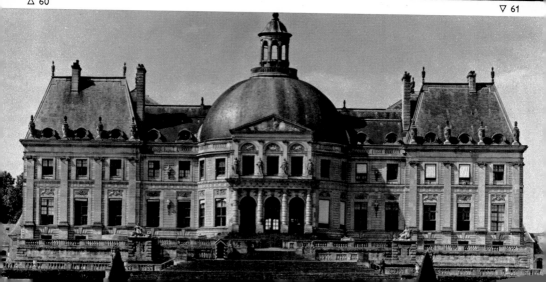

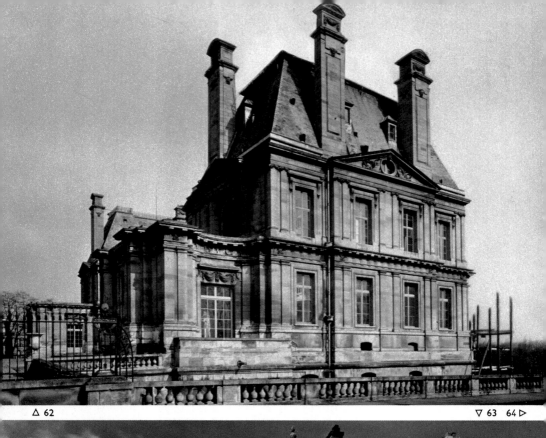

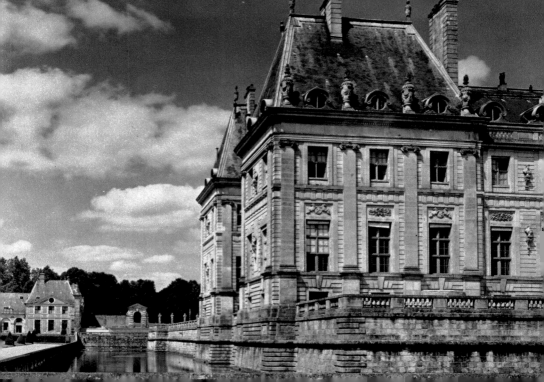

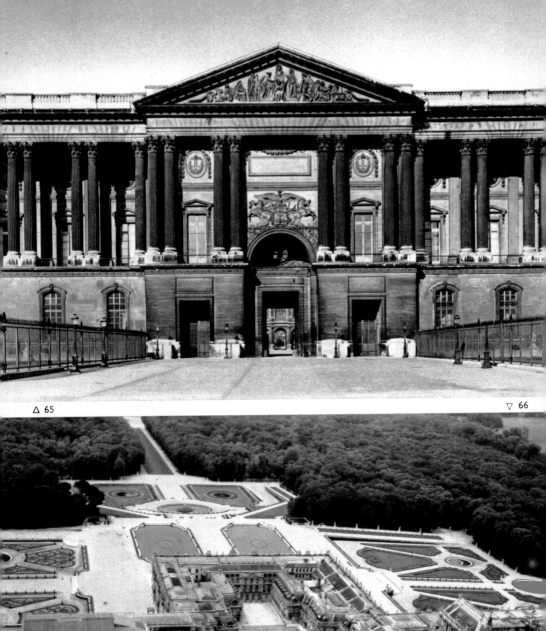

△ 65

▽ 66

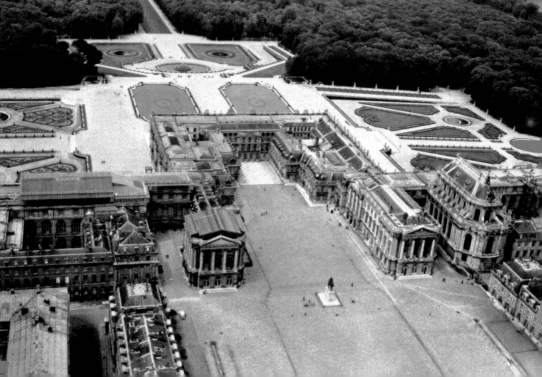

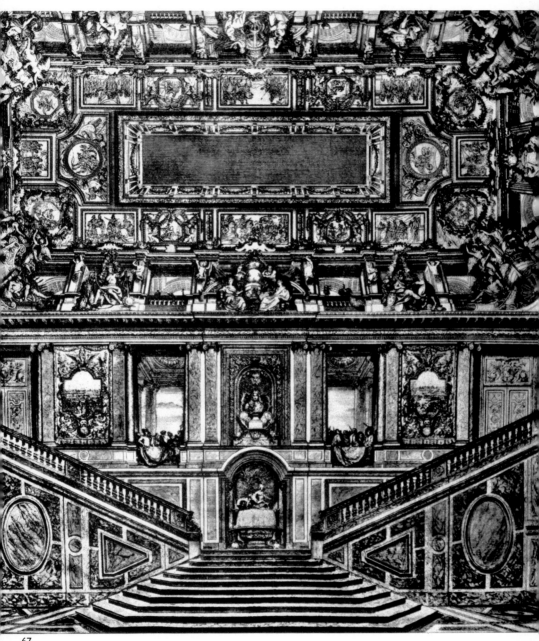

67

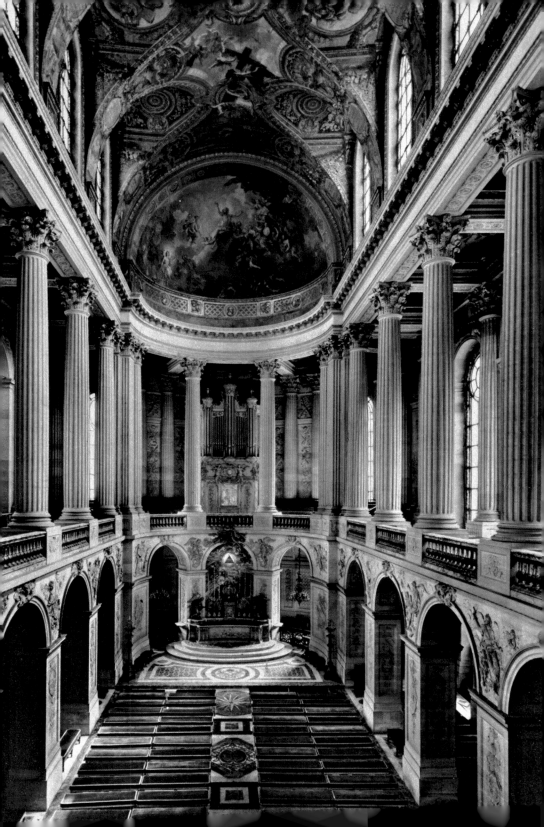

painter, and architect Guarino Guarini (1624–83). Guarini knew Rome, for he stayed there from 1639 to 1647. He admired Andrea Palladio, had an understanding of the Gothic style, and had too a typically North Italian love of theatrical chiaroscuro effects and ornate design (25–27). Guarini designed churches in Messina, Vicenza, Turin, Lisbon, Paris, and Prague. Although few of them were actually built and even fewer have survived, his teaching activities were influential in North Italy—where his pupils included Bernardo Vittone (1704/5–70) and Filippo Juvarra (1678–1736)—and north of the Alps. Like Borromini, he was interested in developing a crossing for the usual type of church structure. This is illustrated by two works in Turin: the church of S. Lorenzo, begun in 1668, and the Cappella della SS. Sindone, built to enshrine the Holy Shroud (25–27). A comparison of the latter with Borromini's S. Ivo (22–24) reveals profound differences, both in the concept of space and in the structure. Guarini devised a new type of crossing: it was not, however, by imitating Borromini's fusion of opposing elements, but by inserting a complex interior into a relatively simple external "container." The innovation was epoch-making, for it showed how existing churches could be remodeled internally. The richness of his invention appears in one of Guarini's church designs (5). Basically it has the usual elements: nave, aisles, crossing, and apse; but these major areas in fact consist of centralized units linked by arcades and grouped in such a way as to form a netlike pattern, covered by domes and shallow vaults. Because of their syncopated rhythm in plan and elevation, and the way they open into each other, the individual units lose much of their separate identity. At the same time the interior as a whole acquires new focal points and a multiplicity of views which it does not possess intrinsically. This is the point, around 1700, at which the third phase of Baroque architecture begins.

Around 1590, Paris—which a hundred years later was to be a European art center of world renown—was a weary city, afflicted by civil war, without hope or particular distinction, and architecturally less important than many a Dutch or Hanseatic merchant town. All architectural enterprises on a monumental scale had come to a halt. The Louvre was a mixture of old and new: rebuilding had begun with Lescot's wing in the Cour Carrée, but work had then been abandoned. Outside the city walls, the pitiful remains of the Tuileries Palace, begun earlier in the century, stood unfinished, and all work on the rotunda of the Valois family tomb at St-Denis had also ceased (1585). St-Eustache, the only 16th-century church of note, still had a Gothic appearance, its improvised roof rising above the surrounding medieval houses. Buildings such as the Hôtel Carnavalet and the Hôtel de Lamorgnon, seemingly striking examples of the "modern idiom," were in fact mere reflections of the chateaux that had been built outside Paris, mainly in the Loire Valley, since the reign (1515–47) of Francis I.

Politically, culturally, and architecturally the French chateau was rooted in the medieval world of feudal estates. The layout and component parts were ancient—a broad courtyard with towers and curtain walls, an encircling moat, drawbridge, and gate. From Late Gothic times onward, there were mullioned and transomed windows

of stone, often large and set in vertical bands, and characteristic high roofs with dormer windows. The significant change in this picture occurred about 1540, with the appearance of the wing and the pavilion, the latter clearly being the tower transformed. Yet how could a tower be turned into a pavilion? This question has tended to divide art historians into national camps, but the answer is surely this: by becoming increasingly assimilated in form and proportion to the curtain walls, which in the process became wings. This transformation can only be accounted for by the impetus of the Italian Renaissance. The next stage in French architectural history is illustrated by the Luxembourg Palace, prior to its alteration and extension in the 18th and 19th centuries (55–56). In front of the main block, or *corps de logis,* lies the courtyard, flanked by two long, galleried wings and closed by a low entrance range with a gate pavilion (55). The rusticated ashlar masonry contributes further to the palacelike character of the building. Salomon de Brosse (1562–1626), who built this first city-palace in Paris, had used the same scheme in the country chateau at Blérancourt (destroyed). It set the style for the "classical" French palace of the 17th century, which was related to the Italian villa-palace, and beyond it to the ideal of the *maison antique,* or ancient Roman villa. One important consequence was the establishment of an architectural differentiation between the courtyard and garden façades of a building; another was the creation of an open forecourt, which parallels the opening up of the façade in Roman Baroque palaces. It is hardly surprising that at the time when Blérancourt and the Luxembourg Palace were being designed (1610 and 1615, respectively), Henry IV was directing the first major replanning of the city of Paris: the Place de Vosges, the rebuilding of the Pont Neuf, construction of the Place Dauphine, resumption of work on the Louvre with the wing along the Seine, restoration of the Tuileries Gardens, and the improvement of the city's water supply. Admittedly, during this phase the architecture was simple and still akin to that of the Netherlands, being a mixture of brick and masonry used decoratively, characterized by narrow windows and an articulation consisting of flat, vertical bands of ashlar (*chaînes*).

From 1630 to 1661, French architecture developed on a colossal scale. Paris became the center and the foundations of the *style classique* were established. Rome was now the model and inspiration for all artistic endeavors. For the first time architects emerged in Paris who were both receptive to the aims of the Baroque style and capable of carrying them out. Significant religious architecture began to appear there (St-Paul-et-St-Louis, by François Derand, completed 1634). The most important innovations were the adoption of the dome with drum and the Roman-type church façade. There was a renewal of townhouse (*hôtel*) building by the moneyed aristocrats and officialdom, favored by the increasing power of the state (Hôtels de la Vrillière and Lambert). Work on the Louvre went forward again. There was an increase in endowments by the Court—the Sorbonne by Richelieu in 1638, the church of Val-de-Grâce by the Queen Mother in 1643 on the occasion of the birth of the future Louis XIV, the Collège des Quatre Nations by Mazarin, designed by Louis Le Vau in 1660. Decorative painting of interiors, particularly the galleries, became usual, the motifs being drawn

from antiquity and from such Baroque models as Pietro da Cortona and Giovanni Francesco Romanelli. The decorations of the Hôtel de la Vrillière (by François Perrier, 1645–50), of the Palais Mazarin (lower and upper galleries, from 1646), the Louvre (1655–57), and the Hôtel Lambert (from 1648) are notable examples.

The leading architects of this period were Jacques Lemercier (1585–1654), François Mansart (1598–1666), and Louis Le Vau (1612–70)—contemporaries of Maderno, Borromini, and Rainaldi in Rome. Lemercier was in Rome until 1614, and was subsequently appointed private architect to Richelieu, for whom he built the chateau and town of Richelieu (from 1631) and the church of the Sorbonne, his masterpiece (*70*). Lemercier also played a part in the complicated development of Val-de-Grâce, competing there with Mansart. The latter, an architect who had begun his career as a sculptor, is the outstanding personality of the period. He was as slow and difficult as Borromini, yet he grasped the principles of the Roman style independently, without the usual period of apprenticeship in the Eternal City, and put its concepts into practice in a highly individual manner.

Mansart's major contribution to the history of chateau building was the extension of Blois (completed 1636), commissioned by Gaston d'Orléans. He used a harmonious grouping of parts and invented the motif of open, curving colonnades as an architectural linking device. Mansart was the first to achieve truly sculptural effects by powerful, energetic relief treatment of the wall, in which the traditional vertical window bands are perfectly balanced against horizontal tiers of pilasters on each floor. The exterior and interior of the Château de Maisons, with its monumental staircase, demonstrate Mansart's great genius, which for all its severity still has a dynamic effect (*60, 62*). This emerges even more clearly when the building is compared with the chateau of Vaux-le-Vicomte, built somewhat later (1657–61) by Louis Le Vau for the all-powerful finance minister, Nicolas Fouquet (*61, 63*). Mansart uses distinctly layered reliefs, rich in contrasts, which wrap tightly around the corners of the building; the motif of pilasters arranged in pairs echoes older French designs. While the effect of everything in Mansart's work is one of immediacy and plasticity, Le Vau uses more color, with alternation of ornament rather than articulation, and a greater contrast between large and small motifs.

In 1661, Vaux, with its garden by André Le Nôtre (1613–1700), was completed. The young King Louis XIV attended a glittering banquet featuring a performance of Molière's ballet *Les Fâcheux,* with music by Jean-Baptiste Lully and scenery by Charles Le Brun—an event described by La Fontaine. The downfall of Fouquet followed soon after: Louis, who on the death of Mazarin had declared his intention to be sole ruler, proceeded to act accordingly. He now took over the entire team of artists that Fouquet had assembled for Vaux, and commissioned extensive projects of his own.

Versailles was the personal creation of Louis XIV. Here he had himself portrayed and glorified as the *Roi Soleil,* the Sun King, alluding to an ancient allegory of the state, enriched with mythological trimmings. Versailles is not only an architectural

work: Le Nôtre's garden forms an integral part of the layout (66), as does the large-scale decoration of the interior produced under the direction of Le Brun (67). Versailles is not a "chateau" in the manner of Maisons or Vaux. After its first enlargement by Le Vau (begun in 1668), the building as seen from the garden consisted of wings linked across a recessed central section by a low terrace resting on arches. Le Vau's articulation of the façade gives the structure an individual quality, and places it in the category of the *venaria reale,* or royal hunting lodge. In the second enlargement of Versailles, begun in 1678, this quality was replaced by quantity, on a scale that was almost urban. The building underwent a radical iconographic alteration. Jules Hardouin-Mansart (1646–1708), a great-nephew of François Mansart, filled in the open west side by facing the terrace with the Galerie des Glaces, or Hall of Mirrors, whose pictorial decoration encompasses the life of Louis XIV between the poles of war and peace (represented symbolically by two separate rooms at the ends): thus the institution of the monarchy and the concept of the state were brought into prominence. By the time the Trianon des Marbres was finally built in the park of Versailles as a retreat from the public eye, and the Royal Chapel was begun, in 1689 (68), to reinforce the monarch's sweeping claim to be the head of state and head of the Church, the era of Louis XIV had long been established as the first period of European "state art" in the modern sense.

The history of this state art dates back to 1661, with the appointment of Colbert as chief adviser to the king and the centralization of talent, planning, and resources. This laid the groundwork for unrivaled teamwork by painters, sculptors, ornamental artists, and landscape architects. The reorganization of the Manufacture des Meubles followed in 1665, in which year Colbert also tightened the reins on the Academy of Painting and Sculpture and appointed Charles Le Brun his minister of art. This choice determined the subsequent dualism in the decorative style of the reign of Louis XIV —Late Baroque in setting and deliberately classicist in theme. The foundations of a state architecture were laid in 1671 with the establishment of the Academy of Architecture, which formulated a series of rules governing every conceivable question concerning architecture.

In 1673 the standard French translation of *Vitruvius Britannicus* appeared. The translator was Claude Perrault (1613–88), a physician and natural philosopher, designer of the Observatoire and the triumphal arch in the Faubourg St-Antoine. He could pride himself on having emerged victorious in a contest with Bernini for the symbolic and political conception of the famous east front of the Louvre (65), whose design is in all probability due to him (Michael Petzet). In 1662 Louis Le Vau had been commissioned to produce the definitive plan for the Louvre's façade; but Colbert soon turned to Rome, inviting designs from Pietro da Cortona, Carlo Rainaldi, and Bernini. Finally, in 1665, Bernini was officially invited to Paris, having already sent from Rome two projects which had obviously impressed Louis XIV. An outline of this dramatic visit can be read in the *Journal du Voyage du Cavalier Bernin en France* of Paul Fréart de Chantelou, for whom Bernini represented the humanist ideal of the

"great man," as opposed to Colbert, who advocated and put into practice the idea of the absolute state. It is to the credit of the leading architect of the time, Jules Hardouin-Mansart, that the church of St-Louis des Invalides in Paris (*3, 72, 73*) rises above the effect of this cold and restrictive dogma and embodies all that carried French architecture of the 17th century beyond its national frontiers.

In Germany the 17th century began auspiciously with works of considerable originality. The Residenz in Munich was enlarged for Maximilian, first Elector of Bavaria in the first part of the 17th century; Elias Holl's Town Hall (1615–20) completed the monumental replanning of the center of the free city of Augsburg. After the Thirty Years' War (1618–48), however, this surge of activity came to an end. The bourgeoisie now withdrew its patronage of new buildings. For a long time foreign architects and craftsmen dominated German architecture—Huguenots and Dutchmen in the north, Italians in the south, following the same pattern that had existed in Prague and in Austria since the 16th century.

There followed a period in which the Catholic regions of Germany were receptive to the Italian Baroque, while in the Protestant lands religious architecture remained undistinguished until well into the 18th century, using time-worn Late Gothic forms. During this phase in Prague, colossal monasteries and palaces were erected (Clementinum; Jesuit college in the Neustadt; Czernin Palace on the Hradčany) and church interiors of vast dimensions and distinctive character were created (St. Ignatius, begun in 1668; the Baroque transformation of the Jakobskirche). These works, and the Baroque cathedral at Passau, where Carlo Lurago directed construction from 1668 onward, are all evidence of a monumental approach to architecture, albeit not without certain unique features. Yet there is something largely schematic and monotonous about all German buildings erected during this phase.

Around 1690 the situation altered radically. Originating in Austria, an entirely new form of Baroque architecture evolved. What Pinder called an "ardent enthusiasm" for architecture spread rapidly, and by 1700 it had already crossed denominational frontiers (Royal Palace in Berlin by Andreas Schlüter, 1698–1706), leading to the development of monumental ceiling painting (frescoes by Johann Michael Rottmayr in Schloss Frain, 1695, and in the Jesuit church at Breslau, 1704–6), in which various regions developed an artistic character of their own. One might therefore regard the northern Alpine regions as a Baroque "subcontinent." Its heartland was the mountainous country between the Neusiedler See in the east and Lake Zurich in the west. From this center further areas spread out, under the impulse of dynastic expansion: such were the so-called Schönborn lands of Bamberg, Würzburg, and Mainz. This fringe extended in one direction from Vienna through Prague to the Rhine, and in the other through Dresden to Berlin.

For reasons of chronology and content, any survey of Central European Baroque architecture must begin with Austria, and specifically with Johann Bernhard Fischer von Erlach (1656–1723). He spent the years 1670–87 in Italy, studying the master-

pieces of the Roman Baroque, and on his return home immediately began producing remarkable designs and works (first project for Schönbrunn Palace, 1688; triumphal arch erected on the occasion of Joseph I's entry into Vienna as king in 1690). In 1690 Fischer was appointed tutor to the crown prince, in 1696 he was ennobled, and in 1705 he was made imperial chief inspector of buildings. Between 1694 and 1709 he produced a brilliant series of churches in Salzburg: the Dreifaltigkeitskirche (Trinitätskirche) was the most influential, but the Kollegienkirche deserves special mention for its spiritual and artistic qualities (for its plan, see 6). Around 1690, Fischer produced a Bernini-like tripartite design for a pleasure pavilion, in which a high, oval central feature is set between rectangular wings (37). The idea was copied endlessly: examples are the Lobkowitz Palace in Prague by Giovanni Battista Alliprandi; Andreas Schlüter's Buchlowitz Palace in southern Moravia; Karlskrone Palace at Chlumec in Bohemia, by Giovanni Santini Aichel (1723); and the Schwarzenberg (Mansfeld-Fondi) Palace in Vienna, by Johann Lukas von Hildebrandt (begun in 1699).

Fischer produced a novel system of articulating the façade, from ground level upward, through his different handling of the dominant features—projections, entrances, and stories—and in particular through his expressive delineation of detail. "His finest artistic devices," wrote Pinder, "were his use of narrow intervals, his retaining of relief, and his careful choice of unusual emphases" (35–37). Fischer's designs had an educational effect on artisans and on patrons as well, who were no longer satisfied with what had previously been offered to them by the Austro-Italians. Fischer knew how to present his ideas convincingly on paper, and even published them in the form of engravings, aided by his son, Josef Emanuel (1693–1743), who was also an architect and who succeeded his father as court architect. Thus the new style rapidly gained currency over a wide area.

Its attraction must surely have been the heroic language of Fischer's architecture, which employed metaphors drawn from world history and must have seemed the fulfillment of the dream cherished by the imperial court, the princes, and the ecclesiastical and secular nobility—namely, the restoration of the Empire's power, prestige, and splendor. Once the Turkish infidels had been humbled, the next step was for the Empire to outshine the French monarchy. "For to be emperor," wrote Hans Wagner von Wagenfels, "means nothing less than to be the greatest ruler on earth." Seen against this background, there seems to be every justification for regarding Fischer's architecture as an "imperial style," a view put forward by Otto Brunner. Fischer's Hofbibliothek and, to a greater extent, his façade for the Karlskirche in Vienna (31) illustrate what is meant by this phrase.

The charisma, richness, and universality of Fischer's work, as well as his delicacy and precision, are lacking in Filippo Juvarra's mighty basilica of La Superga outside Turin (30), although there are similarities between the two buildings. The contrast between Fischer's style and French architecture is equally marked, though a comparison with Hardouin-Mansart's façade for the church of the Invalides (72, 73), for example, again reveals certain common features. Both Hardouin-Mansart and Fischer restricted

themselves to pilasters and freestanding columns as articulating members, and both set their majestic domes on high drums above the antique motif of a temple portico —a combination which had been considered the hallmark of classicism since the time of Palladio. Fischer von Erlach's feeling for plasticity is entirely un-French, as is his memorable ability to resolve the very clearly stated contrasts in the whole design.

By and large, however, the influence of Fischer von Erlach was exceeded by that of his rival in Austria, Johann Lukas von Hildebrandt (1668–1745), who denigrated the imperial style as "princely architecture with aspirations to a royal style," but in so doing also made it more widely acceptable. In his designs for palaces and castles, Hildebrandt brilliantly exploited all the resources of perspective, landscape architecture, and ornament (38, 39), as well as certain favorite motifs (such as atlas figures and ornamental gables [40]), wherein his intimate knowledge of French ornamental engravings was of immense practical value. He was active in the field of monastic architecture as well, though here Jakob Prandtauer (1660–1726) was the Austrian specialist (Benedictine abbey of Melk, 54); nevertheless, Hildebrandt's design for the abbey of Göttweig while never fully completed, had a marked influence. The unique quality of this and other designs lies in their skillful adaptation of the site and the way in which they are made to blend with older buildings.

As a favorite of the Schönborn family, Hildebrandt was by 1714 already exporting his exquisite Viennese decorative style to the Main-Franconia region of Germany (Schloss Pommersfelden, 41). Later, he was probably the most important influence, after Balthasar Neumann, in the planning of the Würzburg Residenz (53). Despite his reputed Roman training, Hildebrandt had a North Italian artistic temperament. A brightness and energy appears in his treatment of the wall and interior decoration which is foreign to the work of the Austro-Italians. For churches Hildebrandt favored centralized designs: in this respect he differed fundamentally from Guarini, but the latter's ideas were nevertheless an important stimulus for him. The influence of Guarini appears in the façade of the church at Deutsch-Gabel (Německé Jablonné) in northern Bohemia (4), and in the imposing domed space of the Piaristenkirche in Vienna (planned before 1716, but not completed until 1751–53). After 1700, there are innumerable instances of Hildebrandt's influence throughout Central Europe, particularly in Bohemia, Franconia, and Bavaria.

In the Electorate of Saxony, as in the Berlin of the early Hohenzollern kings, the new style was not a spontaneous, indigenous growth, but a product encouraged for political motives by Elector Augustus the Strong, elected king of Poland in 1697, a convert in Protestant territory. Like his ancestors, he had a passion for the theater, music, and glittering spectacle, and up to the time of his death in 1733 planned and directed building on a large scale, the finest product of his patronage being the Zwinger in Dresden (42). By comparison all that had been built in the Saxon capital before 1700, even Johann Georg Starcke's state palace in the Grosser Garten, scarcely appears Baroque. The panorama along the bank of the Elbe River, of which the Zwinger forms an integral part, was the outcome of Augustus's intention to build a

new palace in place of the old one. Among the models closely studied for the new project were the Berlin Schloss by Schlüter, and Viennese architecture.

The Zwinger was ultimately the outcome of a combination of North German and Austrian influences, as Eberhard Hempel has shown. It was the work of the West-phalian master-mason Matthäus Daniel Pöppelmann (1662–1736) and also—in our view, to an even greater extent—of the Salzburg sculptor Balthasar Permoser. The Zwinger also shows the unmistakable influence of Hildebrandt. The scheme for the layout of this festive Baroque arena, originally intended as an orangery, probably came from Augustus himself, since building sketches in his own hand are known to exist. Pöppelmann prepared himself for the commission by a journey to Vienna and Rome in 1710, a choice characteristic of the period. Among Pöppelmann's other works are the Japanese Palace in Dresden, the Wasserpalais (1720–32) at Pillnitz (in the fashionable "Chinese" style), and the rebuilding of the Moritzburg.

The buildings that gave the bank of the Elbe at Dresden its imposing appearance were the Protestant Frauenkirche (1725–43) by Georg Bähr (1666–1738) and the Catholic Hofkirche (begun 1737) by Gaetano Chiaveri (1689–1770). The former, prob-ably modeled on the pilgrimage church of Freystadt (see below), was a towerlike rotunda with a high dome divided into segments, while the latter combined an interior ultimately derived from the Royal Chapel at Versailles (68), with a magnificent exterior and Borrominian tower. Until 1945 the two churches, representing the rival religions in German architectural history, dominated the Zwinger and Dresden's Baroque image.

Among the Baroque lands, Bavaria occupies a special position, which emerged quite distinctly even before 1600 with the Jesuit church of St. Michael in Munich, built under the supervision of Wolfgang Miller and Friedrich Sustris (1582–97). A striking aspect of Bavarian architecture is that it was not uniformly indigenous, but was a heterogeneous assemblage of traditional and foreign elements. The combination produced some original and remarkable forms, not only after the great transitional period of 1690–1700, but quite early in the 17th century. Ferdinand Maria and Max Emanuel of Wittelsbach provided the political impetus for the introduction of Italian elements. The former, married to Adelaide of Savoy, founded the Theatinerkirche in Munich and commissioned his court architect, Enrico Zuccalli (1654–1724) of Grisons, to design a new building for the famous pilgrimage church at Altötting. Although this was not in fact built, it introduced the scheme of an ambulatory with eight semi-domes surrounding a central domed rotunda—an innovation that was to be extremely important for later developments—combined with an oval sanctuary (incorporating the ancient chapel), an arrangement reminiscent of Bernini's use of the oval at S. Andrea al Quirinale (2). Apart from several projects for the Munich suburb of Berg-am-Laim (1724), which were not carried out, this idea was adopted by Giovanni Antonio Viscardi (1647–1743) for his pilgrimage church at Freystadt (1700–8), and was subse-quently developed by Johann Michael Fischer. At Freystadt and in the Dreifaltigkeits-kirche at Munich (1711–14), which is noteworthy for its reminiscences of Guarini (hitherto unrecognized), Viscardi used columnar motifs, introduced into Bavarian

church interiors in the Theatinerkirche in Munich, as an optical element—a device subsequently developed by Johann Baptist Gunetzrhainer (1692–1765) and Fischer (Damenstiftskirche in Munich, early 18th century; church at Landshut-Seligenthal, 1732–34). Zuccalli used columns on the façade of the abbey church at Ettal (design, 1709), with curves reminiscent of Bernini. There were centralized churches built by local architects in the 17th century, but they are atypical, isolated instances. Examples are the church of Westendorf near Rosenheim (1668–c. 1670) and Maria Birnbaum near Aichach (1661–68), by Konstantin Pader, and Vilgertshofen (1687–92) by Johann Schmutzer. Schmutzer (1642–1701) was also an outstanding member of the Wessobrunn group of stucco-workers; the church at Friedrichshafen (1689), built by Vorarlberg craftsmen, contains impressive acanthus decoration by him.

Thus, despite wars and foreign infiltration during the 17th century, the general picture of Bavaria is an unusually rich and significant one, which emerged not "in spite of" foreign domination, but as a result of it. This background must be borne in mind when assessing the ecclesiastical architecture of the brothers Cosmas Damian Asam (1686–1739) and Egid Quirin Asam (1692–1750). The Asams' thought is Bavarian, while their expression is Roman. The brothers were in Rome until 1713, and the churches they built at Munich (St. John Nepomuk, begun 1733) and Weltenburg (98) leave no doubt as to their direct Roman inspiration. It has recently been shown by J. Sauermost that the façade of Weltenburg was modeled on the work of Bernini, and that other features can also be traced to Rome to the chapels of St. Teresa of Avila in S. Maria in Trastevere and of St. Cecilia in S. Carlo ai Catinari by Antonio Gherardi. The theatrical illumination and the bizarre forms of the windows in the Asams' designs are, however, traditional features of Bavarian and Tyrolean art. The high altar of the church at Weltenburg, conceived as a "sacred theater," or *theatrum sacrum,* and perfectly integrated into the articulation of the walls, had forerunners in the Theatinerkirche in Munich. But all these details of form, method, and iconography are of little significance compared with the impact of the new and dynamic work of the Asam brothers, which united architecture, painting, and sculpture. From now on the Bavarian church interior had two focal points—the high altar and the ceiling fresco.

During the Baroque period, South Germany and Switzerland were a rich center of monastery building. The abbey and church at Kempten (1651–66) inaugurated a long line of new buildings, supreme among them being Einsiedeln and St. Gall in Switzerland, Weingarten and Ottobeuren in South Germany. The orderly, rectilinear arrangement of the wings and courtyards, varying according to the spiritual and secular occupations of the religious communities, which were often directly subject to the state; the dominant position of the church, which stood either at the front of the complex (Kempten, Ottobeuren) or on the central axis; and finally the imposing appearance of these monasteries—all point to the fact that they were the products of local craftsmen. Most were in fact built by members of the guilds of architects and masons which had been flourishing in the Vorarlberg region since the mid-17th century, guilds which produced such excellent architects as Christian Thumb (1683–1726),

Michael Thumb (d. 1690), and Franz Beer II (1660–1726). Another skilled member of the group was Caspar Moosbrugger (1656–1723), who was chief architect at Einsiedeln after 1717 and designed the plans of Weingarten and St. Gall.

The characteristic Vorarlberg church is centralized and barrel-vaulted: the vault is supported by projecting internal buttresses called *Wandpfeiler,* which enclose a gallery. The model was St. Michael's in Munich. The Vorarlberg style penetrated into South Germany (pilgrimage church of Schönenberg near Ellwangen, 1682–95; and the church at Obermarchtal, 1686–92—both by Michael Thumb), Switzerland (St. Urban), and Alsace (Ebersmünster). These church interiors provided an alternative to the Italian treatment of a centralized structure—no strong horizontal division between wall and vault, no frontalized continuous articulation to provide relief architecture in the Italian manner, but instead a regular alternation between solid pillars and light-filled openings, and a vault no longer divided into bays, but brought delicately down via curves and arches to the powerfully projecting entablature at the top of the piers. The *Wandpfeiler* form remained unknown in Austria and Bohemia.

About 1700 movement was introduced into hitherto lifeless façades. The Vorarlberg masons adopted centralized vaulting schemes and the dome resting on a drum (both appear at Weingarten). At Einsiedeln (1719–35), Moosbrugger joined a great octagonal nave to a longitudinal choir. His twin-towered façades at Weingarten and St. Gall echo Fischer's favorite motif of the oval rotunda, and are modeled on his Kollegien Kirche in Salzburg. These are clear indications that from 1690 onward the change in style could be felt even in the heartland of the German traditionalists. After 1700 the same trend can be observed in Bohemia.

Christoph Dientzenhofer (1655–1724) was one of a Bavarian family of five architects. His brothers all worked in Franconia; the youngest, Johann (1663–1725), built the cathedral at Fulda, the abbey church of Banz in the Main valley (7), and the palace at Pommersfelden. Christoph was the only one of them to live in Prague, and he was probably the first to introduce the internal buttress, or *Wandpfeiler,* method of construction to this region, where the conventional arcade had hitherto been used. Dientzenhofer employed a combination of pier and shell forms to create Guarinian interior effects, as in the church of St. Margaret in Břevnov (1708–15), now definitely ascribed to him (43). The first narrow bay is succeeded by two broadening central bays, and echoed by a reduced fourth bay. This composition is also visible from the outside. The two narrow bays are elongated transverse ovals treated as shells, while the two central bays have *Wandpfeiler* and form canopies. The four bays form a group extending from the entrance to the choir, with a rotunda acting as an intermediary element. At St. Nicholas on the Kleinseite in Prague, the arrangement is quite different (45). The imposing nave, built in 1704–11, is an impressive illustration of Guarini's ideas of molded architecture: the remarkable curving side walls are extremely unusual. The adjoining chapels and galleries are built on a correspondingly curved ground plan. The design is the outcome of Guarini's conception of the longitudinally planned church treated as a chain of linked yet individual spatial elements (5). At St. Nicholas

those elements are transverse ovals. Because of the broad openings that succeed each other down the length of the church, only fragments of the side walls appear. The vertical gaps between the massive pilasters set at an angle emphasize the flow of movement. The concept was not carried through consistently in the vaults, however, where it was only simulated by the application of ribs. These were removed in the nave to make way for a fresco by Johann Lucas Kracker (1717–79), but traces of them can still be detected in the vaulting.

The first example on Bohemian soil of an interior based on Guarini's ideas, consisting of perfectly formed rotundas extending to the vaulting, is the church of St. Paul at Nová Paka in northeastern Bohemia (1709–24; architect unknown). This very modestly appointed church, without a choir, is nevertheless artistically consistent: it is made up of five rotunda units that are carried up into the vaulting and that are distinct in size and form, producing a spatial grouping around the center. Three of these units, moreover, possess a thin second shell, concentric with the outer layer (following the method introduced by Hildebrandt), with blind arcades piercing the sides, suggesting the remains of a canopy within these rotundas.

The church at Nová Paka advanced the synthesis that had already been arrived at in Prague to the point from which Balthasar Neumann (1689–1753) started out. This "far-sighted intellect" (W. Pinder) had demonstrated his knowledge of Guarini early on, and had taken his first step toward an independent development with his interior design for the Schönborn Chapel of Würzburg Cathedral. Neumann knew Bohemia, had collaborated with Johann Dientzenhofer and Hildebrandt on designs for the Residenz at Würzburg, and had learned about modern French architecture at first hand during his visit to Paris in 1723. Neumann must have been particularly struck by Hardouin-Mansart's imaginative use of the freestanding column (St-Louis des Invalides, *72, 73*). It is also quite likely that the Franconian master came to grips with the problems of joining a rotunda to its covering vault or dome in the manner of Guarini, as well as with the possibilities and limitations of double shells as used by Hildebrandt. These arise from the fact that the inner shell only appears to be detached from the outer one: for it to be really separate, it would have to be supported on *Wandpfeiler* or freestanding columns. Neumann must, therefore, have recognized that it was necessary to unite and condense all previous motifs, themes, and construction methods in order to create the ideal of Baroque church architecture, defined by the critic Günther Neumann (*Neresheim,* 1947) as "total space."

The chapel of the Würzburg Residenz, dating from 1732-40, the pilgrimage church of Vierzehnheiligen (*46–50*), and the abbey church at Neresheim (designed 1747–49, built 1753–92) all illustrate that Neumann not only understood the ideal of "total space" in theory, but that he was also able to translate it into universal reality. His church interiors fulfill the aim of all art: to represent something general and at the same time to bring out the particular in all its individuality. Neumann responded to Fischer von Erlach's ideal in his own way as an architect, and his answer was definitive for the history of European Baroque architecture.

69–73 PARISIAN CHURCH FAÇADES OF THE 17TH CENTURY. These summarize the period in which French architecture turned to, and then rejected, Roman Baroque forms. ST-GERVAIS (*69*) of 1616–21, by Salomon de Brosse, represents the pre-Baroque phase. Massive paired columns are arranged in tiers, already a strong preference in French architecture in the 16th century.

Jacques Lemercier's façade of the CHURCH OF THE SORBONNE (*70*), of 1635, represents the new phase, in which the influence of Roman Baroque models can be felt. There is a very obvious attempt to use the articulation of columns and pilasters and the intervals between them as complementary elements in the composition of the façade as a whole; this is not true of St-Gervais, where the columns alone, and not the intervals, are significant. If this phase is taken as thesis, the façade of the VAL-DE-GRACE (*71*), of 1645–70, emerges as antithesis, for here the complex grouping of large and small forms, the increasing use of sculptural contrasts, and the building up are very plain. Lemercier eventually took over work at the Val-de-Grâce, but the façade is chiefly due to François Mansart.

The famous façade of ST-LOUIS DES INVALIDES (*72, 73*), designed by Jules Hardouin-Mansart and built in 1677–1706, appears as the synthesis of the development. There is an apparent return to the simple principle of St-Gervais: columns set in front of a wall. But here they are arranged in a deliberate development toward the center and upward: the double columns of the dome drum and the articulation of the intervals are relevant elements, pictorially and not merely structurally valid. A striking feature is the way in which the arrangement of the columns flanking the portal leads the eye into the interior (*73*).

74 ST. PAUL'S CATHEDRAL, LONDON. Built by Sir Christopher Wren (1632–1723) in 1675–1710. View of the choir and dome. The dome, ultimately derived from Bramante, is more Renaissance in feeling than is the dome of the Invalides church in Paris (*72*). Below the dome, the building is densely layered and yet imposing in its massive effect. The upper story is a stone screen, masking the roof pitch and adding weight to the body of the church.

75 ST. STEPHEN'S WALBROOK, LONDON. Sir Christopher Wren. 1672–79. A fine example of the transformation of a simple boxlike chamber into a complex sequence of interrelated spaces, with a central dome resting on eight columns, single-bay transepts and chancel, and two-bay nave.

76-77 ENGLAND'S GREAT LATE BAROQUE PALACES. Although almost entirely devoid of features that are specifically Baroque, they are nevertheless related to the Baroque style in the spaciousness of their composition, in which simple yet dynamically articulated structures are united. (*76*) Garden front of CASTLE HOWARD. Sir John Vanbrugh (1664–1726) and Nicholas Hawksmoor (1661–1736). Begun in 1701. (*77*) Garden front of BLENHEIM PALACE. Sir John Vanbrugh for the Duke of Marlborough. 1705–20.

78, 79 FORMER TOWN HALL, AMSTERDAM. Built by Jacob van Campen (1595–1657) in 1648–65 as a monument to peace and to the townspeople, the Town Hall is today the Royal Palace. The plan is symmetrical and rectangular. At the center is the Burgerzaal, a vast hall that rises to the full height of the building (*78*). It stands between two courtyards, and can thus have windows along both walls. The two hemispheres depicted on the marble floor are reference to Amsterdam's mercantile power and territorial holdings overseas. Gerrit Berckheyde's painting (*79*) shows the severe, massive façade on the market place, crowned with a belfry.

80 RIDDARHUS ASSEMBLY HOUSE, STOCKHOLM. Simon and Jean de la Vallée. 1641–74. Façade by Jost Vingboons, 1653. The curving hipped roof covered with copper forms a perfect complement to the articulation of the façade, carried out in a mixture of brick and ashlar. The building is a prime example of the influence from France and Holland on Scandinavian architecture in the 17th century.

81 ROYAL PALACE, STOCKHOLM. Nikodemus Tessin the Younger (1654–1728). 1701–64. The design, a massive square center with two lower flanking wings, is a free adaptation of Bernini's proposals for the Louvre.

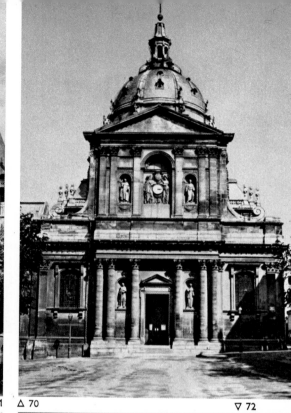

△ 69 ▽ 71 △ 70 ▽ 72

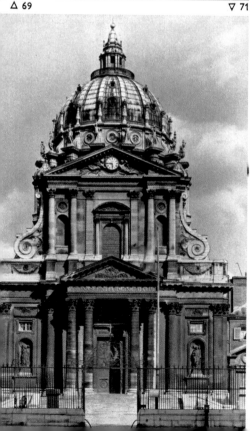

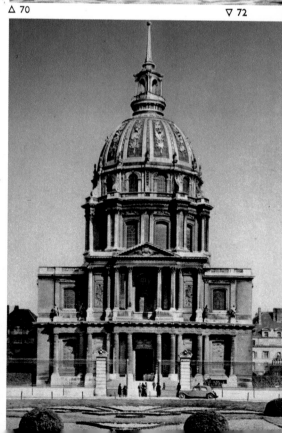

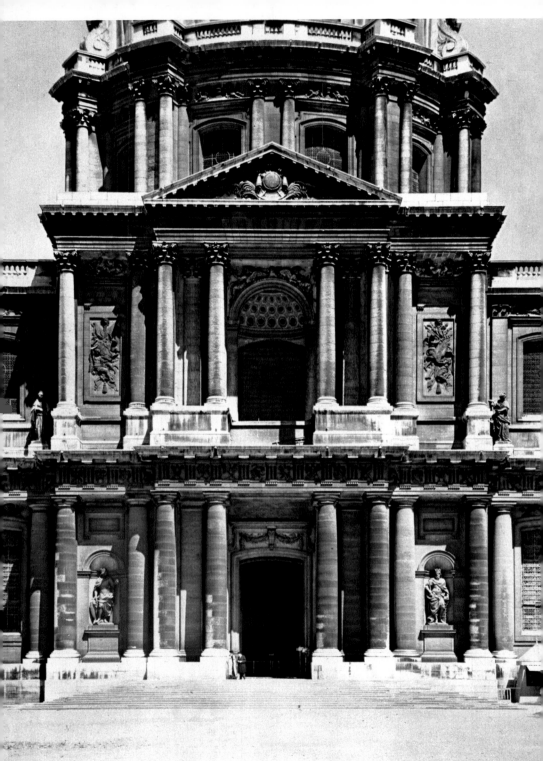

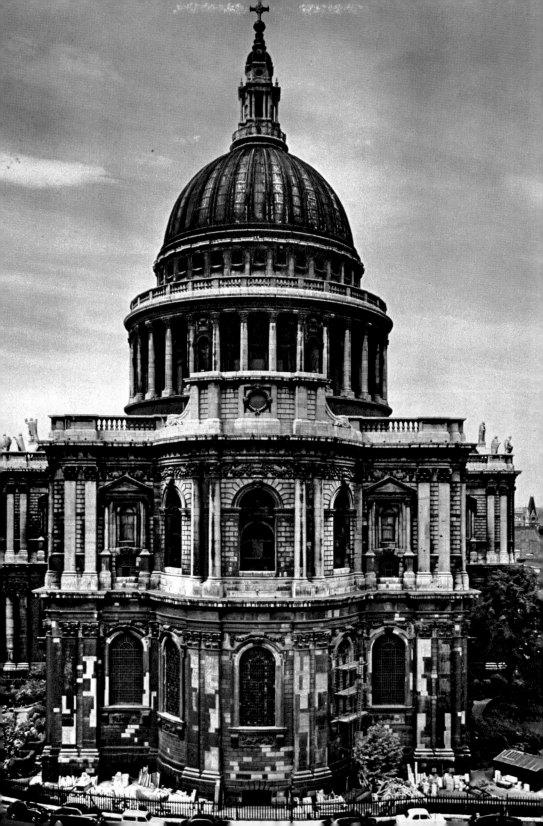

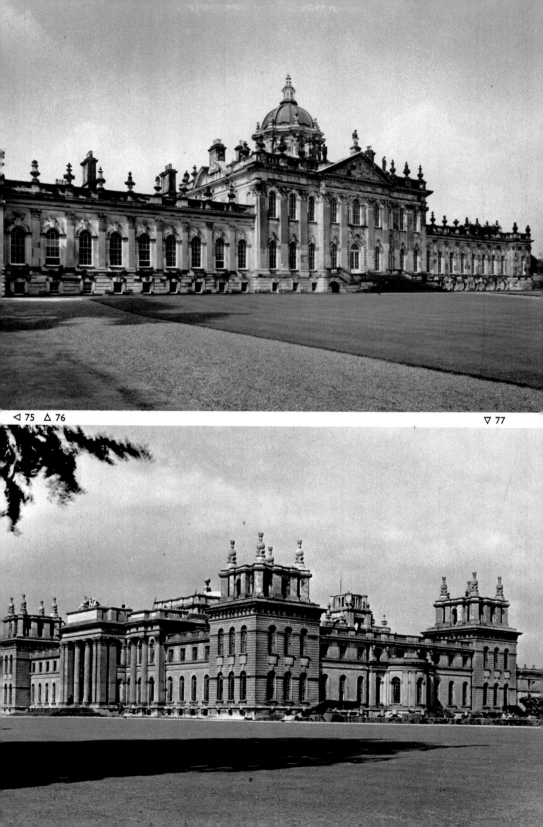

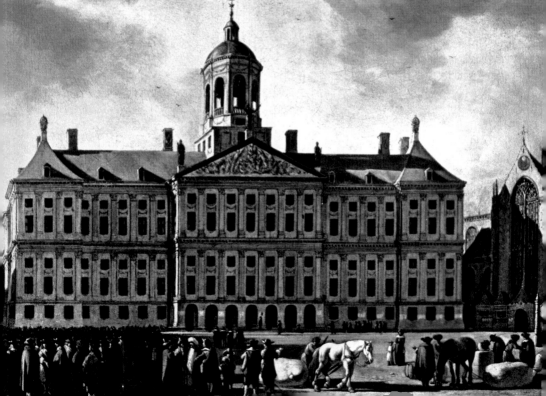

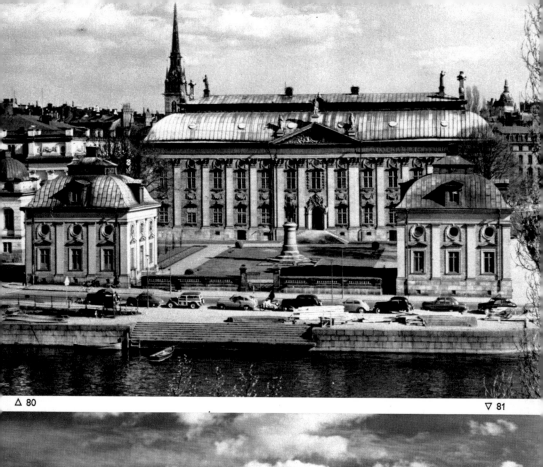

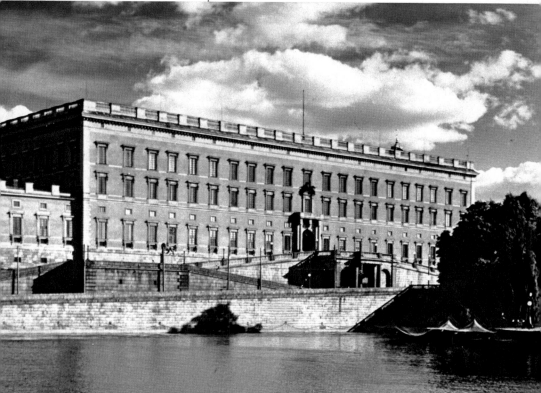

SCULPTURE

In 1625 Gianlorenzo Bernini completed the life-size marble group entitled *Apollo and Daphne* (*82*) for Cardinal Scipione Borghese. Ovid's story in the *Metamorphoses* tells how the nymph Daphne escaped from Apollo's unwelcome advances when, in answer to her entreaties, Diana transformed her into a laurel tree. Bernini chose to portray the moment when the nymph is still being nimbly pursued by the god, but he also indicates the outcome, when the prize that is all but grasped is transformed into something forever unattainable. Bernini succeeded in portraying an instant in the development of a narrative. *Apollo and Daphne* represents the turning point toward a mature Baroque style, in which the subject directly determines the character of the work.

Implicit in this is the reaction to Mannerism. In Giovanni da Bologna's *Rape of the Sabine* of 1583, for example, the spiral movement of the three bodies, skillfully arranged one above the other in stony solidity, is the dominant element, while the subject itself is irrelevant. Bernini, on the other hand, takes the subject seriously and is able to evoke it in a realistic fashion. Giving free rein to his imagination, Bernini selected his material from the minor arts and to theater and festival decorations, where it had long been customary to do what he now elevated to the higher plane of a stylistic principle—the synthesization of relief and statue, of naturalistic and ideal elements. The outline of Daphne's figure, for example, is on one side defined by curves like a statue, while on the other side it appears relieflike. Naturalistic details abound on the plinth, which is represented as earth, with plants sprouting from it and Daphne's toes already rooted in it. The two figures themselves are, however, deliberately idealized: Apollo is a free version of the antique *Apollo Belvedere*. The figure of Daphne is definitely a "painterly" one, especially since the body's surface, smooth with gleaming highlights, is treated as if it were being seen from a distance. Yet from any viewpoint, the main compositional lines dominate the detail. This in fact is what matters: there is unity in all the variety, a swaying and a soaring in the whole that befits the subject and that extends beyond the figures, though it is entirely generated by them. This new element, which no earlier relief, no matter how painterly, and no figure by Michelangelo had possessed, is what gives Bernini's group its poetic charm. It has a beauty that henceforth was to be a part of every good Baroque sculpture: no longer a frozen image, it has a life that is apparent even to those who are unmoved by the subject.

This quality, for which the term decorative is only a poor description, also explains the easy integration of Baroque sculpture with architecture and painting (*88*). Light obviously plays a major role in this success, but it would be a mistake to think that its effects were used mechanically. For, in addition to the highlights and shadows

82 GIANLORENZO BERNINI, APOLLO AND DAPHNE. 1622–25. Marble. Height 243 cm. Villa Borghese, Rome.

created by concave and convex modeled surfaces, new shimmering effects were produced by polishing and roughening different areas of a work, so that light appears to materialize out of nothing. Coloristic effects are obtained, not by painting, but by an entirely sculptured method of drilling, polishing, and smooth modeling. This is what Bernini meant when, in 1665, he said that a good portrait sculptor must translate into marble the appearance of color in a face, and not let the whiteness of the material destroy the impression of life (83, 85).

The marble statues executed by Bernini (after the *Apollo and Daphne*) consist mainly of figures of saints and angels. They are based on the Roman Catholic view of the human body as eternal evidence of the divine incarnation, a view of man in which the path of ascent toward the saints by means of analogy is always open. Bernini, whose deep religious faith is beyond question, translated this viewpoint into the Baroque idiom by using passion, and not merely transitory emotions, for his images of saints. He combined this universally comprehensible expressive element with a balance between ethos and pathos. This applies not only to his famous portrayal of the *Ecstasy of St. Teresa* in the Cornaro Chapel of S. Maria della Vittoria in Rome (1645–52), but also to his *St. Longinus* in St. Peter's, *Daniel* in the Chigi Chapel of S. Maria del Popolo, Rome, and *Blessed Ludovica Albertoni* (in which the saint is shown offering up her heart to God at the moment of death) in the Altieri Chapel of S. Francesco a Ripa, Rome. But in the angels for the Ponte S. Angelo (89, 90) Bernini produced the loftiest concept of holiness—a state of eternal joy and eternal passion, which makes the figures appear to be shining or burning and transforms the garments on the elongated limbs of these creatures into light or fire.

Bernini's overwhelming historical importance can be explained to a great extent by his roles as artistic superintendent to the popes and director of the vast workshop of sculptors, plaster-workers, and bronze-casters engaged on the decoration of St. Peter's from 1624 onward. As a result of this undertaking, Bernini became the teacher of generations of European artists. His absorption in the idea of the Roman Church was so profound that his sculptures have made the whole world come to consider St. Peter's the visible memorial to this idea.

On arriving at the Ponte S. Angelo, we are met by ten colossal statues of angels displaying the instruments of Christ's Passion (89, 90). This *via crucis* (way of the cross) leads us to the Piazza of St. Peter's. Here the ellipse of Bernini's colonnades (10, 11) is populated with saints, confessors, and martyrs—a spectacular representation of the Catholic universe, which opens out to the world and leads in to the church. In the Baldacchino beneath the dome, Bernini's pictorial idiom soars to triumphal heights. This canopied altar over the tomb of St. Peter is like an antique monument with four columns, topped by a cross above the orb, and surrounded by statues of Longinus, Veronica, Helena, and Andrew Martyr in niches in the crossing piers. These niches form gigantic reliquaries beneath Michelangelo's dome. However, the focal point toward which the eye is drawn is the *Cathedra Petri*, or Throne of St. Peter (88), which towers above the tombs of the popes. Thus it is the age-old,

dominant theme of the Roman Church that is embodied in Bernini's sculpture for St. Peter's—the transformation of earthly death into spiritual life in eternity, passion transfigured and turned into triumph. The form, however, is new, for the sculpture is a spectacle of present and future history, making things earthly appear to rise upward, and drawing the heavenly downward, not as the illustration of a transitory moment, but as the realization of what is true and what is to be. There is a connection with the "world-theater" of the Spanish playwright Calderón and with the pictorial world of Rubens. Bernini's work at St. Peter's is a high point of the Roman Baroque.

Directly or indirectly, the influence of Bernini affected all Roman sculptors, including the three major ones; Mocchi, Duquesnoy, and Algardi. Francesco Mocchi (1580–1654)

83-86 THE PORTRAIT BUST IN ROME AND THE NORTH. (83) GIANLORENZO BERNINI, FRANCESCO D'ESTE. 1650–53. Marble. Height 107 cm. Galleria Estense, Modena. (84) ALESSANDRO ALGARDI, CARDINAL LAUDIVIO ZACCHIA. 1626. Marble. Height 70 cm. Skulpturensammlung, Berlin-Dahlem. (85) GIANLORENZO BERNINI, COSTANZA BUONARELLI. c. 1635–38. Marble. Height 70 cm. Museo Nazionale, Florence. (86) ROMBOUT VERHULST, MARIA VAN REYGERSBERGH. c. 1665–68. Terracotta. Height 45 cm. Rijksmuseum, Amsterdam. Verhulst (1624–96), probably the best of the very few Baroque sculptors Holland produced, was influenced by the lively, mobile style of portraiture which originated with Bernini.

87 GIANLORENZO BERNINI, IL MORO (THE MOOR). Colossal figure in the center of the southern fountain in the Piazza Navona, in Rome, executed by Giovan Antonio Mari in 1653–55. Marble. The figure, a nature spirit rather than a god, is portrayed standing on a shell and holding a dolphin, and looking up toward the Palazzo Pamphili. Another fountain by Bernini already stood in the Piazza Navona: the Fountain of the Four Rivers, of 1648–52.

88 GIANLORENZO BERNINI, THRONE OF ST. PETER. 1656–66. Marble, gilt bronze, and stucco. St. Peter's, Rome. Flanked by the tombs of Pope Paul III (left, by Guglielmo della Porta) and Pope Urban VIII (by Bernini, 1628–47), this colossal work, the greatest *theatrum sanctum* or "sacred theater," of the Baroque, proclaims the unity, justice, and permanence of the Catholic Church. The reliquary holding

St. Peter's apostolic throne hovers at the center, indicated by the pointing hands of the statues of the four Greek and Latin Church Fathers; above it are angels and clouds; and at the center of the Glory, illuminated by a window behind, the Holy Ghost appears in the form of a dove.

89-96 DEVELOPMENT OF BAROQUE STATUARY, 1625–1725. (89, 90) GIANLORENZO BERNINI, ANGEL WITH THE SUPERSCRIPTION. 1668–69, Marble. Over life-size. Carved for the Ponte S. Angelo, Vatican City. S. Andrea delle Fratte, Rome. An outstanding example of Bernini's figural inventiveness: as well as the frontal view (90), it offers a variety of interesting views in profile (89) to add further meaning to the subject without diminishing its unity. (91) FRANÇOIS DUQUESNOY, ST. SUSANNA. 1629–33. Marble. Life-size. S. Maria di Loreto, Rome. This is an original portrayal of a saint, not influenced by Bernini but containing certain echoes of Raphael: the expression is softer, it is less clear sculpturally, and the handling of the garment is not as successful as in Bernini's work. Duquesnoy's saint is more closely related to antique prototypes such as the statue of the Muse Urania on the Capitol. (92) CIRCLE OF ARTUS QUELLIN THE ELDER, ST. PETER PENITENT. c. 1650. Terracotta. Height 45 cm. Formerly in the Kaiser-Friedrich Museum, Berlin. An interesting example of Baroque sculpture in the Netherlands directly influenced by Rubens, although the profusion of naturalistic details (garment, hair, base of the Cross, cockerel) is unusual, as is the coarser,

more full-blooded physical type of St. Peter himself. (*93*) PIERRE PUGET, ST. ALEXANDER SAULI. Carved in 1663–68 as part of the Baroque decoration of the crossing in S. Maria di Carignano, Genoa. Marble. Life-size. Impressive example of the transition to Late Baroque. Heightened pathos is produced by a more sharply geometric composition and more dramatic chiaroscuro effects. There is also an emphasis on genrelike incidental details. This is all the more remarkable since Puget had come straight from Bernini when he designed his scheme for S. Maria in Genoa. Of the scheme, only this figure and that of St. Sebastian were executed, not the baldacchino under the dome. (*94*) PEDRO DE MENA, ST. MARY MAGDALENE (meditating on the Passion of Christ). 1664. Cedar wood, partly polychromed. Height 158 cm. Museo Nacional de Escultura, Valladolid. This attractive statue by De Mena (1628–88) is an outstanding illustration of the ability of Spanish Baroque sculptors to use extremely naturalistic details (a characteristic of Spanish art of every period) and subordinate them entirely to the religious content. (*95*) JÖRG PETEL, TRIUMPH OF VENUS. After Rubens. c. 1630/31. Cylindrical ivory salt-cellar. Height 32 cm. Royal Palace, Stockholm. Petel's ivory carving is a most satisfactory translation into sculpture of Ruben's pictorial language. The figures are livelier, and there is greater visual clarity and calm in this compact composition than in many large-scale Baroque sculptures. (*96*) BALTHASAR PERMOSER, APOTHEOSIS OF PRINCE EUGENE. Completed 1721. Marble. Height 230 cm. Austrian Baroque Museum, Belvedere Palace, Vienna. A work characteristic of Baroque in its union of history (the portrait), mythology, and allegory—a sculptural equivalent to the ceiling painting of the period. The armored general tramples on the figure of Envy, while the lion skin and club carried by a putto show him as a new Hercules (a play on one of the Habsburg emblems). Victory, displaying the sun and concealing the moon, honors Eugene of Savoy as a conqueror, and the figure of Fame behind his legs proclaims his glory on the trumpet. Such allegorical sculptures, popular also in the court art of Louis XIV, call for "decorative majesty," which is here delightfully enriched with theatrical gestures and motifs, and imaginatively achived.

97 ANDREAS SCHLÜTER, EQUESTRIAN STATUE OF THE GREAT ELECTOR. 1697–1703. Bronze. Over life-size. Originally placed on the Lange Brücke in front of the Royal Palace in Berlin, it stands today in front of Schloss Charlottenburg. The marble plinth and four bronze slaves, designed by Schlüter, were added in 1704–10. This is the best surviving public equestrian monument of the 17th century, more Baroque than the French statues of Louis XIV of 1683 and after, and unsurpassed in its balance of breeding and power, freedom and majesty.

98 COSMAS DAMIAN AND EGID QUIRIN ASAM, HIGH ALTAR OF WELTENBURG. 1721. Polychromed stucco. In the former abbey church. Famous example of a Bavarian *theatrum sacrum:* the effect is particularly successful because the figures of the mounted St. George, of St. Bernard and St. Maurus, and of the Trinity (above) are not set off merely against the dazzling light, but against the form, color, and scale of the architecture—the whole being clear and rich and visually balanced. Two influences lie behind the altars of the Asam brothers: an Alpine tradition of theatrical altars, which goes back to the Late Middle Ages and was given new life around 1600, and Bernini, in such works as the Cathedra Petri (*88*). At Weltenburg, however, the light, entering from unseen sources, reduces the figures to ethereal silhouettes—an effect quite alien to Bernini.

99 HENRI-FRANÇOIS VERBRUGGEN, PULPIT (from St-Michel, Louvain). 1699. Moved to Ste-Gudule, Brussels, in 1776. The stair, with its vegetation and animals, was added in 1780 in Baptist van der Haegen. At the foot of the pulpit is shown the expulsion from Paradise; on the canopy, the Virgin triumphing over death. Earliest and most important of the 18th-century "nature pulpits" in the Catholic Netherlands, where allegorical figures are replaced by biblical scenes and scenes from the lives of the saints, including many pastoral elements.

△ 83 ▽ 85 △ 84 ▽ 86

△ 89 ▽ 91 △ 90 ▽ 92

△ 93 ▽ 95 △ 94 ▽ 96

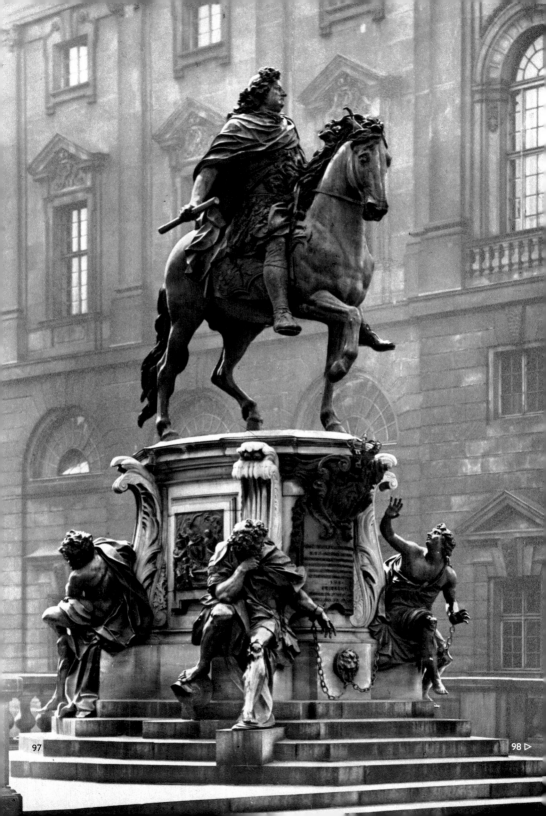

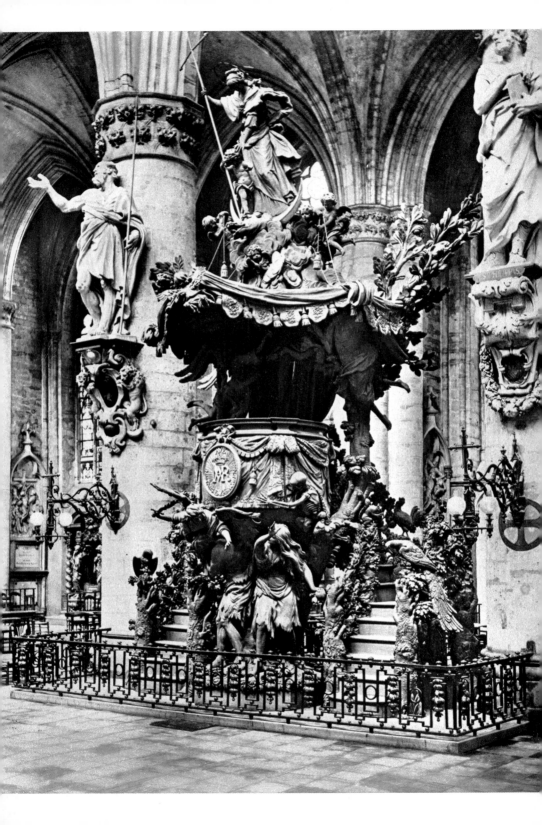

had already produced statues of immense vitality, such as the *Virgin of the Annunciation* for the cathedral at Orvieto, and the two equestrian statues of Ranuccio and Alessandro Farnese in Piacenza (painterly examples of this genre, exuding great vigor), before he began carving the giant *St. Veronica* in St. Peter's, under the direction of Bernini. Compared with Bernini's *St. Longinus,* the breathless excitement of Veronica lacks conviction, proving that it is not the degree of emotion and suggestion that is critical, but the moment selected for portrayal: in Mocchi's case the drama is dissipated by unimportant, though interesting, details.

François Duquesnoy (1594–1643) was far more successful in this respect, especially —as in his *St. Susanna (91)*—when he restricted himself to the expression of naturalism and sweetness in his statues, qualities influenced by his admiration for Raphael. Duquesnoy arrived in Rome in 1619. There, with Nicolas Poussin, he studied Titian's *Bacchanal,* which was at that time in the Villa Ludovisi. The results of his study were the putti and other small figures he produced in endless variations that delighted his Roman and North Italian patrons.

The works of the Bolognese Alessandro Algardi (1598–1654) are more severe, with the quality of Roman Republican art. Algardi is thought to have been influenced by Lodovico Carracci and the Venetians before arriving in Rome around 1625. There he enjoyed the patronage of Pope Innocent X and was given preference over Bernini; he never broke completely free of Bernini, however, least of all in his statues. In his reliefs—a form that never inspired Bernini—Algardi's achievement was considerable (*Attila Repulsed by Pope Leo the Great,* St. Peter's) and as a portrait artist he was frequently regarded as Bernini's equal: when one considers such busts as those in Berlin (*Cardinal Zacchia, 84*) and Rome (Frangipane busts in S. Marcello, monument of Prospero Santacroce in S. Maria della Scala), it is easy to understand why.

In contrast to Mocchi, Duquesnoy, and Algardi, the importance of Ercole Ferrata (1610–86) lies in the influence of his large studio, which was close to Bernini's and leaned heavily on the figural and compositional principles of Pietro da Cortona. This emerges quite clearly in the sculptures in S. Agnese in Agone in Piazza Navona. Ferrata was an able teacher, and his pupils included Melchiore Caffà (1635–68), who did the *St. Catherine* relief in S. Caterina da Siena, and Camillo Rusconi (1658–1728), the most important sculptor in Rome at the beginning of the Late Baroque period (*Apostle* in S. Giovanni in Laterano).

While Ercole Ferrata's pupils have distinct identities, anything that issued from Bernini's large studio was so plainly stamped with his style that the individuality of his assistants takes second place. How many people know, for instance, that on the Fountain of the Four Rivers in Piazza Navona the figure of the Rio della Plata was carved by Francesco Baratta (c. 1590–1666), that of the Ganges by Claude Poussin (d. 1661), the Nile by Jacopo Antonio Fancelli (1619–71), and the Danube by Antonio Raggi (1624–86)—who also worked on the stucco decoration of the nave of Il Gesù (*120*)—or that Giovan Antonio Mari later contributed yet another statue to this popular square, the gigantic figure of *Il Moro (87)*? Far more important for the history of

sculpture than Bernini's full-time assistants were the visitors and students from other regions who were deeply influenced by his creations without actually working for him as specialists. Giovanni Battista Foggini (1652–1723; in Rome before 1676), Filippo Parodi (1630–1702; in Rome before 1661), and Pierre Puget (1620–97; *St. Alexander Sauli* in Genoa, *93*) introduced the style of Bernini to Florence and points north. They are also responsible for transforming the Roman High Baroque into the unique artistic phenomenon that was the Late Baroque.

North of the Alps, Italian Baroque sculpture had no consistent influence, even in Catholic regions, because of the disruptions caused by the Thirty Years' War (1618–48). Isolated works created at that time were the Baroque interior of Bamberg

100–3 DECORATIVE SCULPTURE, 1690–1750. (*100*) KEYSTONE ON THE ARSENAL, BERLIN. Carved in 1695 to a design by Andreas Schlüter, on the ground-floor blind arcade. Sandstone. (*101*) FRENCH STATE COACH (detail). c.1740. From the Paris workshop of Milon. Carved and gilded wood. Marstallmuseum, Schloss Nymphenburg, Munich. (*102*) EGID QUIRIN ASAM, CAPITAL, ST. EMMERAM, REGENSBURG. c.1732. The capital, of stucco, painted and partly gilded, is in the nave of the church. (*103*) JOSEF ANTON FEUCHTMAYER, "HONEY-LICKER." 1749. Detail of a side altar in the pilgrimage church at Birnau. Polychromed stucco. Feuchtmayer (1696–1770), member of a Wessobrun family, was a sculptor of notable talent. His famous *Honey-Licker* is tasting the liquid that symbolizes the sweetness of the words of St. Bernard, in whose chapel he stands.

104 IGNAZ GÜNTHER, TOBIAS AND THE ANGEL. 1763. Polychromed wood. Height 177 cm. Bürgersaal, Munich. A good example of the persistence of Baroque composition in the Rococo period and, at the same time, evidence of the independent development of the art of wood-carving in the Alpine regions. Striking is the deliberate contrast between the elegant, courtly bearing of the archangel and the simplicity of the peasant child. Ornamental beauty plays a major part in the total effect.

105 JOSEF ANTON FEUCHTMAYER, THE VIRGIN. c.1750. Polychromed limewood. Height 162cm. Skulpturensammlung, Berlin-Dahlem. The gesture of the left hand no doubt refers to the words of St. Luke, "Blessed is the body that bore thee, and the paps which thou hast sucked" (11:27). The figure may have been part of a group including St. Bernard, of a type known as *Lactantio S. Bernardi*. The facial type, posture, hairstyle, and dress reflect a courtly ideal. Mannerist elements in the composition appear frequently in South German sculpture of the 18th century.

106 FRANÇOIS GIRARDON, TOMB OF CARDINAL RICHELIEU. Completed 1694. Marble. Life-size. Chapel of the Sorbonne, Paris. Richelieu, who died in 1642, is portrayed as he wished at the moment of "offering up his heart" to God; he is supported by a figure of Piety, while Christian Doctrine turns away in grief. There is no explicit reference to his fame, but it is suggested by the setting, which is reminiscent of a *lever du roi*. Noble restraint and stoic Roman sentiment prevail in this group by Girardon (1628–1715), one of the principal sculptors of Versailles. The pomp, chivalrous decorum, and magnanimous withdrawal are characteristic features of that Late Baroque style under Louis XIV which is usually wrongly called "Classicism."

107 BALTHASAR MOLL, LEAD SARCOPHAGUS OF EMPEROR CHARLES VI. Completed in 1753. Crypt of the Capuchin church, Vienna. A putto displays a medallion with the portrait of the emperor, crowned by a star and snake, symbolizing eternity, while the personification of Austria turns aside in grief. Though this composition, which owes its pictorial ideas to Bernini, was designed by Nikolaus Moll and Josef Pichler as early as 1742, it is an example of Viennese Late Baroque lead sculpture.

△ 100

△ 101

▽ 102

▽ 103

104

105

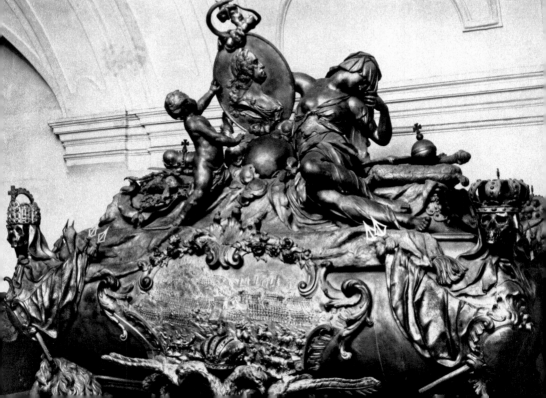

Cathedral (1650) and the fountain in the Residenzplatz at Salzburg (1656–62). The only form that swept rapidly across Europe was the Baroque bust in the Roman manner, which Bernini's own works introduced to London (*Charles I*, 1638) and Paris (*Cardinal Richelieu*, 1640). Its imitations varied considerably according to local conditions and particular traditions of portraiture (*86*). In addition, there was the medal, the cheapest form of sculptural glorification for the European aristocracy, which became current with the founding in 1668 of the Académie des Medailles in Paris and helped to make Baroque stylistic features and pictorial ideas more widely known. Sculptures in gold and ivory, which were mentioned far more often in contemporary writings than they are in modern histories of art, had a similar effect, and occasionally provide more conclusive evidence of a High Baroque form than life-size sculptures dating from the same period (*95*). However, until about 1690 Baroque sculptors per se were a rarity north of the Alps. Artus Quellin the Elder (1609–68) of Antwerp, who had the advantage of unusually favorable local conditions, was the only one to succeed in actually establishing a school (*92*). One major commission (combined with the stimulus provided by Rubens) was responsible for his success: these were the sculptures required to furnish the interior of the new Town Hall of Amsterdam (*78*). The works of the elder Quellin and of the solitary genius Jörg Petel (1601/2–34) from Weilheim (*95*) represent two currents that are discernible in Baroque sculpture throughout Europe.

Around the year 1690 two talented sculptors, Balthasar Permoser and Andreas Schlüter, appeared on the feudal scene in Germany, and amid this world of Late Baroque, already dominated by Parisian taste, established a renaissance of Baroque sculpture north of the Alps. Permoser (1651–1732) came from Salzburg, spent the years 1675–89 in Italy, and then from Vienna went to Dresden as court sculptor to Elector Augustus the Strong of Saxony. Of the two masters, he is the more comprehensive and dynamic. Progressing from ivory curios through secular and religious statues in marble and wood (*Church Fathers* at Bautzen, near Dresden, c. 1720) to the theatrically composed architectural sculptures of the Zwinger at Dresden (*42*), Permoser mastered the full Baroque range of figural composition. His work can be strong as well as soft, and he possessed a hearty sense of humor which breathed fresh life even into allegorical conceits (*96*). Permoser's dynamic, influential force can still be felt in the works of Ignaz Günther (1725–75), the leading figure of 18th-century sculpture in Bavaria, although Günther did not cut himself off from the courtly taste of the Rococo (*104*).

Andreas Schlüter (1664–1714), who worked in Poland until 1694, before his appointment as court sculptor and director of palace building in Berlin, was always profoundly serious and full of dramatic invention. His immensely sculptural imagination had been formed by his experience of Italy (chiefly Bernini and Michelangelo) and France, but his work nevertheless has a highly personal and individual quality. There is always something hard and angular about it, which can occasionally blend superbly with delicate surface ornament, as in the equestrian statue of the Great Elector in Berlin (*97*), the only outstanding work in that genre north of the Alps.

PAINTING

The art historical concept of European Baroque painting rests on the work of Peter Paul Rubens (1577–1640). One can argue at length whether Rembrandt or Poussin was a Baroque painter, but with Rubens there can be no doubt.

Born before 1600 into a wealthy Flemish family and given a careful education, Rubens studied and absorbed the Romanizing tendencies of the Antwerp Mannerists, in particular under Otto van Veen (1556–1629), a cultured and ambitious painter. His studies included the inevitable concentration on engravings of antique works of art, and also Dürer. Rubens spent the years from 1600 to 1608 in Italy, not only as a student of the great painters of the Cinquecento, of Michelangelo and the sculptures of antiquity (which he drew to make himself thoroughly familiar with them), but also as a protagonist in the battle against Mannerism. His contributions in Italy to the anti-Mannerist process of purification include the Gonzaga Altarpiece, three enormous paintings for the Jesuit church in Mantua (1605), the high altarpiece for S. Maria in Vallicella in Rome (1606–8), mythological paintings (*Hero and Leander,* Yale University; *Departure of Adonis,* Düsseldorf), and a series of portraits (some done in Genoa) which exerted a lasting influence on the portrait painting of that region.

On his return to Antwerp, Rubens set up a highly organized studio, where his pupils included Anthony van Dyck. It was here, from 1610 to 1620, that his style developed fully. The influence of Michelangelo and antiquity came to the fore, and Rubens evolved a synthesis of the two opposing forces in Roman Baroque painting —Annibale Carracci and Caravaggio. He liberated the figure from the restrictions of contour imposed by Mannerism, giving it full weight and presence and both an inner and outer mobility. The *Elevation of the Cross* and the *Descent from the Cross* (both in Antwerp Cathedral) overwhelmingly demonstrate his success. With them the great form of the Baroque altarpiece was born. Elaborate preparation (drawings and oil sketches) in Rubens's studio went into the production of such altarpieces as the *Last Judgment* for Neuburg on the Danube (now in Munich) and those for Genoa and for the Jesuit church in Antwerp (now in Vienna). Mythological subjects were also taken up (*148, 151, 152*): Rubens's first cycle (now in Vaduz), based on the story of Decius Mus, succeeded in portraying the many faces of a single incarnation—Rome. Rubens also collaborated with other artists in Antwerp—such as Jan Brueghel the Elder (1568–1625), with whom he produced the *Madonna with Flowers* (Munich)—and provided a fertile stimulus for Netherlandish painting of the time. The inventiveness of his figures was finally matched by his color (*Battle of the Amazons,* Munich), thus laying the foundations for his high Baroque phase of 1620–30.

Rubens now created a synthesis of narrative (mythology, history) and ideology (allegory), of which the most comprehensive example is the Medici cycle, consisting of twenty-one huge canvases (1622–25, Louvre; *149*). This work earned him a fame that has never been entirely eclipsed, and helped the Baroque style to gain European recognition. The output of Rubens's studio was prolific, despite his frequent absences

as a confidential peace negotiator in Spain, France, and England on behalf of Archduchess Isabella, regent of the Netherlands.

As Baroque painting spread, and as Rembrandt, in his series on the Passion of Christ (painted for the Prince of Orange), resolved his stylistic quarrel with Rubens, the latter turned to new territories and fresh subjects at this late stage in his life. The mature Rubens of the 1630s is a man absolute in his mastery of technique, perceptive in his judgment of men, full-blooded, inexhaustibly imaginative, and a true epic poet in his choice of subjects. The allegories of Peace (London: see back jacket illustration) and War (Florence) and the highly individual S. Ildefonso Altarpiece in Vienna (*150*), commissioned as a votive offering by Archduchess Isabella, all date from this late period. Throughout it, Rubens was conducting a dialogue with Titian in paint. He created landscapes combining "the Northern capacity for dreaming" (J. Burckhardt) with a thoroughly non-Northern feeling of freedom stemming from antiquity (*151, 152*). The limits imposed by the artist himself were effortlessly exceeded, and a style emerged which seems at the same time to anticipate and to transcend the best artistic endeavors of the century to come.

Rubens can in fact be taken as the paradigm of the Baroque painter. The *Rape of the Daughters of Leucippus,* completed in 1617, is typical (*148*). The painting shows the abduction by the Dioscuri, Castor and Pollux, of Phoebe and Hilaira, who had already been betrothed by their father, Leucippus. The ancients regarded this act as sacrilege: it cost the perpetrators their lives, though on account of other heroic deeds they were transformed into heavenly constellations. Wilhelm Heinse, who was well versed in the classics and was able to interpret them with sympathy and understanding, saw this subject as a "battle between morals and nature." Everything in the picture consists of pairs—the horses, the men, the *amorini,* the maidens, earth and sky. Yet the pairs fall into two different groups, beginning with the nude women who form the luminous center of the canvas. Both are, as it were, the same body, shown in two complementary views (one of Titian's *concetti*), for they are sisters. At the same time Rubens shows them separated from each other and united with the men, forming units of man and woman, lust still separating them but love already binding them. The expression on the face of the mounted Castor, as he bends down to gather up Phoebe, is quite unforgettable. It is a portrayal of the moment of transition from the "battle between morals and nature" to "connubial accord," in the phrase of H. G. Evers. In this interpretation the moment is indeed vital and permanent.

Rubens achieves the effect of the "permanent moment" by his arrangement of the figures, which form a configuration that is anchored at the lower edge of the picture, at the point where the feet of the maiden and the man touch significantly. Despite the violent internal and external motion, this configuration is absolutely calm, but it is in no way flat. It incorporates two paths of vision, one frontal, terminating with the silhouette of the dapple-gray horse, the other set obliquely to it, and ending with the figure of Castor. Both are ingredients of the pictorial narrative. This becomes even clearer on examining how the figural pattern is related to the coloring, which

ranges between the poles of blue and red. The subdued shades of brown and gray are employed to emphasize the color contrast between the reds and blues that occur, in many gradations, throughout the picture. There is no real yellow: instead there is a golden shimmer. The thematic arrangement of the color emerges very emphatically in two places: in the women's bodies, where the flesh tints contain all colors, though the lighter hues dominate; and at the upper left, where the red cloak abruptly meets the blue of the sky, without any transition. The configuration, the coloring,

108 CARAVAGGIO, BACCHUS. c.1595. Uffizi, Florence. Two features of this work—the elaborately groomed half-length figure which dominates the composition, and the still-life details —were taken up by other artists and became favorite components for biblical and mythological narrative pictures and allegorical genre paintings, chiefly in the Netherlands, but also in Germany and France (160). It is not a coincidence that the convention of half-length figures evolved out of the world of portraiture.

109 CARAVAGGIO, ENTOMBMENT OF CHRIST. Painted in 1603 for the Oratorian church in Rome. What is striking about the works of Caravaggio's maturity, apart from the familiar dark background, is the variety of simple human types and their artistic grouping, as well as the beauty of the color, which heightens their power. The use of religious symbolism in Caravaggio's altarpieces is all too easily overlooked. Here, the gesture of Christ's right hand suggests that the gravestone is also the stone of unction, an ancient symbol of the Mass, or Eucharistic communion of believers, given added meaning by the Passion.

110 GUIDO RENI, ASSUMPTION OF THE VIRGIN. Completed in 1617 after the famous Bolognese painter's third visit to Rome. S. Ambrogio, Genoa. Reni's work, in contrast to the agitated turmoil of Annibale Carracci's compositions, is characterized by a gentle, upward floating movement.

111 DOMENICHINO, THE HUNT OF DIANA. Completed in 1617. Villa Borghese, Rome.

112 GIOVANNI LANFRANCO, ROGER AND ANGELICA. c.1614. The subject is taken from Ariosto. Private collection, Rome.

113 ANNIBALE CARRACCI, THE TRIUMPH OF BACCHUS AND ARIADNE (detail: the retinue of Bacchus). Fresco on the central section of the vault of the gallery of the Palazzo Farnese, Rome, completed in 1604. The semicircular barrel vault of the gallery, some 20 m. long, is entirely covered with frescoes, consisting of large scenes set in gold frames, of herms painted gray to simulate carved stone, of medallions with scenes from Ovid's Metamorphoses, and of glimpses of blue sky. All these elements are of contrasting size, movement, and content, and are disposed in a rich, radiating, multiple wreath around the great central area, from which this detail is taken. Here the theme of the whole ceiling is resoundingly proclaimed: the marriage that brings gods and mortals together and exalts the power of love.

114 ANNIBALE CARRACCI, SEATED MAN WITH A CHILD. n.d. Drawing. Louvre, Paris. The developing freedom of movement and emotion in Carracci's portrayals of nude and clothed figures, for which many drawings in black chalk heightened with white survive, show him as a brilliant figure painter, comparable to Rubens.

115 BERNARDO STROZZI, ST. LAWRENCE DISTRIBUTING CHURCH SILVER TO THE POOR. 1636. S. Nicolò da Tolentino, Venice.

116 JOHANN LISS, THE ECSTASY OF ST. PAUL. A late, undated work. Gemäldegalerie, Staatliche Museen, Berlin-Dahlem. Born in Oldenburg (Holstein) in 1597, Liss lived in Venice from about 1621 onward. His work had a significant influence on 17th-century Venetian painting, though he himself died young, during an outbreak of plague in 1629/30.

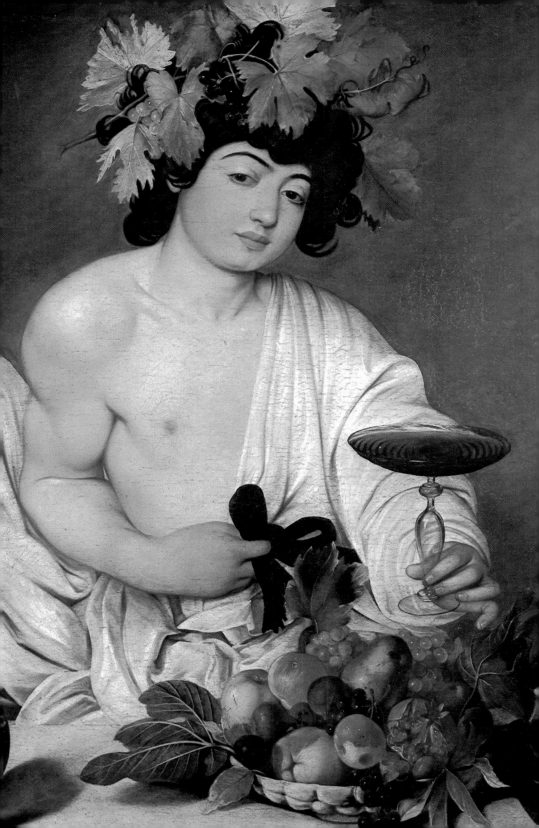

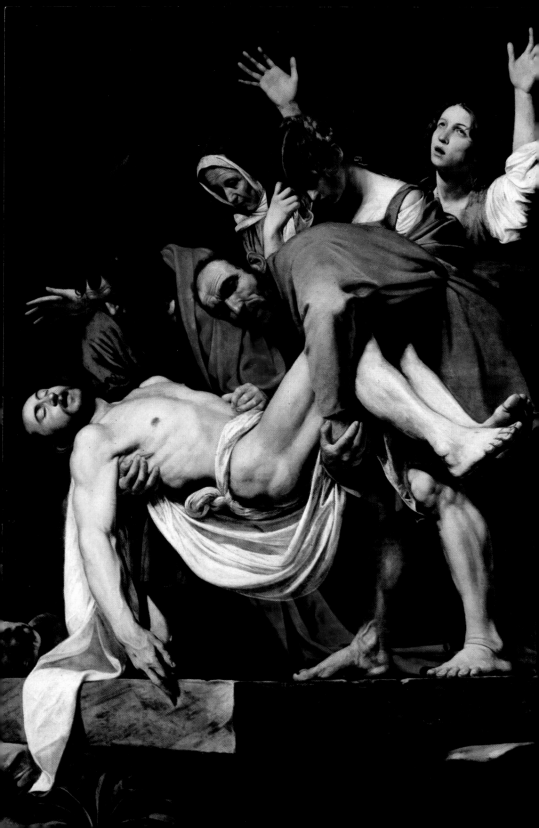

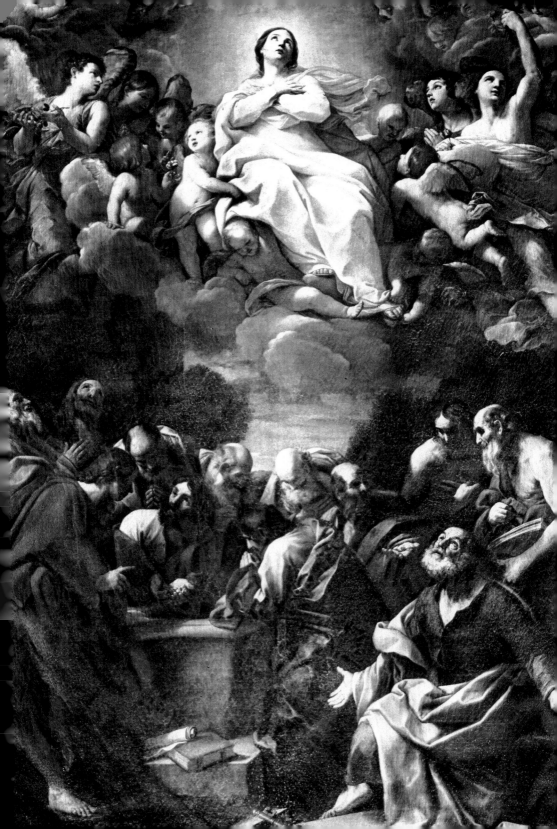

and the subject are fully thought out, and convey an impression of perfect intellectual symmetry.

As in the Cinquecento, Italian painting of the 17th century can be divided into schools, but with different dominants and aims. In place of Venice, Rome now took the lead: since 1600 the Baroque style had been evolving there, crystallizing in the work of the anti-Mannerists, who, though united in their goal, differed in their methods. It has been customary in art criticism from Bellori to Winckelmann to distinguish the "naturalists" from the "eclectics." The naturalists, who always remained in the minority in Rome, favored ordinary models and simple subjects, cultivating an *ars humilis* that corresponds to the spirit of S. Filippo Neri and his Oratorians. The others, the eclectics, adopted the great classical themes of antiquity and the High Renaissance, revived the nude as a symbol of divine freedom, and were consequently compelled to evolve a comprehensive method that was appropriate to the tradition and thus, necessarily, selective.

The leader of the naturalists was Michelangelo Merisi, known as Caravaggio (1573–1610) after his birthplace in North Italy. After an apprenticeship in Milan, he came to Rome around 1596, where he appeared distinctly unconventional and aggressive. He first aroused interest with his genre paintings (*Concert,* Metropolitan Museum, New York), still-lifes (Ambrosiana, Milan), and with the often shockingly suggestive form which he gave to his subjects (*Bacchus, 108; Amor Victorious,* Berlin). As even his contemporaries observed, Caravaggio went back to High Renaissance models (Giorgione, Leonardo), though he was not content with merely copying earlier works. By about 1600 his painting already reflected the monumental quality of Roman art. This appears in his altarpieces for the Contarelli Chapel in S. Luigi dei Francesi (*Calling of St. Matthew*) and the Cerasi Chapel in S. Maria del Popolo (*Conversion of St. Paul*). The figures appear in close-up, with the body given full weight; darkness, even gloom, pervades the picture, and out of it light evocatively picks out the forms, which have receded, utterly absorbed in their own action and emotion, and skillfully arranged in artistic groupings. The colors are few, but glowing and bright (*109*).

Caravaggio's influence was exceptional, even though he had no pupils and there are no known frescoes by his hand. For Northern painters, such as Gerard van Honthorst and Pieter Lastman, the directness and evocative quality of his use of light, his grouping of figures, and the emotionalism of his themes all echoed their own ideas: the latter quality appealed particularly to Rembrandt. Spanish painters, in whose homeland kindred tendencies had evolved quite spontaneously, reacted similarly. Jusepe de Ribera (1591–1652), who settled in Naples, evolved under the influence of Caravaggio a style to which the whole Neapolitan school down to Luca Giordano (1632–1705) and Francesco Solimena owes its naturalistic features. The influence of Caravaggio also affected Romans, Venetians, and Tuscans. Adam Elsheimer (1578–1610), who spent the last decade of his life in Rome, is an exception. He retained his own style uninfluenced by Caravaggio and the antique tradition (*Philemon and Baucis,* Dresden), and he deserves mention for those pictures, frequently miniature in

scale, in which he combined history with landscape to create works of intimacy and great poetic charm. His "night pieces" (*The Flight into Egypt, 128*) prove that the early Baroque use of light in Roman painting was not exclusively Caravaggio's.

Caravaggio's opponent, Annibale Carracci (1560–1609), the leader of the eclectics (who would be more aptly named "Renaissancists"), came from Bologna. There, he and his cousins Agostino (1557–1602) and Lodovico (1555–1619) formed a group calling itself the Academia degli Incamminati, which sought to initiate a reform of the art of painting. Annibale, who possessed a uniquely original talent, greatly admired the Venetians and Correggio. Affecting sentiment and melting colors—these were the values of the time. However, in Rome, to which Annibale had been summoned for the decoration of the Farnese Gallery, a shift from the lyrical to the highly dramatic was taking place. Energy was now as important as beauty, the decorative was accompanied by sweeping, expressive, and dynamic figural composition, and there were brilliance, flexibility, and emphasis in the coloring. It is as if Raphael were being transformed into a primordial force, and Michelangelo liberated from the oppressive grip of loneliness. This can be seen not only in the Farnese Gallery (*The Triumph of Bacchus and Ariadne, 113*), but also in Annibale's great altarpieces, arresting portraits, mythological scenes and drawings (*Seated Man with a Child, 114*), and in a special form of landscape painting, known as "heroic" because of the almost architectural clarity of the structure and the intensely emotional mood.

Annibale's heritage was divided in a number of ways. Domenico Zampieri, known as Domenichino (1581–1641), was a highly educated man of great sensibility, who developed even further the heroic landscape and historical work of his master in a thoroughly personal manner (*The Hunt of Diana, 111*). Nobility and energy emanate from his paintings and from his monumental frescoes; for example, in the choir of S. Andrea della Valle in Rome, he gave to the subject of the call of man by God —realized in so evocative a manner by Caravaggio—a clarity and inner form.

Giovanni Lanfranco (1582–1647) is an entirely different figure. A native of Parma, like Correggio, he entered the circle of the Carracci in Rome but remained only loosely associated with it, developing in a series of remarkable and highly personal works. His painting is characteristically sensuous and luminous (*Roger and Angelica, 112*), occasionally reminiscent of Rubens. By the second decade of the 17th century, he had refined it to the point where it was adequate to the monumental demands imposed by the painting of the dome of S. Andrea della Valle, begun in 1621.

117–20 BAROQUE CEILING PAINTING IN ROME. (*117*) PIETRO DA CORTONA, ALLEGORY OF DIVINE PROVIDENCE AND BARBERINI POWER. 1633–39. Fresco on the ceiling of the *salone* of the Palazzo Barberini. (*118*) PIETRO DA CORTONA, ERCOLE FERRATA, AND COSIMO FANCELLI, DECORATION OF S. MARIA IN VALLICELLA. Frescoes and stucco work in the dome (1647–57) and apse (1655–60). (*119*) ANDREA POZZO, TRIUMPH OF ST. IGNATIUS. 1694. Fresco on the nave vault of S. Ignazio. (*120*) GIOVANNI BATTISTA GAULLI (BACICCIA), ADORATION OF THE NAME OF JESUS. 1676–79. Fresco on the nave vault of Il Gesù. The white and gold stucco decoration is by Antonio Raggi and Leonardo Reti.

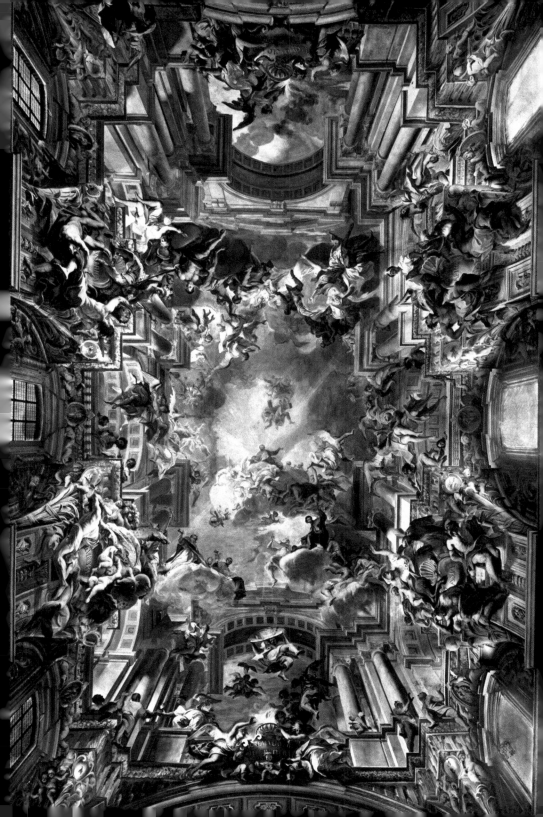

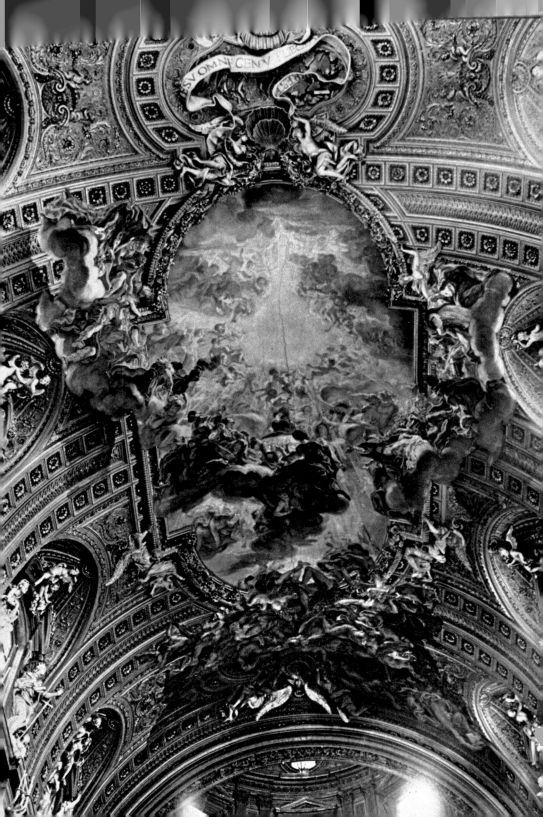

Decorative painting dominated the Roman High Baroque. Its leading exponent was Pietro Berettini, called Pietro da Cortona after his birthplace in Tuscany. A contemporary of Bernini and Borromini, he was an architect of major importance (*20, 21*) and his decorative talent made him a born fresco painter. His fresco (1633–39) on the ceiling of the *salone* of the Palazzo Barberini (*117*) was called by Max Dvořák the "foundation charter" of European High Baroque ceiling painting. It depicts the fame of the house of Barberini, in the form of a gift from Divine Providence, which appears as an allegorical female figure at the zenith of the rich configuration. The fresco is divided into four pictorial zones forming tranquil areas of form and color. The imaginative scheme was conceived by Francesco Bracciolini, official poet to the Barberini family. Every category of painting, from the loftiest to the most humble, is included: history, landscape, still-life, mythology, and allegory. In Pietro da Cortona's church interiors, there is the same generous decorative and figural harmony, to which the stucco-work also contributes. In 1647–65 Pietro painted the choir, dome, and nave vault of S. Maria in Vallicella (*118*). Here, as elsewhere, he concentrated on the linear element, retaining a distinctly classical discipline; it is the bodies that are dominant, and not the light. Only under the influence of Bernini did light become the dominant spiritual and formal element in Roman ceiling frescoes.

It is this use of light that has made the fresco on the nave vault of Il Gesù (*120*) —by Giovanni Battista Gaulli, known as Baciccia (1639–1709)—so famous. Baciccia came to Rome from Genoa around 1653, and was well equipped to paint the effects of light; but without the inspiring example of Bernini in such works as the *Cathedra Petri* (*88*), his Gesù fresco would not have turned out as it did. The impression one receives when looking up at the ceiling is not due merely to the individual details, but to the organization of the vault space as a whole. The painting itself is only part of that whole. The subject of the fresco on the ceiling, taken from St. Paul's Epistle to the Philippians, is the Adoration of the Name of Jesus. It called for the presence of representatives from all the continents of the earth: instead of being included in the painted area, these were modeled, in the form of white stucco figures, by the sculptors Antonio Raggi and Leonardo Reti (active 1670–1709), in the niches around the windows. It should also be noted that the light in the painting would appear quite different and less impressive without the counterpoint effect of the gilt on the vault decorations.

The Gesù fresco is the apogee of Roman High Baroque ceiling painting. The vast fresco on the nave vault of S. Ignazio (*119*), very similar in design to Baciccia's, represents a decline. It was painted by Andrea Pozzo (1642–1709), who entered the Jesuit Order and earned recognition through his theoretical work on the correct method of constructing *trompe-l'œil* architecture (*Perspectiva Pictorum*, 1685 ff.). Pozzo, however, imposed on the monumental fresco a corsetlike constraint, never approved of in Rome, by asserting that the pictorial architecture—admittedly regarded as a "continuation of the room"—should be designed to be seen by the beholder from one specific point only. The illusionistic ceiling found far greater favor with Austrian and German architectural patrons and painters than with the Romans.

After the death of Lodovico Carracci in 1619, Guido Reni (1575–1642) became the head of the Bolognese school. His style (*110*) magnetically attracted many pupils, but they frequently reduced it to a watered-down academicism. Reni himself, however, was an intellectual and artistic force of the first rank. His development bears some resemblance to that of Rubens. He studied first with a Netherlandish artist, Denys Calvaert (c. 1545–1619), and was later associated with the reform movement of the Carracci in Bologna. He did not fully come into his own in Rome until just after 1600 (*Massacre of the Innocents*, Vatican Gallery; *Samson*, Pinacoteca, Bologna; *Aurora*, Casino Rospigliosi, Rome). Reni took his stand outside both of the trends current in Roman painting at the time. He comes closest to the eternal idea of Italian art—pure beauty—in his Madonnas, and in those paintings that contain one or only a few figures. As a colorist Reni is remarkable, and was probably the first in Italy to make the transition from chiaroscuro to pure chromaticism.

The school of Venice would probably have declined into mere reproduction after the death of Tintoretto in 1596, had not the city's reputation as a mecca for painting and its favorable living and working conditions continued to prove attractive. Between

121 DIEGO VELÁZQUEZ, THE TOPERS. c. 1628/29. Prado, Madrid. The early *bodegones,* or kitchen-scenes, painted by Velázquez in the 1620s, invite comparison with the work of Caravaggio. Unlike Caravaggio, however (*108*), Velázquez places his Bacchus among Spanish peasants, showing not only the voluptuous form of the god, but also the company that has gathered to join him and other gods in feasting, celebration, and dancing. *The Topers* recalls the work of Rubens, and also shows the influence of Dutch painting, by then well known in Spain. The composition, in which the full-length figures are, appropriately to the subject, kept close to the ground in crouching, kneeling, and reclining positions, would be unthinkable without the influence of Italy; and yet it suggests a highly independent and personal choice of models, including some from 16th-century North Italian painting. This Spanish attitude toward great foreign traditions produced spectacular achievements after 1630.

122 DIEGO VELÁZQUEZ, POPE INNOCENT X. 1650. Galleria Doria-Pamphili, Rome. Velázquez's portrait, inspired by Raphael's *Leo X,* is the finest of all papal portraits; and his painting of *Prince Balthasar Carlos on Horseback* in the Prado (c. 1635/36, front jacket illustration)

surpasses all earlier equestrian portraits using this pose, either painted or drawn (J. Callot), and might be seen as a gay, light, unsophisticated counterpart to Titian's *Charles V.*

123 DIEGO VELÁZQUEZ, LAS MENINAS (THE MAIDS OF HONOR). 1656. Prado, Madrid. Detail showing the Infanta Margarita, a court lady, and the artist, Velázquez. The king and queen, parents of the infanta, appear reflected in the mirror. In *Las Meninas,* Velázquez gave an entirely new formal and intellectual dimension to the group portrait, which here comes closer to Venetian works in this genre than to Dutch ones. Even in the masterpieces of Frans Hals (*136*) and Rembrandt (*134*) there is not the striking, aristocratic, and significant isolation of the individual human being which Velázquez conveys; and the Northern works also lack the sense of relationships between the people in a painting which Velázquez suggests, by means of a look or a gesture, or even by quite impersonal details. Velázquez transcended the conventional class barriers, and was probably the first painter to have portrayed the connection between man, freedom, and loneliness.

124 FRANCISCO DE ZURBARÁN, ADORATION OF THE MAGI. 1638. Musée des Beaux Arts, Grenoble.

121

1620 and 1650 several important artists went there to work: Domenico Fetti (1588–1623), who arrived from Mantua in 1621, was an eccentric with an original talent, and produced imaginative paintings of parables; Johann Liss (c. 1597–1629/30), born in Holstein, arrived in Venice in the same year as Fetti. After a short spell in Rome, he returned to Venice for the remainder of his short life. Liss was an artist of genius, and his mature works—altarpieces (*The Ecstasy of St. Paul, 116*), mythological, historical, and genre scenes—seem like a foretaste of the 18th century. His are the first and only Baroque works in which the figures risk being submerged by masses of glowing color and light. In the field of 17th-century Italian painting, it is Liss who carries the painterly qualities to their extreme.

Bernardo Strozzi (1581–1644) occupies an entirely different position from Liss. His color sense must have been influenced by the pictures by Rubens that were to be seen in his home town, Genoa (*The Circumcision of Christ* and the late *Miracle of St. Ignatius*, both in S. Ambrogio), and their effect may have been reinforced when Anthony van Dyck came to stay in Genoa. Strozzi was a Capuchin monk, and was bound to have been familiar with the new Counter-Reformatory style of devotion. This could explain his preference for such "humble" subjects of nature as still-lifes. In 1630 he went to Venice, and there he painted the altarpiece of *St. Lawrence Distributing Church Silver to the Poor (115)*. Its composition is an effortless combination of Veronese with a powerfully naturalistic handling of figures and color—something quite rare in Italy.

Spanish Baroque painting is the product of curious and very special conditions. It consists mainly of portraits, biblical scenes, and devotional paintings. Antiquity plays no part whatsoever in the choice of subject matter. Particularly noteworthy are the *bodegones*, or kitchen scenes, in which are early examples of still-life which were developed with enormous power in their own right by such artists as Juan Sanchez Cotán (1561–1627; *126*). To consider these subjects, ennobled by Velázquez, Cotán, and Zurbarán (in some respects Murillo's famous *Beggar Boys Throwing Dice, 125,* can also be included among them), as mere genre painting would be quite mistaken: they are religious allegories, pointing out the ephemeral nature of all earthly things, and expressing the pious conviction that in all earthly creatures there is a divine origin—the humility that recognizes a brother in the lowliest of beings.

Second to the Church in its role as patron and spiritual guide was the royal court in Madrid. Its greatest influence was on portrait painting, which had already emerged in 16th-century Spain with the Spanish works of Titian, as a preferable alternative to statues and portrait busts. The range of the court's requirements was extensive (*122, 123*), for in addition to busts, full figures, pairs, and groups on a small or large scale, there was also a demand for equestrian portraits (see front jacket illustration) and battle scenes. In the 16th century, the court purchased whatever art it required in the way of mythology outside Spain—from Italy, and also from Antwerp, once Rubens had become available (paintings for the royal hunting lodge, the Torre de la Parada, near Madrid).

It has been rightly pointed out that in the 17th century Spanish painters were still struggling for the social recognition that had long since been a matter of course in Italy and the Netherlands. Consequently, even the leading masters were used to seeing themselves regarded as mere craftsmen. The country produced no indigenous theory of art. The treatise on painting (1649) is of little significance as a system of teaching, even though the information about art and artists that is interspersed throughout it by Velázquez's father-in-law, Francisco Pacheco, is valuable.

125 BARTOLOMÉ ESTEBAN MURILLO, BEGGAR BOYS THROWING DICE. 1675. Alte Pinakothek, Munich.

126, 127 STILL-LIFE. (*126*) JUAN SÁNCHEZ COTÁN, STILL-LIFE OF FRUIT. c. 1602. Fine Arts Gallery, San Diego, California. (*127*) SEBASTIAN STOSSKOPF, STILL-LIFE WITH SKULL ("VANITAS" STILL-LIFE). 1641. Musée des Beaux-Arts, Strasbourg.

The still-life, which only emerged as a legitimate subject for painting in the 17th century, could contain a variety of objects, depending on the underlying purpose of the work. Early Spanish (*126*) and German (*127*) examples—among which one must include the paintings, mostly small in format, of the German artist Georg Flegel—frequently combine the portrayal of fruit, flowers, bread, and wine with motifs alluding to religion or morality (note the skull in the still-life by Stosskopf [1597 to 1657]).

In Holland this allegorical intention, a legacy of the late Middle Ages, soon became obscured by the splendor and richness of the physical objects themselves, so that sheer pride of possession and love of life radiate from the paintings, which are by now also larger in format. The objects are arranged in such a way that their color provides a dazzling, often elaborate, and elegant feast for the eyes (*147*). Accuracy was, however, always a requisite. Special literature on plants and fruits accompanied this type of painting (for example, the meticulous botanical pictures by Maria Sibylla Merian), just as animal paintings were followed by explanatory texts.

128 ADAM ELSHEIMER, THE FLIGHT INTO EGYPT. 1609. Alte Pinakothek, Munich.

129 REMBRANDT, STORMY LANDSCAPE. c. 1638. Herzog Anton-Ulrich Museum, Braunschweig.

130–32 REMBRANDT: GRAPHIC WORKS. (*130*) THE HUNDRED GUILDER PRINT (Christ, healing the sick and denouncing the Pharisees). Etching, repeatedly modified between 1640 and 1649. Rijksmuseum, Amsterdam. (*131*) SELF-PORTRAIT. c. 1627/28. Pen and brush drawing. British Museum, London. (*132*) SELF-PORTRAIT, DRAWING AT A WINDOW. 1648. Etching. Rijksmuseum, Amsterdam.

Between 1628 and 1661 Rembrandt produced, in addition to some 1,500 drawings which have survived, about 300 etchings on a wide range of subjects; from the point of view of content, therefore, his graphic work should be studied in conjunction with his painting (also the case with Dürer). As he frequently returned to the same plate after printing several impressions to alter its appearance, often making radical changes, his prints exist in various states. Some impressions were taken from his plates as late as the 18th century. He would occasionally work on one print for a long time, as on *The Hundred Guilder Print* illustrated here (*130*). In such cases it is possible to see where the design has been modified, and to appreciate the extraordinarily rich process of development. This particular etching (28.1 × 38.5 cm.) is a superb example of the monumentality of Rembrandt's compositions. In his drawn (*131*) and etched (*132*) self-portraits he produced complete works of art that rank with his paintings as portrayals of an entire psychological world.

△ 126

▽ 127

In the 17th century, the school of Seville was outstanding. It was here that the *bodegón* was invented. A port with world-wide connections, the city offered painters an outlook on the world. The two leading masters of the Seville school were Zurbarán and Murillo. Francisco de Zurbarán (1598–1664) belonged to the generation of High Baroque painters. After 1630, he worked in Seville, where in 1634 he produced a series of paintings on the legend of Hercules and several battle scenes for the court. In 1658, faced with mounting competition from Murillo, he moved to Madrid. Like all the great Baroque painters of Spain, his style is highly personal and varied. In his superb altarpiece on the *Adoration of the Magi (124)*, Zurbarán reveals his control of all elements into an artistically integrated composition. Its essential charm lies in the expressiveness of the different postures—figures are shown kneeling, standing, and turning. There is here a kind of mathematics and geometry such as Pascal might have envisioned—an embodiment of given, fixed proportions, which speak for themselves without any psychological allusions, and in a penetrating and spiritual way. The work possesses an original beauty, a purity found nowhere else in Spain.

Bartolomé Esteban Murillo (1617–82) represents the generation of Late Baroque in Spanish painting. By 1650, he had finally overtaken Zurbarán, and in 1660 he was elected first president of the newly founded Seville Academy. Implicit in his style are not only the Spanish masters of the Early and High Baroque, but also Rubens and Guido Reni. The density of composition and color that was so important to Zurbarán is perceptibly loosened in Murillo's work. He is responsible for the archetypal image of the Virgin Immaculate, whose merits were as much exaggerated until the late 19th century as they have been underestimated since. In addition, the quality of his numerous altar paintings, portraits, and genre pictures is variable. Yet the assessment of Murillo's achievement should not be a matter of taste: what he sought to do was to create an ideal image, much as Palladio (with success) sought to embody an architectural principle in his Villa Rotonda. Murillo's *Immaculate Conception* is thus a pictorial type having the same validity as Reni's version in Munich. Yet employing these criteria to compare him with Reni plainly reveals the Spaniard as less powerful, less mature. This explains why, since the 18th century, his famous *Beggar Boys Throwing Dice (125)* has on the whole been admired more than his religious pictures: these street urchins already constitute a kind of genre painting.

Diego Rodríguez de Silva y Velázquez (1599–1660) made his reputation at court as a portrait painter, and that is what—in the eyes of his royal patron, Philip IV—he always remained from 1623, the date of his appointment, until his death. Anyone who has seen Velázquez's *Pope Innocent X* in the Galleria Doria-Pamphili in Rome *(122)* can judge for himself how he revolutionized the entire concept of portraiture. Velázquez transformed the portrait into a work of creative imagination (to a far greater extent than did, for example, Van Dyck), at the same time remaining within the framework of the conventional form. And how else should one interpret the group portrait called *Las Meninas* or *The Maids of Honor (123)*? Even with a painter such as Velázquez such a work implies more than its explicit intention. The scene is the

artist's studio, with the master himself at the easel. The Infanta Margarita stands in the foreground, ladies-in-waiting attend her, while reflected in the mirror are the king and queen. Velázquez creates here a new and inexhaustible series of relationships, with his own self-portrait and the mirror image of the royal couple at their center. The clear-cut geometry of the rear wall and the striking isolation of the individual figures are appropriate to such expressive understatement. The handling of the paint

133 REMBRANDT, THE PRODIGAL SON. c. 1656. Hermitage, Leningrad.

134 REMBRANDT, THE NIGHT WATCH (detail). 1642. Rijksmuseum, Amsterdam.

135 GERARD TER BORCH, PORTRAIT OF A YOUNG MAN STANDING. c. 1645. National Gallery, London.

136 FRANS HALS, OFFICERS OF THE MILITIA COMPANY OF ST. HADRIAN (detail). 1633. Frans Hals Museum, Haarlem.

137 FRANS HALS, WILLEM CROES. Before 1658. Alte Pinakothek, Munich.

138 FRANS HALS, THE WOMAN REGENTS OF THE OLD MEN'S ALMSHOUSE IN HAARLEM (detail). Frans Hals Museum, Haarlem.

139-42 DUTCH LANDSCAPE PAINTING. (139) HERCULES SEGHERS, VIEW OF THE TOWN OF RHENEN. c. 1635. Gemäldegalerie, Staatliche Museen, Berlin-Dahlem. (140) JACOB VAN RUISDAEL, SAND DUNE LANDSCAPE. 1647. Alte Pinakothek, Munich. (141) JAN VERMEER VAN DELFT, VIEW OF DELFT. c. 1650. Mauritshuis, The Hague. (142) MEINDERT HOBBEMA, THE AVENUE, MIDDELHARNIS. 1689(?). National Gallery, London.

However much Dutch landscape paintings may profess to be undemanding, though brilliantly executed, portrayals of local scenes, they contain a very evident degree of stylization. This can best be seen in the early paintings of the first quarter of the 17th century, and in those of the second quarter which Jantzen (1912) termed "impressionistic," such as the landscapes of Adriaen Brouwer (1605/6 to 38; 153) and Hercules Seghers (c. 1590–before 1643; 139): "Since the eye can no longer distinguish any physical objects, it is directed to the delicate appeal of minute differences in tone. The heightening of a tone by a single degree is to be noted and enjoyed." This presupposes an emphasis on tone painting, i.e., a coloristic differentiation of light values, an approach that is basically "far-sighted," and also the suppression, to a great extent, of dramatic motifs. Seghers (who was also an inventive and brilliant printmaker) concentrated on the relationship between vertical and horizontal to such an extreme degree in his view of Rhenen (139) that it was later thought necessary to piece on extra canvas and extend the area of the sky.

Paintings dating from c. 1650 and later, described by Jantzen as "composed" landscapes, are different. Jacob van Ruisdael attached great importance to the darkening of the foreground and to emotive silhouettes, but the tension in his works arises out of their coloring, which hovers between yellowish and bluish tones, here producing an electrifying effect (140). In his view of Delft (141), Vermeer emphasized the horizontal grouping of the houses between sky and water to give a sense of unreality, and achieved a virtuoso display of changing color across the canvas. The famous avenue of poplars by Meindert Hobbema (1638–1709 [142]) defied the convention that depth should be suggested by means of a dark foreground and light background: the dangers inherent in the composition—in which a straight road runs directly away at the center of the picture—are overcome by his skillful use of harmonious color. The "unity" of these landscapes lies not merely in their illustrative qualities, but in that serene self-awareness which is bound up with the contemplation of such visual splendor.

143 JAN VERMEER VAN DELFT, ALLEGORY OF PAINTING. c. 1660. Kunsthistorisches Museum, Vienna.

△ 139

▽ 140

△ 141

▽ 142

itself, however, is of a splendor and richness that has aroused tremendous admiration from the time of the Impressionists to the present day.

An early painting that is full of vitality, *Los Borrachos* or *The Topers* (*121*), which must have been painted before July 1629, still shows uncertainty in the grouping of the figures and, despite the suggestion of "total" frontal presentation, very conventional motifs—for example, strongly emphasized foreground figures. It was not until he became familiar with Italian painting on his two visits in 1629–30 and again in 1649–51 that Velázquez, the greatest Spanish painter, discovering himself what all European painters saw in antique and modern art, was able to express his own ideas with perfect certainty.

In the 17th century Holland celebrated its liberation from Spanish domination with an unparalleled development in painting. The output was prolific and immensely varied, but amid the many outstanding painters, one towers above all—Rembrandt—whose origins were in Dutch painting, even though he ultimately parted company with it. During the first three decades of the century, the leading schools were those of Haarlem, Utrecht, and Amsterdam. By 1650 the second generation of painters had replaced the pioneers, and by about 1680 the influence of French taste was already discernible: the so-called Golden Age of Dutch painting was over. The entire process was the outcome of conditions and forces extending far beyond the history of art. As a cultural phenomenon, Dutch painting can be explained in terms of Dutch history, and has its parallels in the South Netherlands, from which Holland finally broke away. In art historical terms, however, there is no denying a decisive external influence exerted by the work of Caravaggio, which had been seen by those Dutch artists (referred to as Caravaggisti) who had been to Rome and who had come together in about 1620 to form the Utrecht school—Gerard van Honthorst (1590–1656), Hendrick Terbrugghen (1588–1629), and Dirck van Baburen (c. 1590–1624). Whereas the Flemish followers of Caravaggio, such as Abraham Janssens (1576–1632), Jan Janssens (1590–1650), and Theodor Rombouts (1579–1637), had met with little response in Antwerp, Dutch painters in general eagerly seized on their innovations and adopted them wholeheartedly. Pieter Lastman (1583–1633), Rembrandt's teacher, was the chief exponent of Caravaggism in the Netherlands.

A striking characteristic of Dutch 17th-century painting is the number of masters who specialized in one particular pictorial form or subject. This was doubtless connected with contemporary demand, conditioned by the intellectual outlook and expectations of the patrons. The practice—or malpractice—of specialization seems also to have been associated with a high degree of connoisseurship and its pleasures. One inevitable consequence of the narrowing of the artist's horizon was that his concentration was intensified and the quality of his execution enhanced; this in turn made possible more refined criticism, not only of what was painted but also of the techniques that were used. The three greatest painters in Holland, after Rembrandt, were all pure specialists: Frans Hals (1585/86–1666), who from the time he left Antwerp for Haarlem was

exclusively a painter of portraits (including half-length pictures in the manner of Caravaggio); Jan Vermeer van Delft (1632–75), a genre painter; and Jacob van Ruisdael (1628/29–82), who painted nothing but landscapes. There were, however, even more limited subjects for painting, such as marines (*The Cannon Shot, 144,* by Willem van de Velde the Younger, 1633–1707); flowers (Jan Davidsz. de Heem, 1606–84); still-lifes (*147,* by Willem Kalf, 1619–93); church interiors (Emanuel de Witte, 1617–92); animals, and so on.

With the most scrupulous exactitude, numerous artists applied themselves to portraying seemingly humdrum subjects, which are rendered effective through the delicacy of the painting, the technical accuracy, and the genuine sense of atmosphere: examples are *The Small Country House* (*145*) by Pieter de Hooch (1629–after 1684) and *Outside an Inn* (*146*) by Jan Steen (1626–79).

The one specialty that every Dutch painter was expected to practice was portraiture. What was wanted was an honest, technically sound, neat likeness, and what was actually produced was a surprisingly large number of masterpieces. The variety in both interpretation and style is enormous, ranging from the homely bourgeois portrait to such aristocratic images as the *Portrait of a Young Man Standing* (*135*) by Gerard Ter Borch (1617–81). The format, even for a full-length portrait, was usually small. The automatic assumption that the size of the portrait should correspond more or less to that of the subject—a factor that still governed Frans Hals's work—now no longer applied. The framed painting to be fixed to a wall became increasingly valued as an artistic object, and its size depended ultimately on the ceiling height of the intended interior.

Group portraits, however, which were usually displayed in public buildings, and which were also assessed publicly rather than privately, were expected to be "as large as possible." Hals used this form many times from 1616 onward for portraits of soldiers (*Officers of the Militia Company of St. Hadrian, 136*), and it affords us an opportunity to observe the extraordinary changes undergone by Holland's best portrait artist after Rembrandt. Bold as the presentation of these standing and seated soldiers may be, and clever as their arrangement (always a crucial problem in this type of picture) may appear by contrast with earlier solutions, it is by no means on the same level as Rembrandt's militia group portrait of 1642, known as *The Night Watch* (*134*). The same is true if we contrast Hals's characteristically "impressionist" portrait of Willem Croes (*137*), a painting that vibrates with life, with Rembrandt's calm and sober *Self-Portrait Drawing at a Window* of 1648 (*132*). Rembrandt's art of portraiture

144 WILLEM VAN DE VELDE, THE YOUNGER, THE CANNON SHOT. c. 1660. Rijksmuseum, Amsterdam.

145 PIETER DE HOOCH, THE SMALL COUNTRY HOUSE. 1655. Rijksmuseum, Amsterdam.

146 JAN STEEN, OUTSIDE AN INN. c. 1660. Gemäldegalerie, Staatliche Museen, Berlin-Dahlem.

147 WILLEM KALF, STILL-LIFE. c. 1688. Gemäldegalerie, Staatliche Museen, Berlin-Dahlem.

transcends the limits of Dutch painting: "Rembrandt," wrote Wilhelm von Bode, "is a Dutchman through and through, he could only have happened in Holland; and yet he is more, surpassing by far Dutch art and culture."

Rembrandt Harmensz. van Rijn (1606–69) started out from Dutch painting, gradually outdistanced it, and finally left it behind completely. These are the important stages in both the artistic and the intellectual development of this great master. He was not a genre painter, from the outset applying himself ambitiously to what was regarded in his time as the most difficult task—history painting. He sought out the "moderns," the Dutch followers of Caravaggio, and there can be no other possible explanation for his choice of teachers in the years 1622 to 1625: Pieter Lastman and (according to Houbraken) Jan Pynas (1583–1631), both Caravaggisti. Rembrandt, that inexhaustible inventor, was not concerned with creating new iconographical formulas. All the supposed evidence of this that may be found in his work can be traced back either to traditional forms or to pictures by Lastman, even down to the theatrical properties which he frequently used (clothing figures from biblical history as Orientals). Rembrandt had an intimate knowledge of the iconographical tradition; he observed the conventions of this kind of masquerade, and adopted and assimilated as much of it for himself as necessary. He was thus completely in accord with Lastman and his associates when in 1631 or 1632 he left Leiden for Amsterdam, where he married Saskia von Uylenburgh and set himself up in great style.

In the course of the ten years that followed, up to the time of *The Night Watch,* Rembrandt grew increasingly remote from his surroundings and origins. This process began under Rubens's influence, which is noticeable in Rembrandt's early paintings of the Passion done for Prince Frederick Henry of Orange (Alte Pinakothek, Munich) and in the Frankfurt *Blinding of Samson* of 1636. The *Stormy Landscape* of 1638 in Braunschweig (*129*) can no longer be compared with any previous Dutch landscape painting, except possibly with certain works by Rubens (*151, 152*). It establishes Rembrandt as an imaginative artist, no longer a "naturalist" or "realist." For him the world of reality, which his Dutch colleagues regarded with undisguised pride as their own personal preserve, was a source of ideas to be explored, not a set of properties which could be assembled in different variations.

The group portrait of a militia company that is known as *The Night Watch* (*134*) shows how far Rembrandt had moved away from convention. For it was precisely his originality—the fact that the picture bore the stamp of the artist's own creative imagination—that provoked the protests of the patron who had commissioned it. With this work, painted in the year of Saskia's death, Rembrandt parted company with Dutch painting. Those who remained within its confines, even those painters with a broad field of activity, very seldom succeeded in conveying anything more than technical virtuosity. (An exception was Jan Vermeer: see, for instance, his *Allegory of Painting* in Vienna, *143*.) Rembrandt's isolation from his artistic compatriots continued to prevail throughout his tragic late works, such as *The Prodigal Son* (*133*).

In the 19th century Rembrandt, the great philosopher and creator, was thought to

have produced only "wall decorations." It is essential to bear in mind the connection between his paintings and his drawings and etchings (*130–32*); for without it, his pictorial world is arbitrarily fragmented. Rembrandt's painted, drawn, and etched self-portraits form a unified series that transcends the artificial boundaries of medium; moreover, the range of his portraits of others represents far more than an essay in color or a mere illustration of pietism.

Compared with Dutch painting, which Alois Riegl saw as republican and individualistic, Baroque painting in Flanders was concentrated on one artistic center, Antwerp, where Rubens and his studio acted as a magnet. Rubens himself very sensibly saw to it that his artistic colleagues in Antwerp did not lack for work, and that even his collaborators, for example the still-life and animal painter Frans Snyders (1579–1657) and the landscape painter Jan Wildens (1586–1653), were able to maintain their own studios. He made sure that the engravers, whom he had assembled for the reproduction of his compositions, made a good living in the city where the great printing house of Plantin-Moretus was based, and he was also careful not to antagonize Jordaens or Van Dyck, the two Antwerp artists whose work was most frequently reproduced.

Jacob Jordaens (1593–1678), who maintained a large studio, designed tapestries and produced most of the historical and allegorical paintings that now adorn the Orange Room in the Huis ten Bosch at The Hague, and also executed many pictures from sketches by Rubens for Philip IV's hunting lodge, the Torre de la Parada. At the center of his pictorial imagery is the family: he celebrates the close union between the sexes and the generations, often through scenes of family meals and weddings. As a Baroque painter, Jordaens is what Rubens is usually (but wrongly) called—the

148 PETER PAUL RUBENS, RAPE OF THE DAUGHTERS OF LEUCIPPUS BY THE DIOSCURI, CASTOR AND POLLUX. Completed in 1617. Alte Pinakothek, Munich.

149 PETER PAUL RUBENS, MARIE DE' MEDICI LANDING AT MARSEILLES. c. 1622/23. Oil sketch for the eleventh painting of the Medici cycle in the Louvre, Paris. Alte Pinakothek, Munich.

150 PETER PAUL RUBENS, S. ILDEFONSO ALTARPIECE. 1631/32. Central panel. Kunsthistorisches Museum, Vienna. The scene represented is the vision of S. Ildefonso: the Virgin, surrounded by saints and cherubs, appears and presents a heavenly robe to the saint.

151 PETER PAUL RUBENS, LANDSCAPE WITH PHILEMON AND BAUCIS. Before 1630. Kunsthistorisches Museum, Vienna. In this scene taken from Ovid, Philemon and Baucis, small figures

on the right next to Jupiter and Mercury, watch aghast as a deluge is sent to punish the inhospitable Phrygians.

152 PETER PAUL RUBENS, LANDSCAPE WITH ODYSSEUS AND NAUSICAA. After 1630. Palazzo Pitti, Florence.

153 ADRIAEN BROUWER, THE SHEPHERD BY THE WAYSIDE. c. 1635. Gemäldegalerie, Staatliche Museen, Berlin-Dahlem.

154 ANTHONY VAN DYCK, ENGLISH LANDSCAPE. After 1632. Pen and watercolor. Devonshire Collection, Chatsworth.

155 ANTHONY VAN DYCK, CARDINAL BENTIVOGLIO. 1624. Palazzo Pitti, Florence.

156 ANTHONY VAN DYCK, CHARLES I. c. 1635. Louvre, Paris.

157 JACOB JORDAENS, THE WIFE OF KING CANDAULES. 1649. Nationalmuseum, Stockholm.

146

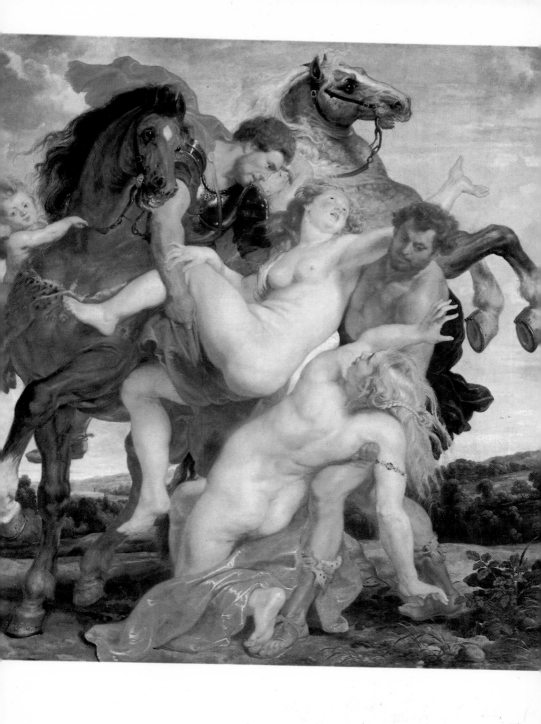

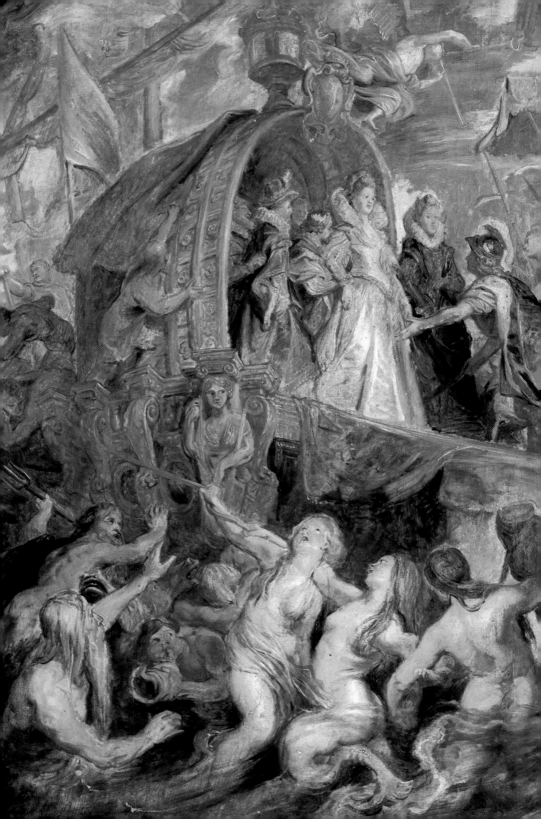

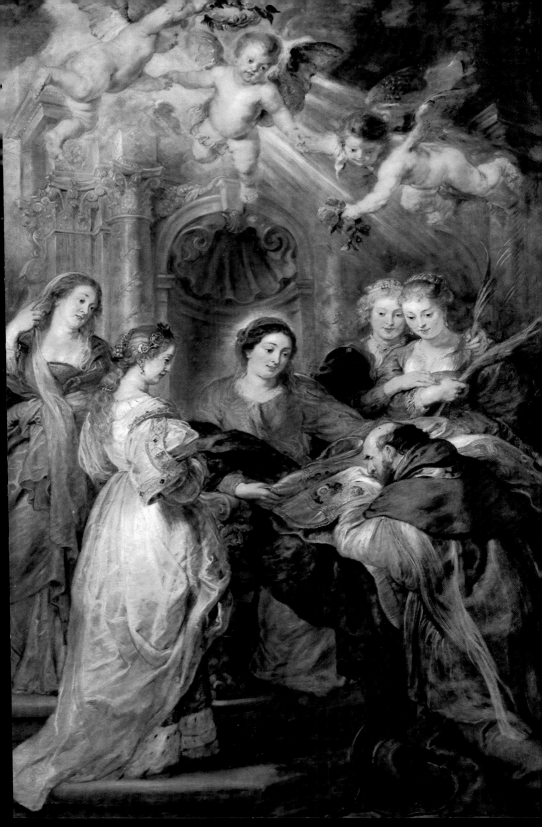

true exponent of Flemish love of life, a rustic who delights in an abundance of material possessions and sensuality (*157*).

Sir Anthony van Dyck (1598–1642), who had already appeared on the art scene in Antwerp in 1615 as a child prodigy, was employed as an independent collaborator in Rubens's studio from 1617. He spent the years 1622–27 studying in Italy. In 1632 he went to England as court painter to Charles I: there he became a master of the aristocratic portrait, brilliant in both characterization and color (*156*). Van Dyck produced altarpieces and historical paintings, and also, during his English period, a number of surprisingly fresh watercolor landscapes. To compare him with Rubens would be unfair. Van Dyck was the founder of a school of English painting, but he had neither the universal outlook nor the immense facility of Rubens.

Painting in France before about 1660 lacked homogeneity: after that date, under the direction of Charles Le Brun (1619–90) and the Academy, it became standardized and, except for great decorative ceiling paintings, had little vitality. The fate of French painting was decided not on home ground but in Rome, by Nicolas Poussin (1593–1665) and, to a lesser extent, by Claude Gellée, called Claude Lorrain (1600–82). Evidence of stylistic uncertainty in early 17th-century French painting is manifest in the continuing life of the courtly Mannerist style of the School of Fontainebleau and in the ready acceptance of influences from the Netherlands. One example is the *Bacchanal* (*158*) by Jacques Blanchard (1600–38), who, after Mannerist beginnings, was influenced by Venetian painting, and came to be regarded by his contemporaries as a "French Titian."

Until 1622, Frans Pourbus the Younger (1569–1622) of Antwerp was the most sought-after portrait painter in Paris. He was followed by Rubens, with his Medici cycle, and then by Philippe de Champaigne (1602–74). The latter was a native of Brussels, and had started out as a landscape painter. During the course of his long life, he became in a way the center around which Parisian painting revolved. Ultimately he came under the influence of the Jansenists (*161*).

At the same time, independent forces of considerable importance were emerging in the provinces, especially in Lorraine, where the court of Nancy was particularly lively in its fostering of the arts. The revival of French engraving began in Nancy with the work of Jacques Callot, a brilliant printmaker trained in Florence (*Misères de la Guerre,* 1633). Georges de la Tour (1593–1652), an enigmatic and fascinating artist, lived and worked from 1621 onward in Lunéville, where he produced a small number of impressive and monumental altarpieces (*160*) and genre pictures. "The elegant tones of his colors, veiled with a thin, as it were melancholy layer of gray, reveal him to be a Northerner who was at heart a Latin. His silence is different from the more robust stillness of the North" (Georg Kauffmann, 1970). To this day there is no satisfactory explanation for the ambiguous quality of this French follower of Caravaggio, nor for the artistic origins of the brothers Le Nain—Antoine (1588–1648), Louis (1593–1648), and Mathieu (1607[?]–77) (*159*).

A large number of French artists went to Rome. Many of them became followers

of Caravaggio, among them a certain Cecco del Caravaggio, who in 1615 was known to be living in the house of the Roman painter Agostino Tassi; Jean Le Clerc (1587–1633), who worked with Carlo Saraceni (1579–1620); and above all Valentin de Boulogne (c. 1594–1632), a Burgundian whose works were sometimes mistaken for those of Caravaggio himself. Simon Vouet (1590–1644) too began his career in Rome as a *tenebroso* (the name later given to those painters who used an emotive chiaroscuro), but even before his return to Paris in 1627 he adopted a brilliant, luminous High Baroque pictorial form (*162*). It was not until 1647, when Giovanni Francesco Romanelli (c. 1610–62), a follower of Pietro da Cortona, was called to Paris to decorate the gallery in the Palais Mazarin, that grand decorative painting on the Roman model successfully took root. The style that Romanelli introduced into France was taken up by François Perrier (c. 1584–1650) and further embellished by Le Brun.

With Nicolas Poussin, French art lay claim to the Roman succession. Poussin fulfilled the secret aims of the *Grand Siècle*, and thus presented his nation with a great legacy, both artistically and morally. Whether classicism, which regarded itself as the executor of this legacy, was ever adequate to the task, is still debated. Poussin came from a modest background and completed his studies in France without distinction. It was not until 1624 that he realized his dream of going to Rome. There he was encouraged by Domenichino, who introduced him to patrons who helped Poussin gain recognition, first in Rome (Cassiano dal Pozzo, the collector of antiquities and classical manuscripts, for whom Poussin did the first version of his Sacraments cycle after 1636), and later in Paris (the brothers Fréart de Chambray, and the Sieur de Chantelou who acquired the second cycle of the Sacraments). The only time Poussin left the Eternal City was in 1640, when he was asked to decorate the Grande Galerie in the Louvre, a prestigious commission, though one that in actuality proved a hopeless task.

Poussin's artistic output was not large. Before starting on a painting, he made careful preparatory drawings and checked the writings of classical authors. He worked slowly, and his pictures were fairly small in format; his clients were cultivated con-

158 JACQUES BLANCHARD, BACCHANAL. 1636. Musée des Beaux-Arts, Nancy.

159 MATHIEU AND LOUIS LE NAIN, VENUS IN VULCAN'S FORGE. 1641. Musée St-Denis, Rheims.

160 GEORGES DE LA TOUR, THE NEWBORN. A late work of c. 1650. Musée de Rennes.

161 PHILIPPE DE CHAMPAIGNE, ÉCHEVINS OF THE CITY OF PARIS. 1648. Louvre, Paris.

162 SIMON VOUET, THE VISION OF ST. BRUNO. c. 1635. Louvre, Paris.

163 NICOLAS POUSSIN, INSPIRATION OF THE POET. c. 1630. Louvre, Paris.

164 NICOLAS POUSSIN, THE ARCADIAN SHEPHERDS. c. 1629. First version. Devonshire Collection, Chatsworth.

165 NICOLAS POUSSIN, LANDSCAPE WITH DIOGENES. 1648. Louvre, Paris.

166 NICOLAS POUSSIN, THE SACRAMENT OF MARRIAGE. 1647/48. Duke of Sutherland Collection, on loan to the National Gallery of Scotland, Edinburgh.

167 CLAUDE LORRAIN, COASTAL SCENE WITH ACIS AND GALATEA. 1657. Gemäldegalerie, Dresden.

168 CLAUDE LORRAIN, VIEW OF THE CAMPAGNA. n. d. Wash drawing. British Museum, London.

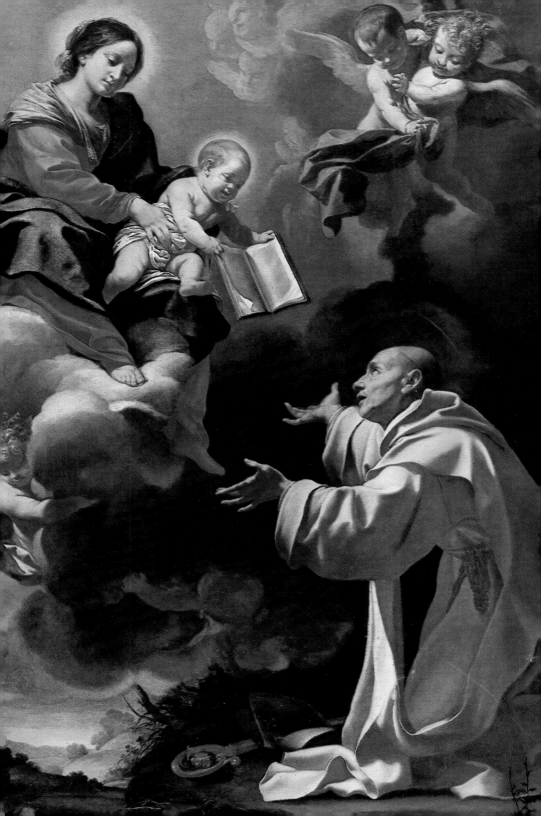

163

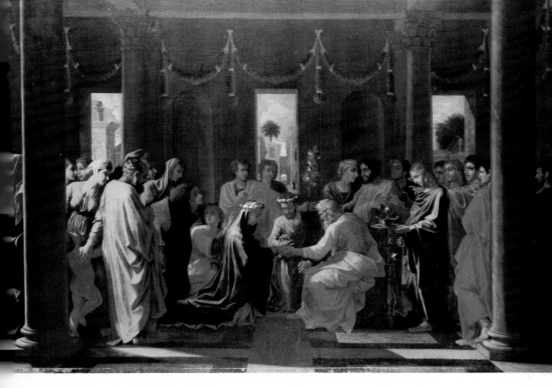

△ 167

▽ 168

noisseurs. Particularly after 1642, Poussin lived in Rome (in a house on the Pincian Hill) like a philosopher, in near solitary retreat. In many instances, he himself chose the subject for his paintings, which were mostly intended for his friends. Antique mythology, stories from the Old Testament and Roman history, bacchanals, and landscapes predominate: with the exception of one self-portrait, there are no portraits by Poussin. Such material, however, only provided the framework for what Kurt Badt called Poussin's "transcendental themes," which are often reflected in the titles traditionally given to his pictures—for instance, *Inspiration of the Poet* (*163*), the two versions of *The Arcadian Shepherds* (*164*), and both cycles of the Sacraments (*The Sacrament of Marriage, 166*). The setting is always idealized and full of significance for the painter, usually antique in character, without any suggestion of the passing of time. The grouping of the figures is determined by a visible choreography, which in itself already expresses the particular theme in bold outline. Poussin's color is used in the same way, as it changes abruptly from light, transparent, golden-veiled tones to increasingly strong hues. The size of the figures, which in early works are seen close up and fill the canvas, gradually diminishes as his later works tend to depict large figural groups. Poussin uses the human figure and its various postures in his compositions in much the same way as a poet balances words and positions them according to the demands of meter and rhyme. As a result, his paintings increasingly take on the character of humanistic icons, whose evocative portrayal stimulates the mind, enabling them to convey a *philosophie des images* that is usually found only in verse, or at least in the written word. Fundamental to all Poussin's works is a special concept of nature. It is the highest form of self-knowledge available to man, which—as Badt observed of the *Landscape with Diogenes* (*165*)—"is first grasped in the mind, and proceeding from this experience is projected onto physical reality, and is imprinted on it." For Poussin the portrayal of nature *is* self-knowledge. It is executed through the tension between freedom and law, and from it beauty is born.

Unusual and specifically French as this concept of nature may be, it nevertheless extends beyond Poussin and allows the style that we call Baroque to be understood in terms of a "oneness of the spirit." Works of 17th-century painting that appear fundamentally different can be more meaningfully compared in this context than by the use of such arbitrary devices as counting the number of figures they contain, or by superficial classification according to abstract geometric features of composition. This emerges quite plainly in the field of landscape painting, which in its developed form was an invention of the 17th century: it is certainly quite wrong to assume that because the figures are often small or sometimes even absent man plays no part, and that all we are dealing with is impressive *peinture*, or "art for art's sake." One need only turn to Claude Lorrain's delightful pictures suffused with light (*167*), the *Stormy Landscape* by Rembrandt (*129*), and the Homeric works of Rubens (*152*). Common to them all, despite their quite distinct aims and despite their different characters, is that concept of nature and the "transcendental theme" created by the unifying spiritual bond of the great imaginative painters of the Baroque age.

To the popular mind "Rococo" means decadent, unnatural, precious, intimate—but extremely beautiful. What is striking about such cliché-ridden definitions is the antithesis between moral and aesthetic evaluation. This ambivalent attitude can be explained by two factors. Rococo art was condemned, along with the *ancien régime,* after the French Revolution. In the late 19th century, by contrast, it had become very fashionable: it fit better than the Baroque into the formal-psychological art theories of the moment, theories which had their roots in the 18th century. There was also the wide influence of the Goncourt brothers' two-volume work, *L'Art du dix-huitième siècle* (1873–74), and a growing interest in stylistic criticism promoted by Heinrich Wölfflin, August Schmarsow, and Alois Riegl. The view was gaining ground that, like Gothic, Renaissance, and Baroque, the Rococo was an independent, comprehensive style.

Rococo is to Baroque much as Mannerism is to the Renaissance. In both there is the same stylistic particularization, whereby certain aspects of the "parent style" develop unilaterally and become absolute, without completely displacing the parent style. This is recognizable in the Rococo style in the supreme importance given to ornament—which suggests the unilateral development of the decorative, painterly elements of the Baroque synthesis—and also in a curious relationship between the private and public sectors in art, which was alien to the Baroque.

In the history of 18th-century art, which by the end of the century had changed so radically from what it had been at its opening, Rococo forms an episode of French origin; it gave rise to an international courtly taste throughout Europe which produced special forms of the Baroque, and finally it was unable to impede the triumphant advance of Neoclassicism.

Chronologically, the Rococo period coincides more or less with the reign of Louis XV in France, from 1723 to 1774: its beginning is separated from the Late Baroque by the short, artistically significant phase of the Régence, named after the regency of Philip II of Orléans (1715–23). Paris was the birthplace of the Rococo and the main center from which the new style spread after 1700. By about 1720, the Parisian Rococo was setting the tone in interior decoration and the applied arts, and it was supreme from 1730 to 1745. Then it swiftly faded into the *style Pompadour,* a transitional phase preceding the somewhat pedantic style of Louis XVI. By 1761, when Boucher was violently attacked in the Salon by Diderot, the Rococo was already outmoded in Paris, though in the ducal courts of Europe it was still considered modern. Strangely enough, Venice, with its political and cultural inclinations and its position as an international city, became an outpost of the Rococo, particularly in painting—a fact which in turn affected the large-scale painting of the Alpine regions. England maintained a distinctly independent position with regard to the Rococo. Such creations as the enlightened, moralizing satires of William Hogarth (1699–1764), the portraits of Sir Joshua Reynolds (1723–92) and Thomas Gainsborough (1727–88), the informal landscape garden, and the pottery of Josiah Wedgwood all seem closer to the artistic

concerns of the 19th century than to those of the Baroque or Rococo. This is even truer of the Spanish painter Francisco Goya (1746–1828), who might be said to have dug the grave of European Rococo painting.

Parisian Rococo was a cultural phenomenon. It evolved as a reaction to the solemn, official state art of Louis XIV, which was all-embracing and of a fundamentally public nature. This reaction could already be felt in the 17th century—for example, in the dispute between the Poussinist and Rubenist factions in the Academy (linearists and colorists, respectively) and in an increasing fondness for the precious, the intimate, and the irregular as opposed to the monumental, the representative, and the regular. The grand style was now challenged by private taste. Those who supported this new taste (le goût, or taste, was a favorite word of the time)—the concept and portrayal of which was expressly opposed to the official style—were the enlightened, urban aristocracy of Paris, who, though small in number, were sufficiently wealthy and cultured to set the tone. "The elegant town hôtel of smaller proportions now replaced the manorial castle, as exemplified by the Paris residence of the Archbishop of Strasbourg, the Château de Rohan, designed by Robert de Cotte and begun in 1731" (A. E. Brinckmann, 1940). The regent himself sanctioned the new taste when he commissioned the interior decoration of the Palais Royal, executed in 1716 by his Italianate court architect, Gilles-Marie Oppenordt (1672–1742). The Parisian financier and art collector Crozat, who was an admirer of Watteau, competed with Philip II, and others followed the new Rococo fashion by redecorating their hôtels (Hôtel d'Assy, 1719; Hôtel de Toulouse, 1717–20 [169]; Hôtel de Soubise, 1737–39 [170]).

There was now an unprecedented separation in the arts between the private and public sectors, but it was quite different from that in, say, 17th-century Holland, for the new taste in Paris, though private, was anything but middle-class. Elegance (la grâce) became the chief aesthetic value, a value to be intuited, not deduced by means of rules and principles (Roger de Piles): thus the Abbé Dubos asserted in 1719 that art is governed by feeling, not intellect. Love of the theater took a new turn, and men sought to produce "the greatest illusion, only to break it by exposing the pretence in an ironically playful fashion" (Nikolaus Pevsner). The social ideal of the time was the "gallant." He was by no means the mindless, effeminate, theater-going dandy that he was made out to be by bourgeois parvenus at the time: for him, there was undoubtedly an element of self-portrayal in acting, with its reflection and illusion, perception and understanding, and the dialectic of intellect and sensuality. It is thus not surprising that, at the decisive moment of transition to this new culture of "taste," Antoine Watteau's pictorial narratives were entitled fêtes galantes.

This narrowing of the concept of style to a concept of taste, and the division between private and public, is reflected throughout Parisian architecture in the contrast between "inside" and "outside," with Rococo becoming firmly established for private interiors, while on the outside—and in the interiors of public buildings—the gradual petrification of Baroque gave way to Neoclassicism. This can be seen in the Ecole Militaire (begun 1751) by Ange-Jacques Gabriel (1698–1782), his two buildings in the

Place de la Concorde (1753–63), and the completed façade of St-Sulpice (begun 1745), and finally in Ste-Geneviève (later the Panthéon; 1755–92) by Jacques-Germain Soufflot (1713–80). Church interiors of this period clearly counted as public architecture, and consequently they look quite different from the standard notion of Rococo churches. This Janus face displayed in Paris is clearly part of Rococo: only where a similar division is to be found, as in the Potsdam of Frederick the Great, can one refer without reservation to Rococo.

The Rococo style is renowned for ornament—not only the *rocaille* motif, which brought together elements of the cartouche, the shell, and the cameo, and which in the 19th century gave its name to the entire movement, but the totality of the association of form and color, for instance in pattern and background. The same process was later carried even further in Art Nouveau.

169 HÔTEL DE TOULOUSE, PARIS (now Banque de France): Galerie Dorée. 1717–19. A masterpiece of the Parisian Régence style of decoration, designed by Robert de Cotte and executed by F. A. Vassé.

170 HÔTEL DE SOUBISE, PARIS (now Archives de France): Salon de la Princesse. 1737–39. Exquisite Rococo decoration designed by Germain Boffrand; spandrel paintings by Charles Joseph Natoire (originals in the Louvre).

171 SANSSOUCI PALACE, POTSDAM: Library. The palace was built in 1744–47 as a private retreat for Frederick the Great. The library, completed in 1756 and restored after World War II, is a superb example of the transformation of Rococo in Germany due to the influence of local Baroque traditions. The walls are paneled in cedar. The bookcases are by Johann Christian Hoppenhautt, the gilded bronze ornaments by J. G. Kelly. Above each of four antique busts from the Polignac collection are allegorial reliefs (above Homer, for instance, is an allegory of Learning by Benjamin Giese). The stucco work on the ceiling is by Merck. Opposite the mirror, the view out to the garden is focused on an antique statue of a praying youth.

172, 173 THE BAVARIAN CHURCH INTERIOR. (*172*) DIE WIES (WIESKIRCHE). View toward the choir from the oval nave. This famous pilgrimage church near Steingaden was built and decorated by the brothers Dominikus and Johann Baptist Zimmermann in 1748–53. (*173*) FORMER BENEDICTINE ABBEY CHURCH, ROTT-AM-INN. Johann Michael Fischer. 1759–63. Splendid sculpture by Ignaz Günther and Johann Baptist Straub (1704–84), ceiling fresco by Matthäus Günther (1705–88), pupil of Cosmas Damian Asam, 1763. Die Wies and the church at Rott-am-Inn are important examples of the decorative organization of the arcade area to form a zone of transition from the wall articulation to the frescoed vault.

174–77 REJECTION OF ROCOCO IN FRENCH PORTRAIT SCULPTURE ON THE EVE OF THE REVOLUTION. (*174*) AUGUSTIN PAJOU, MADAME DU BARRY. 1773. Marble. Height 70 cm. Louvre, Paris. (*175*) JEAN-BAPTISTE PIGALLE, DIDEROT. 1777. Bronze. Height 42 cm. Louvre, Paris. (*176*) JEAN-ANTOINE HOUDON, MADAME HOUDON. 1787. Original plaster. Height 62 cm. Louvre, Paris. (*177*) JEAN-ANTOINE HOUDON, VOLTAIRE. 1778. Bronze. Height 45 cm. Louvre, Paris.

178 PANTALONE. Nymphenburg porcelain figurine, from a group of polychrome figures of the Italian Commedia dell'Arte stock players modeled by Franz Anton Bustelli (1723[?]–63), c. 1760. A fine example of Rococo small-scale sculpture, in the material whose formula was "discovered" in 1708/9 by Johann Friedrich Böttger at Meissen. Bayerisches Nationalmuseum, Munich.

179 FRANCESCO GUARDI, PALAZZO LABIA NEAR S. GEREMIA AT THE MOUTH OF THE CANAREGGIO IN THE GRAND CANAL, VENICE (detail). c. 1760. Alte Pinakothek, Munich.

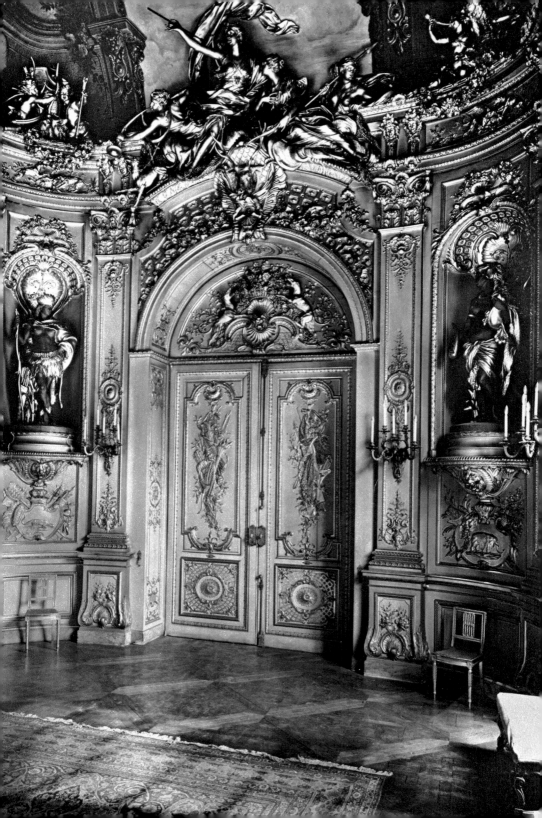

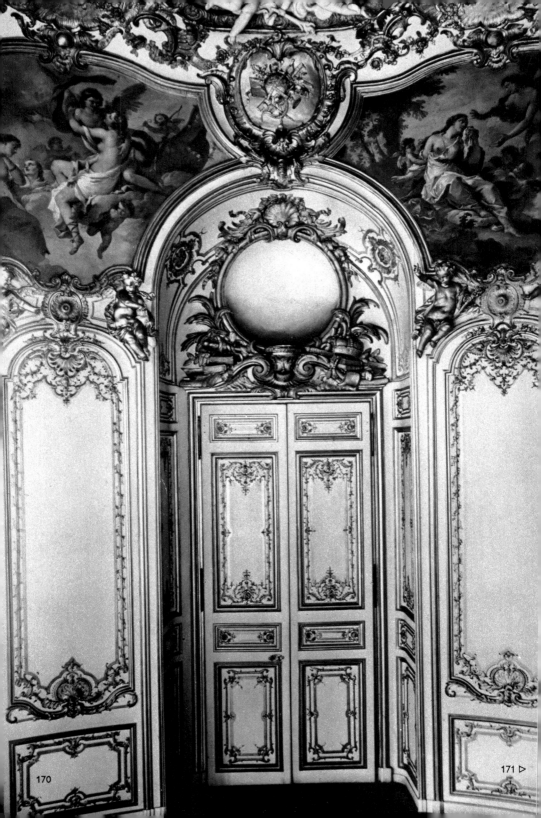

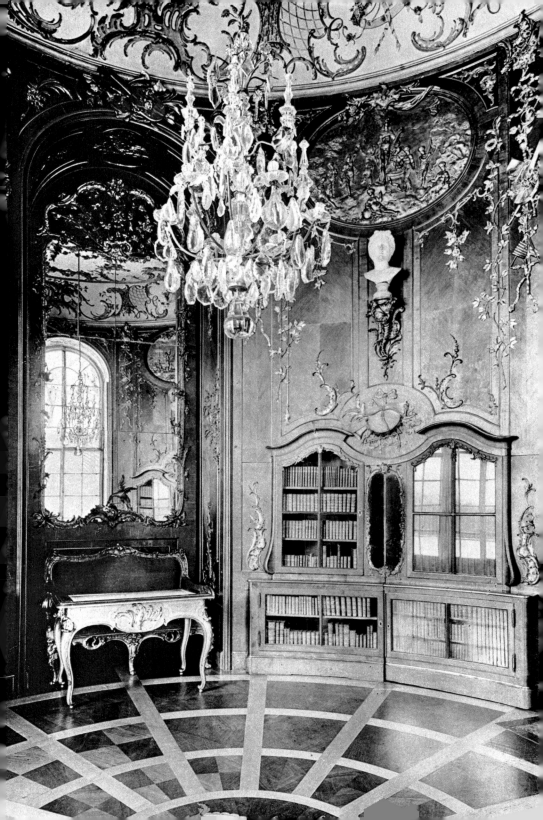

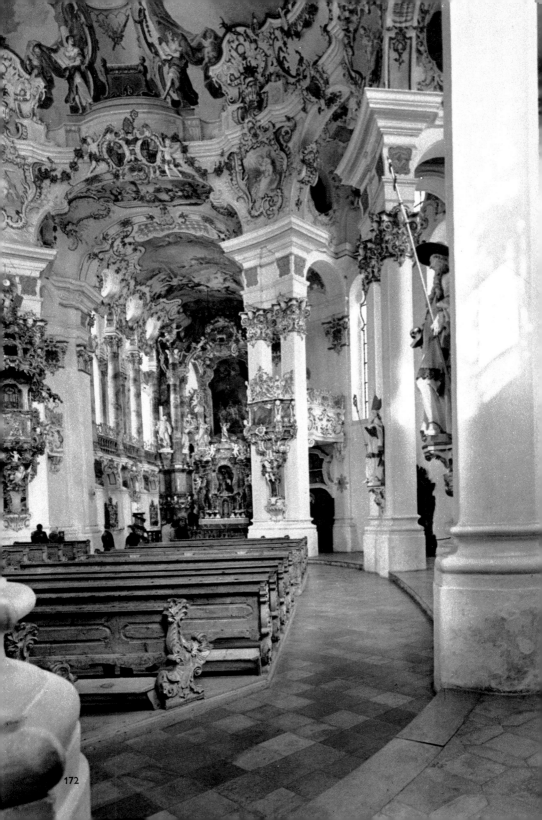

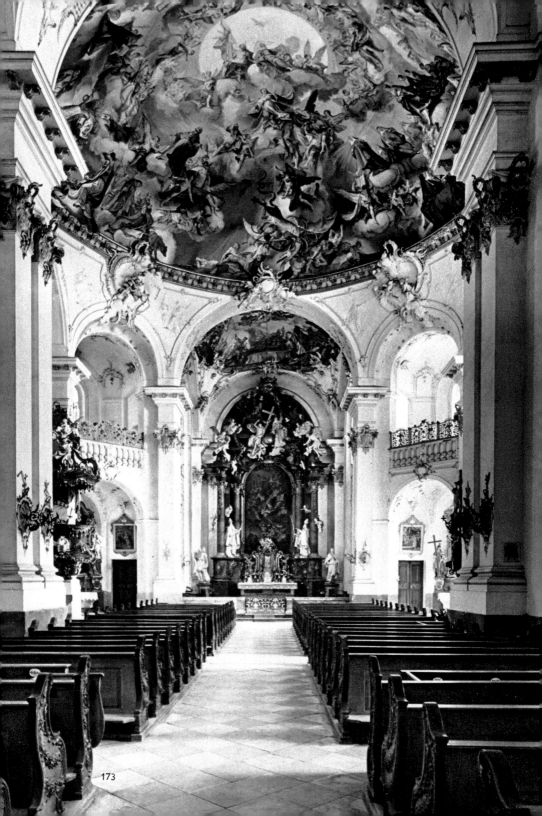

173

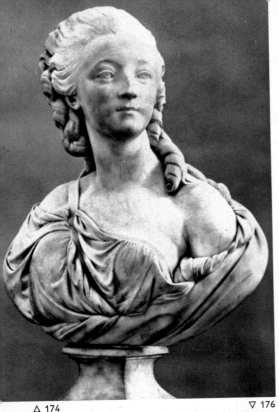

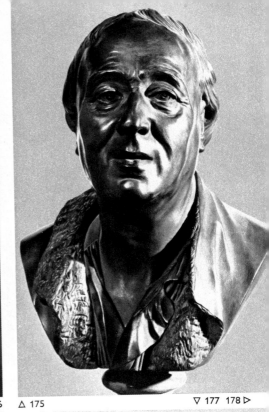

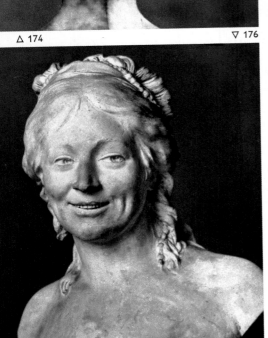

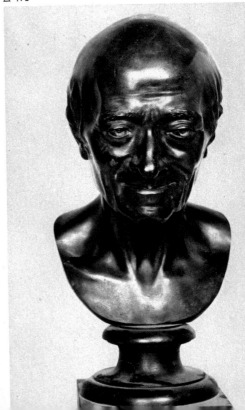

Rococo ornament incorporates recognizable objects, and indeed their presence is one of its themes. Their meaning, however, is secondary to their role as decoration. Within Rococo ornament there is continual transformation—a figure becomes abstract pattern, pattern becomes plant, frame becomes filling. For the ornamental method makes it possible for anything to be combined with anything else: as early as the Régence period it was incorporating and absorbing everything (*169*). The importance and character of ornament in this age is illustrated by French and German ornamental engravings, which played a fundamental part in the development of Rococo, and remained the ideogram of the Rococo style. These engravings of ornaments, which developed along the lines of the Renaissance grotesque, were produced by architects such as Gilles-Marie Oppenordt, Juste-Aurèle Meissonier, Germain Boffrand, and François Cuvilliés and by painters, including Claude Gillot, Antoine Watteau, and François Boucher.

After 1720, when in Paris private taste could be said to have conquered public display, the characteristic Rococo type of ornament gained ascendance over all previous Baroque media and forms in the area of interior decorations. This can be seen by comparing a mature Rococo interior, dating from before 1740, with a Régence interior, also in Paris (*169, 170*). Decoration of the Régence period, exemplified by the Hôtel de Toulouse (*169*), still works on the Baroque principle of hierarchical distinction, keeping to pilasters for the articulation of the wall, and graduating the motifs and the degree of relief according to size, thereby producing a gold and white wall surface that remains close to the Baroque ideal of showy, clearly articulated richness. Rococo decoration, seen in the Hôtel de Soubise (*170*), is entirely different. Here all the elements are given more or less equal weight. There are no longer any classical orders: slender fillets serve as the only guidelines. The wall of carved and gilt wood ornamentation is not divided off from the ceiling in any way; it is linked to it in wavelike forms, which now also determine the form of the spandrel paintings. The ornament is tastefully distributed, with the extensive main areas assuming an eloquent quality rather like that of blank paper to be drawn on. Amid the ornamental covering there is a suggestion of the old French motif of panelling, but the wall decoration no longer falls into zones, as it had in the 17th century, because the frames are becoming filled in and no right angles are used, although verticals and horizontals imperceptibly govern the scheme. Everything is linked to everything else, though not physically, as in Mannerism, but by symmetry, analogy, directional emphasis. The individual element is absorbed in the whole, it is *tout l'ensemble* that dominates (Roger de Piles). Enormous wall mirrors, fashionable since they were used in the Galerie des Glaces at Versailles, heighten the ornamental character of this decoration; the ornamentation becomes disembodied and reduced to floating appearance. A perfect analogy is in contemporary porcelain, whose colored decoration in no way alters the object on which it is painted because the object is identified by the format and brilliance of its design.

Cabinets inset with porcelain and mirrors were popular in Germany. Examples are to be found in the Residences of Munich (before 1736) and Ansbach (1739–40) and in the Millionenzimmer of the Schönbrunn Palace in Vienna, where Indian and

Persian miniatures rather than porcelain were inserted into the Rococo decoration. Another fashion in Rococo was for things Chinese (an aspect of that exoticism which had already taken hold in the 17th century), including lacquer furniture.

The applied arts in general are the display ground of Rococo. The costly inlaid floors of André Charles Boulle (1642–1732) at Versailles were already a pointer in this direction. Ornament is introduced to furniture in the form of gilt-bronze mountings and inlays of various woods—ivory, tortoiseshell or metal—by the application of small colored Rococo pictures, sometimes made of porcelain, and, in the case of seating, by the use of Gobelins tapestry covers. Magnificent examples of this kind of work were done by Charles Cressent (1685–1768) in Paris and by Abraham (1711–93) and David (1743–87) Roentgen, who established the largest furniture workshop in Europe at Neuwied in Germany. Of all the many wonderful items produced for palaces, mention must certainly be made of the wrought-iron grilles of the Place Stanislas in Nancy (by Jean Lamour, 1751–52) and of those at Würzburg (by G. Oegg, c. 1740).

Rococo ornament caused a sensation in Europe. It spread to Munich, under the influence of the Wittelsbachs, and to the Electorate of Cologne, and Frederick the Great approved it for his palace of Sanssouci at Potsdam (*171*). German artists also produced engravings of ornaments, and their designs were reproduced by virtuoso stucco-workers. Outstanding examples of this are the decorations executed in Munich to designs by François Cuvilliés (1695–1768) in the Amalienburg in the park at Nymphenburg (1734–39) and the Theater of the Residenz (1750–53). Here, outside Paris, symmetry was abandoned in single ornaments and in large sections (for example,

180 GIOVANNI BATTISTA TIEPOLO, EUROPE. Detail of the ceiling fresco over the staircase in the Residenz, Würzburg, signed and dated 1753. Europe is represented as surrounded by the Arts (music, painting) and flanked by representatives of the Church and the Empire. Above is a tribute to Prince-Bishop Carl Philip von Greiffenklau, Duke of Franconia.

181 PAUL TROGER, ASSUMPTION OF THE VIRGIN. Oil sketch. Design for the fresco in the choir of Brixen Cathedral (Austria), completed in 1750; used again for a ceiling in the Maria-hilfkirche in Vienna, 1760. Remarkable for the way in which the decoration of the vault —stuccoed at Brixen—merges with the circular painting, the pair of putti on clouds and the bright illumination acting as linking elements. Despite these Late Baroque devices, the transition to Rococo is apparent in the coloring. Bayerisches Nationalmuseum, Munich, Reuschel Collection.

182 ANTOINE WATTEAU, THE SIGN OF THE ART DEALER GERSAINT (detail). 1720. The painting, which served as a shop sign, shows buyers and connoisseurs in the gallery of the art dealer Gersaint. It was acquired by Frederick the Great. Verwaltung der Staatlichen Schlösser, Berlin-Charlottenburg.

183 JEAN-BAPTISTE SIMÉON CHARDIN, SAYING GRACE. 1739/40. Louvre, Paris.

184 ANTOINE WATTEAU, GILLES. 1717–20. Portrait of an actor. Louvre, Paris.

185 ALEXANDER ROSLIN, LADY WITH A VEIL. 1768. Portrait of the artist's wife, the pastel artist Marie Suzanne Roslin. Nationalmuseum, Stockholm.

186 FRANÇOIS BOUCHER, THE TRIUMPH OF VENUS (detail). 1740. Nationalmuseum, Stockholm.

187 JEAN-HONORÉ FRAGONARD, LA GIMBLETTE. c. 1765–72 *Gimblette* signifies the sugar ring with which the girl is teasing her pet dog. This is probably the earliest appearance of this "gallant" subject, of which several versions are known. Cailleux Collection, Paris.

in hollow moldings); isolated pictorial zones with figures and scenes appear, a feature that had long been established in the Baroque stucco work of the Alpine regions. In South Germany and Austria everything is richer, more sculptural, and more full of tension than in Paris; it is also more mobile and gay than, say, in Sanssouci and the Charlottenburg Palace (begun 1695) in Berlin. Far more common, however, than such relatively pure court Rococo is a mixture of Rococo with Baroque elements, which by now were widespread and thoroughly assimilated. The altar in Vierzehnheiligen (*50*) by Jakob Michal Küchel (1703–69) has four high-set volutes, covered with figures and ornaments, which are basically nothing but Bernini's baldacchino of St. Peter's (*88*) without the four columns. This trend was not limited to works of craftsmanship, but also appeared in monumental architecture. The Belvedere Palace in Vienna (*38, 39*), the Zwinger in Dresden (*42*), and the façade of the Preysing Palace in Munich by Johannes Effner (1687–1745) are notable examples. The French influence, mainly transmitted by the ducal courts, undoubtedly promoted this transformation of Baroque, but it did not succeed in displacing Baroque.

Nowhere does this emerge more clearly than in the churches built in Bavaria between 1730 and 1760. Here Rococo ornamentation was adopted as architectural motif in a way that has no parallel in France. The classic example is the pilgrimage church of Die Wies (*172*) by the brothers Dominikus (1685–1766) and Johann Baptist (1680–1758) Zimmermann. The ring of free-standing paired columns, encircling the nave of the church and set in front of the outer walls, which are pierced with windows at frequent intervals, delimits the nucleus of the oval church in the center, and forms an ambulatory around it. These piers are loosely linked by a delicate linear ornamentation, which here covers the customary arch forms and reaches up into the great ceiling fresco, which it penetrates like a series of huge, crested waves. The stucco decoration forms a transitional zone between the architectural and pictural zones. This blending of detached piers with the shell of the vault is carried further in the choir. The decoration is as important to the architectural effect as are light and color.

How to fuse the wall articulation with the great polychrome fresco in the vault was similar to the problem, already solved, of unifying illusionist frescoes and altar compositions. Of the various possible solutions, the only feasible one was that which Johann Michael Fischer (1692–1766) used in his earliest buildings, beginning in 1727. It consists of alternately strengthening and "softening" the piers and the archivolts so as to create a curved transitional zone between the free-standing piers or internal buttresses (wall-pillars) and the vault, which in Fischer's work is always covered with a large fresco (St. Anna-am-Lehel, Munich, 1727; church of the former abbey of Rott-am-Inn, *173*). Large main arches, strongly emphasized with flat soffits, alternate with softened, vaulted areas, so that the main nave and the light-filled side chapels, usually arranged diagonally around it, appear rather like pattern and background, and an effective transition is made to the vault fresco.

Next, decoration was applied to this zone at the top of the arches, at Steinhausen (1728–33) and later in the church of Die Wies (*172*), by the Zimmermann brothers.

Equally important was the way in which Cosmas Damian and Egid Quirin Asam had produced a total decorative unity in their church interiors—at Weltenburg (*98*), Rohr (1717–25), Osterhofen (1726–40), and finally Munich (St. John Nepomuk, begun in 1733)—by the use of methods quite foreign to Rococo. Thus, even before the full development of Parisian Rococo, Late Baroque had produced in Bavaria a style of decoration capable of unifying an entire interior.

Bavarian Baroque has been mistakenly seen as a product of Rococo, but there is no need to look so far for an explanation. Johann Michael Fischer, the architect, worked with the Asam brothers (one a stucco-worker, the other a painter) at St. Anna-am-Lehel in Munich and at Osterhofen, and he was also associated with the stucco-worker and painter Johann Baptist Zimmermann and with François Cuvilliés, the Bavarian court architect, whose superb gift for imaginative decoration brought him fame far beyond the borders of South Germany. The use of ornament as a connecting link between architectural and pictorial forms was pioneered in the Baroque churches of the Alpine regions, and brought to perfection in works which have never yet been regarded as "unarchitectural."

It is impossible to cover by a single term all the trends, local schools, masters, and products of painting in the period from 1700 to 1760. However, in comparison with the "classic" Baroque painting of the 17th century a common element does emerge with increasing clarity, and it is one undoubtedly connected with Rococo taste: the absolute preeminence of coloristic unity in figure painting, and hence a one-sided concentration on "painterly" qualities. Lyricism is the dominant mood. The effects of this change in style can be seen in Boucher's tapestrylike paintings (*186*); in the smoky chiaroscuro of frescoes by Franz Anton Maulbertsch (1724–96); in the weightlessness and insubstantiality of Giovanni Battista Tiepolo's figures (*180*); and in the positioning, and the swooning, dancing, and floating movements of the figures in the atmospheric canvases of Watteau (*182*). It can also be detected in the bold, sketchy manner of Francesco Solimena (1657–1747), Alessandro Magnasco (1667–1749), Giovanni Battista Piazzetta (1683–1754), and Paul Troger (1698–1762 [*181*]), whose sparkling application of color almost suggests a quality of drawing.

When these works are compared to Baroque paintings, it is apparent that the figures in them have less impact: how different are Rubens's Castor and Pollux (*148*) from Boucher's Triton, who appears like a scene-shifter amid waves that are dry as dust (*186*). However psychologically complex Caravaggio's *Bacchus* (*108*) may seem in isolation, by comparison with *Lady with a Veil* (*185*) by Alexander Roslin (1718–93) he is direct and uncomplicated. Looking backward from the 19th century we can see that in the painting of the Rococo period there was an increase in psychological interpretation, an ability to suggest different moods through the color of a picture, and also an increasing emphasis on brushwork to make a nervous, flickering life play over "dead" things or to produce a purely ornamental beauty of line.

In Italian painting, Venice took the lead. Venetian architectural views, or *vedute*, became what they have remained to this day—highly sought-after wall decoration,

unfailing symbols of culture and taste, the embodiment of the picturesque. The weight-less luminescence of the *vedute* of Antonio Canale (called Canaletto; 1697–1768), with their hidden geometry and absolute concrete clarity, was closer to Rococo taste than the grandiose or antiquarian views of Rome by Gian Paulo Pannini (1691/2–1778) or Gaspar van Wittel (called Vanvitelli; 1653–1736). In the painting of architecture there were two fashions, which developed outside Venice, chiefly in Naples (Luca Giordano, Solimena) and Genoa (Magnasco), but came into full flower in Venice. One type, the *capriccio,* consisted of imaginative fantasies on well-known architectural motifs from Venice and antiquity, culminating in the visionary etchings by Giovanni Battista Piranesi (1720–78) of imaginary prisons, the *Carceri.* The second approach to topo-graphical art was the "sketch style," a bravura artistic adaptation of architectural draftsmanship for use in painting, which became increasingly popular during the century with connoisseurs and collectors. The works of Franceso Guardi (1712–93), are typical of this genre. In his *vedute,* usually small in format, he transformed the architecture of Venice into a picturesque optical experience which so captivated foreigners that they accepted his impressionistic coloration as the true face of Venice (*179*). As a colorist, Guardi, like Piazzetta, was a follower of the *tenebrosi,* those painters who made much use of chiaroscuro. Their style had persisted as an undercurrent through-out the 17th century, particularly in Naples; in it the realistic coloring of the age of Caravaggio was abandoned in favor of eclecticism and coloristic features which exerted a strong influence on northern fresco painters (*181*).

The future of colorism lay not with the *tenebrosi,* but with Giovanni Battista Tiepolo (1696–1770). In 1727–29 he emerged from the particularism of the Venetian sketch and of chiaroscuro painting, and produced frescoes (in the Archbishop's Palace at Udine) whose transparency, weightlessness, and shadowless luminosity represented a new flowering of the Baroque ideal figure, on a new plane of greatly refined psychological and coloristic subtlety. Tiepolo's greatest admiration was not for Rubens or Pietro da Cortona, but for Veronese. His works incorporate what A. E. Brinck-mann called "dangerous vast expanses of sky," which could only be made interesting by his masterly use of every tone of gray and brown, and by his festive, resplendent treatment of the work as a whole. His masterpieces at Würzburg (*52, 180*), in the Palazzo Labia and Ca' Rezzonico in Venice, and in the palatial villa of the Pisani at Strà, can never be overpraised. Before his departure for Madrid in 1762, Tiepolo's style had become widely known through his teaching and through his works, which included altarpieces as well as paintings of mythological subjects, and whose influence extended as far as France.

The history of French painting during the Régence and Rococo periods is dominated by four masters: Watteau, Chardin, Boucher, and Fragonard. Antoine Watteau (1684–1721), from Valenciennes, was in 1702 a virtually unknown genre painter in the Flemish manner. In 1712 he was admitted to the Academy as "a painter of *fêtes galantes,"* having invented the dreamy, beautiful pictorial world which the enlightened aristocracy yearned for as a poetic Arcadia. Exponents of the Rococo chose him as

leader, ladies dressed themselves in the fantasy costumes of his pictures, his compositions appeared on furniture and on porcelain and were imitated far afield. Watteau's fantasies were fed by two sources: Rubens, whose pictures he had studied since 1709, and the theater, which he devotedly depicted in innumerable figure studies, paintings of theatrical performances and portraits of actors in costume (*184*). But anyone who turns from the late works of Rubens (for instance, the *Garden of Love* in the Prado) to Watteau's feasts of love on the island of Cythera (Louvre; Berlin) or in a park (Dresden; Wallace Collection, London) and to *The Sign of the Art Dealer Gersaint* (*182*), will see Rubens's bold, universal, worldly outlook transformed. In Watteau's atmospheric world everyone is absorbed, preoccupied by art, music, emotion. The figure is lost in the picture or dissolves into mere semblance, which can be all or nothing. The metaphor for this person is the actor (*184*).

Jean-Baptiste Siméon Chardin (1699–1779) is more earthly, more bourgeois, more sceptical than Watteau. His theme is the transient existence of man, creature, and thing, purified by an innocent eye, and raised to unimagined vividness by color. Chardin was self-taught: the son of a joiner, he was discovered by the portrait painter Nicolas de Largillière, and admitted in 1728 to the Académie as an "animal and fruit painter." What made him popular in his own time was clearly not what we today value in his work: it was his amazingly faithful rendering of the material world. Now, greater value is attached to his power as a painter of people, one who presented an un-sentimental view of everyday things—a girl peeling turnips, a boy building a house of cards, saying grace (*183*) at a humble table. These subjects have their origin in Flemish painting; but Chardin has transposed the scene from the calm splendor and ostentation of the Flemish interiors, with their pride of possession and sense of order, to a gray reality which is then itself transformed by the magic of paint. Tone-painting is unknown to him: even the splendid pastel portraits he did in his old age are pure color composition, in this respect true precursors of Impressionism. But what charac-terizes them and distinguishes them from Impressionism are the sensations of smell, hearing, and taste that are conveyed by Chardin's portrayal of inanimate things.

François Boucher (1703–70) has been condemned by bourgeois criticism for his lack of seriousness—a charge that is admittedly hard to refute. He was nevertheless an acknowledged master, a prizewinner at the age of twenty, who spent the years 1727 to 1734 studying in Italy, and was highly admired by Madame de Pompadour. Boucher shows in every one of his good paintings that the subjects are merely excuses for a play of form and color, in which it is the fragile, hermetic reflection of the figure in the picture that is significant. Boucher arranges his figures, with their delightful linear purity, in ornamental patterns and tender colors like flowers in a herbarium (*186*). For him there is clearly only one unpardonable error—that of verisimilitude. As a draftsman Boucher was an excellent observer, with a refreshing naturalness, particularly in his portrayals of animals; as soon as he transfers such details to his paintings, however, their vitality is lost in the pattern of form and color.

Totally different from this art of ornamental, glasslike fragility, dusted with the

finest powdering of color, is that of Jean-Honoré Fragonard (1732–1806), a French-man from the south, terror of the bourgeois world, with a God-given talent for color. Closer than Boucher to Italy, from 1756 to 1761 he was in Rome, where he befriended Hubert Robert, the painter of classical ruins, and in 1773 he returned to Rome again. He must have discovered—long before Goethe—an original, natural, Orphic quality there. He is one of the few French artists who does not imprison man in social conven-tion. He alone was able to treat "gallant" subjects without any awkwardness and without any psychological complications. Even when dealing with erotic subjects, he is never lascivious (*La Gimblette, 187*). According to the Goncourt brothers, he was a genius, but a pure sensualist. He is full of wit and imagination, never merely daubing color, and at home with every subject. A painting of such poetic richness as *The Fête at St-Cloud* (Banque de France, Paris) is both disarmingly natural and intensely alive. His brilliant series of pictures in the Wallace Collection in London, of which *The Swing* (1766) is often reproduced as an illustration of social history, provides a comprehensive view of Fragonard the man, who in a divided world knew how to portray the range of human nature in visions of passionate color.

The characteristics of the great French painters of the 18th century naturally emerge most clearly in portrait painting. For it was this medium that directly reflected the new ideal of taste cherished by fashionable society, which also spread very rapidly abroad, through the usual channels. Notable portrait painters outside France were Antoine Pesne (1683–1757) in Berlin, Georg Desmarées (1697–1776) in Munich, and Pietro Longhi (1702–85) in Venice. The growing importance of the pastel portrait, in Venice (Rosalba Carriera, 1665–1757) and in Paris (Maurice Quentin de la Tour, 1704–88), can be readily explained by reference to the great popularity of porcelain (*Pantalone, 178*). The late portraits by Chardin form a special category, for as a rule the Rococo portrait tends to mask the subject under a veil of idealized, childlike beauty. Nevertheless, 18th-century painters and sculptors increasingly used a wealth of characterization in their portrayal of the individual, so that the reaction against the social inhibition of individual qualities found a considerable outlet in French portraiture after 1770. This new freedom of expression is evident in the ardent, informal bust of the great encyclopedist Diderot by Jean-Baptiste Pigalle (1714–85 [*175*]) and can even be detected in the more restrained portrayal of Madame Du Barry by Augustin Pajou (1730–1809 [*174*]). In this movement sculptors were well to the fore (*174–77*), and it was they who finally destroyed the elegant façade of the Rococo portrait. Hildebrandt's comment that "the individual triumphs over convention, and character over decoration" calls to mind Jean-Antoine Houdon's brilliant series of portrait busts (*176, 177*) immortalizing virtually all the great, important, or merely famous figures at the end of the *ancien régime*. However, the triumph of the individual and of personal freedom was a short-lived dream. In his old age, Houdon (1741–1828), the brilliant recorder of important faces, had to set about executing public commissions in the straitjacket of a new convention, with a new decorative bias. Neoclassicism returned to the grand manner, an official style, and the ideal of service to the state.

BIBLIOGRAPHY

BAROQUE

PERIOD AND STYLE

Burckhardt, Jakob. *Recollections of Rubens* (1897). London: Oxford University Press; New York: Phaidon, 1950.

Haskell, Francis. *Patrons and Painters.* London: Chatto & Windus; New York: Knopf, 1963.

Justi, Karl. *Diego Velázquez und sein Jahrhundert* (1888). 2 vols. Bonn: Cohen, 1922–23.

Kitson, Michael. *The Age of Baroque.* New York: McGraw-Hill, 1966.

Mâle, Emil. *L'Art réligieux après le Concile de Trente.* Paris: Colin, 1932.

Swoboda, Karl M., ed. *Barock in Böhmen.* Munich: Prestel, 1964.

Wölfflin, Heinrich. *Principles of Art History* (1915). New York: Dover, 1950.

GENERAL STUDIES

Blunt, Anthony. *Art and Architecture in France: 1500–1700.* Harmondsworth and Baltimore: Penguin (Pelican), 1957.

Hempel, Eberhard. *Baroque Art and Architecture in Central Europe.* Harmondsworth and Baltimore: Penguin (Pelican), 1965.

Hubala, Erich. *Die Kunst des 17. Jahrhunderts.* Berlin: Propyläen, 1970. (Propyläen Kunstgeschichte, 9).

Kubler, George and Soria, Martin. *Art and Architecture in Spain, Portugal and Their American Dominions: 1500–1800.* Harmondsworth and Baltimore: Penguin (Pelican), 1959.

Mahon, Dennis. *Studies in Seicento Art and Theory.* London: Warburg Institute, 1947.

Maricheau-Beaupré, Charles. *L'Art au XVIIᵉ siècle en France.* 2 vols. Paris: Le Prat, 1946–47.

Rosenberg, Jakob. *Dutch Art and Architecture: 1600–1800.* Harmondsworth and Baltimore: Penguin (Pelican), 1966.

Weisbach, Werner. *Spanish Baroque Art.* Cambridge: Cambridge University Press, 1941.

Wittkower, Rudolf. *Art and Architecture in Italy: 1600–1750.* 2d ed. Harmondsworth and Baltimore: Penguin (Pelican), 1965.

ARCHITECTURE

Argan, Giulio Carlo. *Borromini.* Milan: Mondadori, 1952.

Brauer, Heinrich and Wittkower, Rudolf. *Bernini's Drawings* (1930). 2 vols. New York: Collector's Editions, 1970. Reprint of the original German edition.

Downes, Kerry. *English Baroque Architecture.* London: Zwemmer, 1966.

Guarini, Guarino. *Architettura civile* (1732). Milan: Il polifilo, 1968.

Hubala, Erich. *Renaissance und Barock.* Frankfurt-am-Main, 1969.

Norberg-Schulz, Christian. *Baroque Architecture.* New York: Abrams, 1971.

Pinder, Wilhelm. *Deutscher Barock: Die großen Baumeister des 18. Jahrhunderts.* Düsseldorf, 1912.

Portoghesi, Paolo. *Guarino Guarini.* Milan, 1956.

— *Roma Barocca: The History of an Architectonic Culture.* Cambridge, Mass.: M.I.T. Press, 1970.

Reuther, Hans. *Die Kirchenbauten Balthasar Neumanns.* Berlin: Hessling, 1960.

Sedlmayr, Hans. *Österreichische Barockarchitektur.* Vienna: Filser, 1930.

Thelen, Heinrich. *Francesco Borromini: Die Handzeichnungen.* Graz: Akademische Druck, 1967. See Section 1 (2 vols.).

SCULPTURE

Brinckmann, Albert E. *Barock-Bozzetti* (1917). 4 vols. Frankfurt-am-Main: Frankfurter Verlagsanstalt, 1923–25. English-German edition.

Faldi, Italo. *La scultura barocca in Italia.* Milan, 1958.

Ladendorf, Heinz. *Andreas Schlüter.* Berlin: Rembrandt, 1937.

Magni, Giulio. *Il Barocco a Roma nell'architettura e nella scultura decorativa.* Turin: Crudo, 1911–13.

Pinder, Wilhelm. *Deutsche Barockplastik.* Königstein-im-Taunus: Langewiesche, 1933.

Pope-Hennessy, John. *Italian High Renaissance and Baroque Sculpture.* 3 vols. London and New York: Phaidon, 1963.

Riccoboni, Alberto. *Roma nell'arte. La Scultura nell'evo moderno.* Rome: Casa Editrice Mediterranea, 1942.

Weise, Georg. *Spanische Barockplastik.* 2 vols. Reutlingen: Gryphius, 1939.

Wittkower, Rudolf. *Gian Lorenzo Bernini: The Sculptor of the Roman Baroque.* 2d ed. London and New York: Phaidon, 1965.

PAINTING

Bernt, Walther. *The Netherlandish Painters of the Seventeenth Century.* London and New York: Phaidon, 1970.

Blunt, Anthony. *Nicolas Poussin.* 2 vols. London: Phaidon, 1968; New York: Pantheon, 1967.

Bode, Wilhelm von. *Great Masters of Dutch and Flemish Painting* (1906). London: Duckworth, 1909.

Drost, Willi. *Barockmalerei in den germanischen Ländern.* Potsdam: Athenaion, 1926.

Evers, Hans G. *Peter Paul Rubens.* Munich: Bruckmann, 1942.

Friedlaender, Walter. *Caravaggio Studies.* London: Oxford University Press; Princeton. N.J.: Princeton University Press. 1955.

Lassaigne, J. *La Peinture espagnole.* 2 vols. Geneva: Skira, 1952.

Rosenberg, Jakob. *Rembrandt: Life and Work.* Rev. ed. London and New York: Phaidon, 1964.

Thuillier, Jacques. *French Painting II: From Le Nain to Fragonard.* Geneva: Skira, 1964.

Tintelnot, Hans. *Die barocke Freskomalerei in Deutschland.* Munich: Bruckmann, 1951.

Voss, Hermann. *Die Malerei des Barock in Rom.* Berlin: Propyläen, 1924.

Waterhouse, Ellis: *Baroque Painting in Rome: The Seventeenth Century.* London: Macmillan, 1937.

ROCOCO

Brinckmann, Albert E. *Die Kunst des Rokoko.* Berlin, 1940.

Dacier, Emile. *L'Art au XVIIIᵉ siècle en France: Époques Régence, Louis XV, 1715–1760.* Paris: Le Prat, 1951.

Feulner, Adolf. *Bayerisches Rokoko.* 2 vols. Munich: Wolff, 1923.

—*Skulptur und Malerei des 18. Jahrhunderts in Deutschland.* Potsdam: Athenaion, 1929.

Hitchcock, Henry-Russell. *Rococo Architecture in Southern Germany.* London and New York: Phaidon, 1969.

Kimball, Fiske. *The Creation of the Rococo.* Philadelphia: Museum of Art, 1943.

Norberg-Schulz, Christian. *Late Baroque and Rococo Architecture.* New York: Abrams, 1972.

Réau, Louis. *L'Art au XVIIIᵉ siècle en France: Style Louis XVI.* Paris: Le Prat, 1952.

Savage, George. *French Decorative Art: 1638–1793.* London: Penguin; New York: Praeger, 1969.

Schönberger, Arno and Soehner, Halldor. *Age of Rococo.* London: Thames and Hudson, 1960. Issued as *The Rococo Age.* New York: McGraw-Hill, 1960.

Wilckens, Leonie von. *Fest- und Wohnräume deutscher Vergangenheit: Barock bis Klassizismus.* Königstein-im-Taunus: Langewiesche, 1967.

INDEX

Descriptions of the illustrations are listed in boldface type

195